The Forgotten Fifties

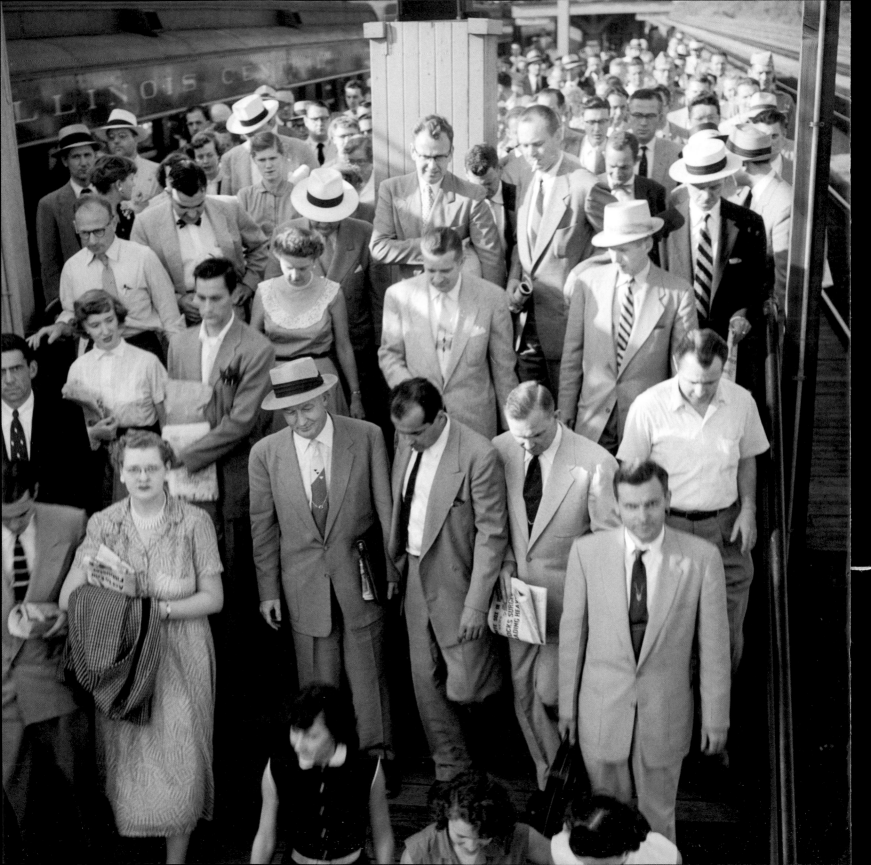

The Forgotten Fifties

America's Decade from the Archives of *Look* Magazine

James Conaway
In association with the Library of Congress
Introduction by Alan Brinkley
Photo Editor: Amy Pastan

Skira *RIZZOLI*
NEW YORK

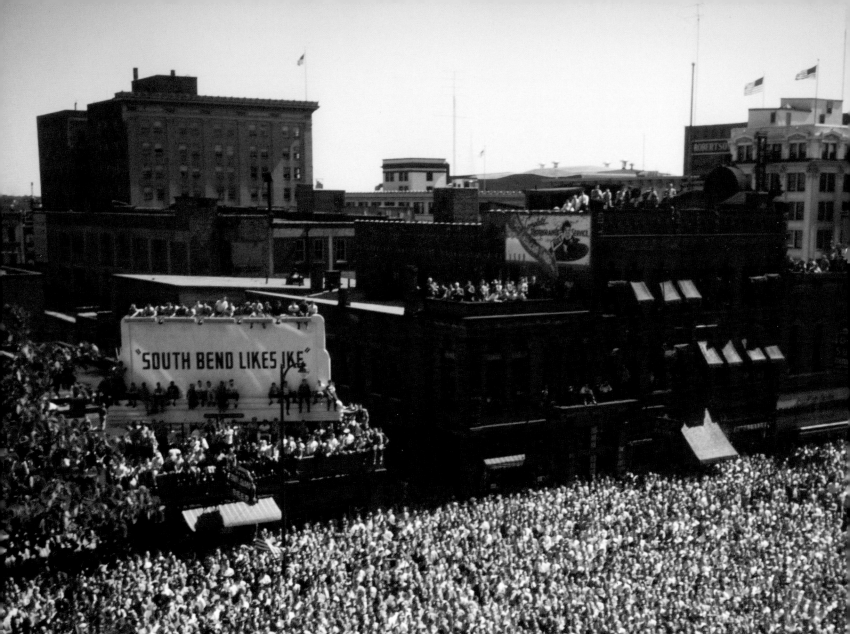

Contents

PREVIOUS PAGES: In February 1954, *Look* tabbed eleven communities as "All-American Cities." Among them was Park Forest, Illinois, a village south of Chicago, created in 1946 for commuters like these train passengers, who have embraced the advantages of suburban living.

OPPOSITE: At a 1952 rally for Republican candidate for president, Dwight D. Eisenhower, the people of South Bend, Indiana, turned out to see the hero of World War II.

Introduction

by Alan Brinkley

GREAT PHOTOGRAPHS first appeared in the nineteenth century, and great photographs continue to be published and exhibited today. But the popularity of mass-market picture magazines did not flower until Henry R. Luce launched *Life*, the first American weekly picture magazine, in October 1936. It quickly became the most popular magazine in the United States and remained so into the early 1970s. Luce did have a significant rival. Gardner "Mike" Cowles Jr. and his brother John, the executive editors of the *Des Moines Register* and the *Des Moines Tribune* newspapers, also created a powerful picture magazine, *Look*, at nearly the same time. At first, in early 1937, their magazine was distributed weekly with a circulation of 400,000. Soon it became a bi-weekly, and by the mid-1950s, *Look* sold 3.7 million issues.

In its first decade, *Look* was, according to Gardner Cowles' wife, Fleur, "barber-shop reading . . . rejected by the serious advertising community."[1] Its visual content was mostly pictures of female actresses, and its editors insisted that "*Look* tells stories in pictures . . . A child can understand *Look*, yet the most intelligent, best informed adult enjoys *Look*." Despite those lofty goals, *Look* wasn't taken seriously through the 1940s. "It grieves me to recall that the magazine was long characterized as 'sensational,'" Gardner Cowles later said. "Not until 1950 did *Look* begin to reach that level of quality for which I had hoped."[2]

Luce wanted *Life* to serve important purposes and hoped to show Americans an increasingly troubled world. *Look*, on the other hand, aimed at a different readership.

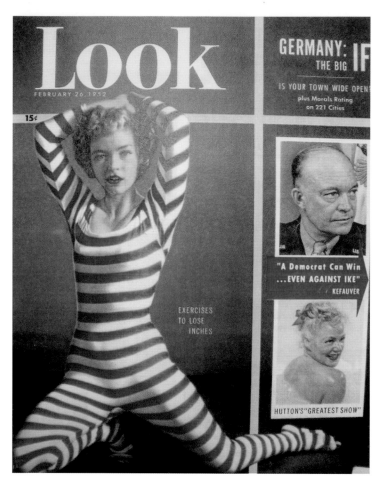

There were some serious articles in *Look*. But as *Time*, *Life*'s sister publication, said at the launching of *Look*, the magazine had "reader interest for yourself, for your private secretary, for your office boy"—a magazine mostly for the middle class and for ordinary lives.[3]

Gradually, the *Look* photographs became of unusual interest, and by the dawn of the fifties, they began to reflect a broad range that included fashion, politics, comedy, sports, religion, the Korean War, movies and movie stars, automobiles, racial issues, family life, and music. *Look* photographers gave readers an idea of how Americans lived in a period of much change. The magazine recruited some of the great photographers, among them, Arthur Rothstein and John Vachon, who had worked in the New Deal's Farm Security Administration (FSA) during the Great Depression. Many of those FSA photographers went on to contribute to *Look* and *Life* and other magazines. And *Look* was helped by its talented editors, among them Daniel D. Mich, the editor through much of the 1950s. He was, according to longtime *Look* contributor Leo Rosten, a "roughhewn, abrupt, often abrasive" man who "despised guile, fence-straddling, or laziness. He was totally fearless for the poor and powerless."[4]

The years from the end of World War II to the end of the 1950s saw powerful changes in American life, reflected in many of the photographs that appeared in *Look* and in this book. Among these changes were the birth of the Cold War and the "Great Fears" that it created, and the dramatic explosion of affluence that transformed the lives of many—though not all—Americans. There was also a growing angst among many men and women who came to feel that their lives were too constricted by the staid culture of the era. And *Look* helped to create images of a growing subversive culture lying beneath the smooth, stable surface of the decade.

PREVIOUS PAGES: In the wake of the 1957 launch of Sputnik by the Soviet Union, children like these in Cocoa Beach, Florida, got accelerated lessons in science. The space race overtook the arms race in importance during the latter days of the decade, as reported by *Look* in its July 24, 1958, issue.

ABOVE: The cover of *Look*, February 26, 1952.

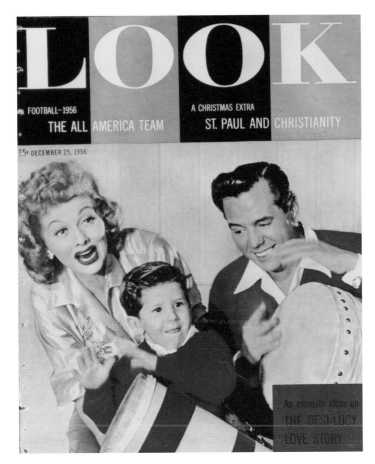

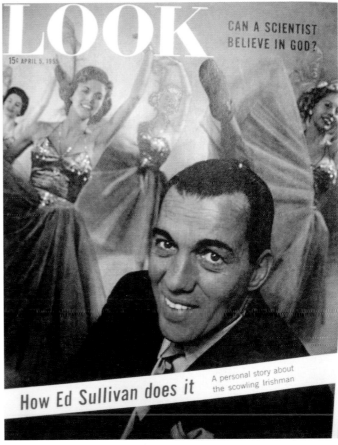

ABOVE LEFT: Lucille Ball and Desi Arnaz on the cover of *Look*, December 25, 1956.

ABOVE RIGHT: Ed Sullivan on the cover of *Look*, April 5, 1955.

THE FIFTIES OPENED with mounting fears of the Cold War. On February 9, 1950, in a speech delivered in Wheeling, West Virginia, Joseph McCarthy, a forty-one-year-old United States senator from Wisconsin, waved a piece of paper before his audience. He claimed to "hold in my hand" a list of people named by the secretary of state as members of the Communist party still serving in government, including the military. For the first five years of the decade, McCarthy raged through the political world, flogging this issue, though he never identified anyone who was ever convicted of treason or subversion.

In 1954, McCarthy's Permanent Subcommittee on Investigations launched an investigation into subversives serving in the U.S. Army, and hearings opened that spring. Millions of citizens followed the proceedings on television, radio, and through daily

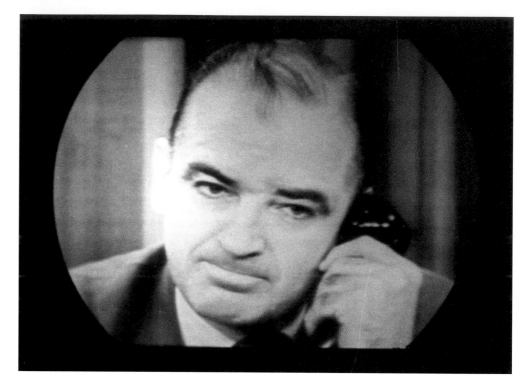

Senator Joseph McCarthy made his anti-communist crusade the obsession of Americans, whether they supported him or decried his tactics as underhanded and self-serving. This photograph by *Look* magazine was shot from a TV screen during his March 9, 1954 appearance on Edward R. Murrow's *See It Now* program.

stories in the newspapers. On one side was McCarthy and his young, aggressive, ragtag staffers. On the other were the combined forces of the Eisenhower administration, the U.S. Army, some of the Republican Party establishment, almost all of the Democratic Party, much of the press, and a significant portion of the legal profession.

When what became known as the Army-McCarthy hearings opened in April; some observers thought the hearings would last for two weeks, but the proceedings didn't conclude until after thirty-six days of testimony. For much of that time, the two sides remained locked in unequal combat. Senator McCarthy, a victim in the end of his own arrogance, recklessness, and laziness, staggered out of the hearings, discredited by his colleagues. The brilliant lawyer Joseph Welch, working as special counsel, humiliated McCarthy in the final days of the hearings, which led in December to McCarthy's formal condemnation by the senate. By 1957, he was dead of alcohol-related illnesses.

McCarthy was an important figure in a great crusade against domestic subversion, but he was only one of many who helped create the Great Fear. The American Civil Liberties Union warned, "The threat to civil liberties today is the most serious in the

history of our country." In 1954, historian Richard Hofstadter wrote of "the widespread foreboding among liberals that this form of dissent will grow until it overwhelms our liberties altogether and plunges us into a totalitarian nightmare."[5]

The Red Scare was visible in almost every area of American life. Between 1949 and 1955, all but four of the forty-eight state governments in the United States passed laws designed to root out subversives and suppress communist activities. State and local courts engaged in remarkable excesses in pursuing and punishing people thought to be communists. Even city and county governments tried to root out people they believed to be subversives. But it was in the federal government that the Red Scare developed most rapidly and decisively.

Two years before Joseph McCarthy's West Virginia speech, the case of Alger Hiss electrified the anti-communists. In 1948, Whittaker Chambers, an editor of *Time* magazine, testified before the House Un-American Activities Committee that in 1937 he had acted as a conduit for passing classified State Department documents to the Soviet Union. The man who had given him the documents, he said, was Alger Hiss, a former high-ranking official in the State Department. Hiss, who was out of government by then, denied the charges. Most people seemed to believe him. But Chambers produced evidence that damaged Hiss's claim of innocence. Richard Nixon, a young congressman from California, pursued Hiss with great determination. Hiss was finally convicted of perjury (the statute of limitations having run out on the actual espionage) and was sentenced to a short term in prison.

Then, in 1950, a British atomic scientist named Klaus Fuchs, who had worked on the Manhattan Project during the war, admitted to Scotland Yard that he had been passing atomic secrets to the Soviets. Fuchs's confession sparked an investigation that led to New York and a lower middle-class Jewish couple, Julius and Ethel Rosenberg. The Rosenbergs were charged with having been conduits through whom Fuchs's secrets, and the secrets of others, had been passed to the Soviets. Tried in an atmosphere of near hysteria engineered by the Justice Department and the judge in the case, they were convicted of treason and sentenced to death. They were executed in June 1953.

The great fear continued through the 1950s and into the 1960s, when it slowly abated. With McCarthy gone and no national figure to stoke it, and with no further cases of espionage revealed, the fire died down and rabid anti-communism moved to the political fringes of American society.

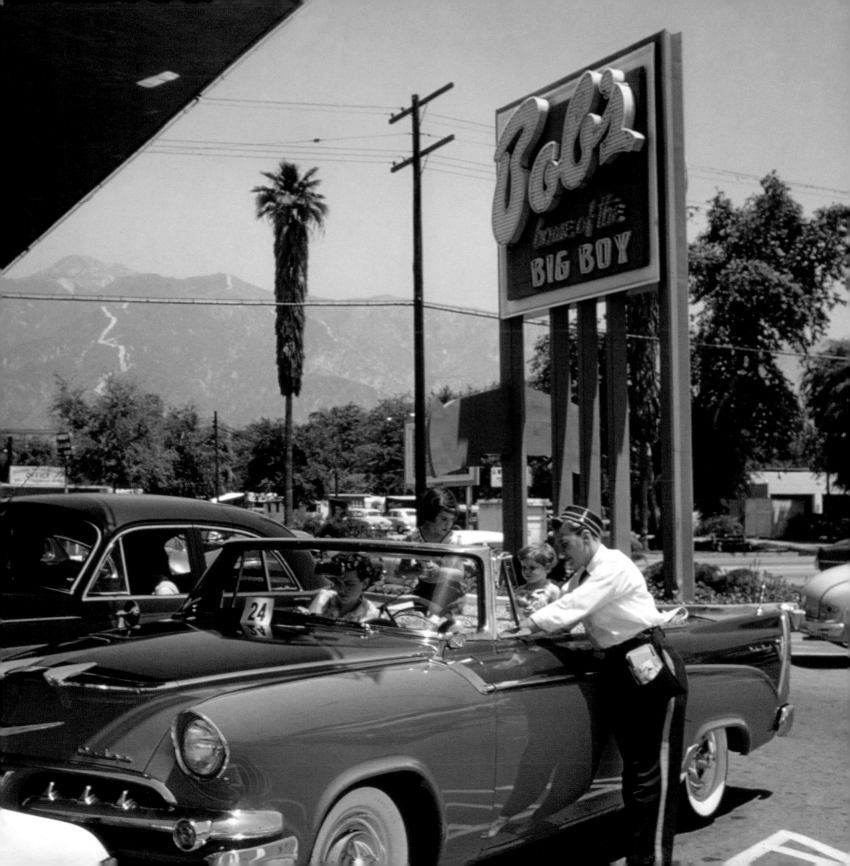

THE AMERICAN ECONOMY in the decade after World War II was "the crossing of a great divide in the history of humanity," one historian said. It was often described as an "economic miracle."[6] The GNP grew fourteen times as fast as the population and seven times the rate of inflation. The average family income expanded as much in the ten years after World War II as it had grown in the previous fifty years combined. Between 1940 and 1965, average income grew from about $2,200 per family per year to just under $8,000.

These years also saw a significant decrease in poverty in America. The percentage of families below the official poverty line in 1950 was approximately 30 percent. By 1960 it had dropped to 22 percent, and by the 1970s it had dropped to under 14 percent. Between 1950 and 1970, in other words, poverty declined by more than 60 percent.

What fueled this remarkable prosperity? One element was government spending, which was the major factor in ending the Depression in the early 1940s. Government expenditures in 1929 were 1 percent of GNP; by 1955, they were 17 percent. The bulk of this increase in the early 1950s came from military spending until the end of the Korean War. After that, highways and home construction picked up much of the slack. Veterans' benefits (mortgage and education assistance) and government-sponsored research (including military and space) all helped to fuel the economy. Another boost for postwar economic growth was the population explosion. The increase in the birthrate in the decade after World War II (known as the "postwar baby boom") fed the population from the late 1940s and through the 1950s at twice the rate it had grown in the 1930s.

The growth of suburbs after World War II was one of the great population movements in American history. Eighteen million people moved to the suburbs in the 1950s, and they would grow dramatically in the next decade. The suburban population grew 47 percent. Suburbs built a vast new market, providing an important boost to some of the most important sectors of the economy: the housing industry, the automobile industry, highway construction, and also a wide range of consumer industries. Another element was the transformation in labor relations. The new power of unions allowed workers to receive better wages and benefits for their members.

The effect of these changes led to a radical shift in American life—the birth of an economy (and a society) in which most Americans came to consider affluence a norm. Many Americans came to believe that enhancing the quality of one's economic life was a basic right. They considered material abundance one of the ways in which many Americans defined their world.

In its September 18, 1956, issue, *Look* published a portrait of Los Angeles subtitled "Living Bumper-to-Bumper" about the city's obsession with automobiles. Exhibit A: the rising popularity of drive-in restaurants.

The economist Joseph Schumpeter was hardly an uncritical defender of capitalism. But in his book, *Capitalism, Socialism & Democracy*, he expressed wonder and enthusiasm over this new system. About capitalism, he wrote simply, "It works!" and he went on to say, "In the United States alone there need not lurk behind modern programs of social betterment that fundamental dilemma that everywhere paralyzes the will of every responsible man, the dilemma between economic progress and immediate increase of the real income of the masses."[7]

The new economic vision was based on the principles of Keynesianism: the idea that there was now a "modern," "scientific" way to manage the economy—not directly by controlling the corporations, but indirectly by manipulating fiscal and monetary levers. By the mid-1950s, the belief that Keynesianism worked, that it could provide the key to keeping the economy stable, gained traction with a growing number of economists.

Many economic thinkers believed they had discovered the secret of permanent growth and permanent stability, along with new possibilities for social progress. Keynesianism, some of its disciples argued, made it possible to turn capitalism into a genuinely revolutionary force. Arthur Schlesinger Jr. wrote, "Keynes, not Marx, is the prophet of the new radicalism." *Fortune* magazine published an article entitled "The Permanent Revolution." The economist Paul Samuelson said, "The New Economics really does work. Wall Street knows it. Main Street . . . knows it . . . You can bet that the statisticians in the Kremlin know it." The growth of affluence also provided an opportunity to improve the lives of Americans and to meet social needs. The economist John Kenneth Galbraith urged a major increase in public spending on such items as schools, parks, hospitals, urban renewal, and scientific research.

The October 1957 launch of Sputnik, the first Soviet satellite to be sent into orbit (almost four months before the United States managed to do so), introduced another set of priorities into American politics and culture. It persuaded many Americans, and their government, to ask for a massive social investment in an effort to "catch up" with the Soviets—particularly in science, technology, and education.

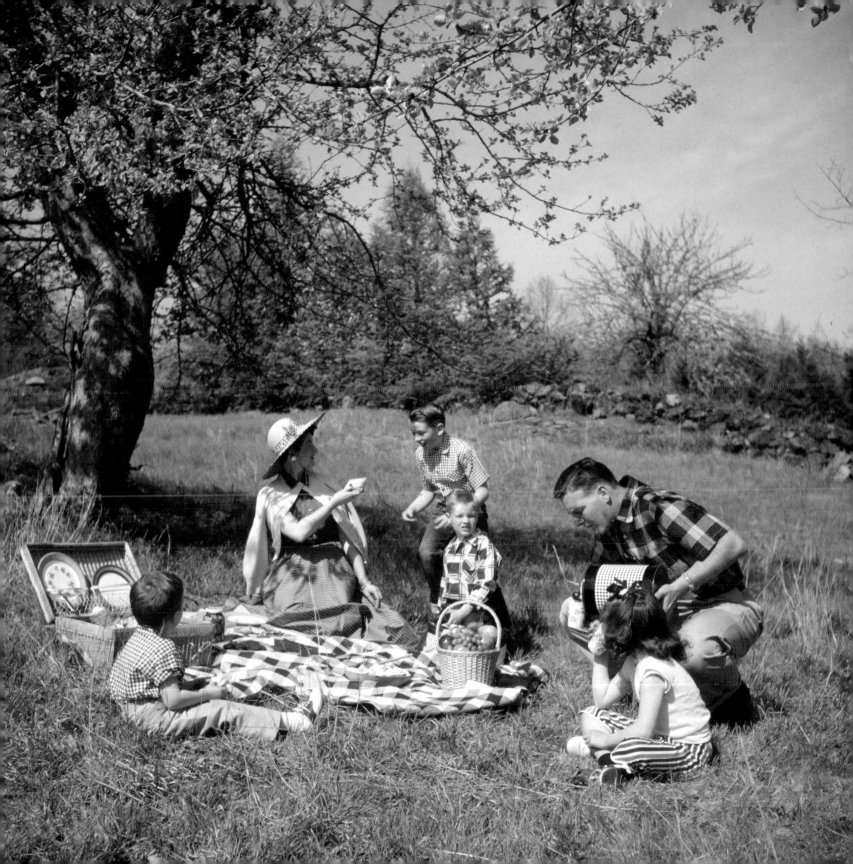

MANY AMERICANS in the 1950s considered their era to be a time of affluence, community, and unity. They saw those years as a golden era. Even the most sophisticated chroniclers of that time believed in the great successes of the 1950s. The renowned historian Richard Hofstadter would write, "The jobless, distracted, and bewildered men of 1933 have in the course of the years found substantial places in society for themselves, have become homeowners, suburbanites, and solid citizens."[8] French writer Simone de Beauvoir said of America in the 1950s: "Class barriers disappear or become porous; the factory worker is an economic aristocrat in comparison with the middle-class clerk; even segregation is diminishing; consumption replaces acquisition as an incentive. America . . . as a country of vast inequalities and dramatic contrasts is ceasing to exist."[9]

There was rapid growth in the number of people able to afford what the government called a "middle-class" standard of living, i.e., 60 percent of the American people. Home ownership rose from 40 percent in 1945 to 60 percent in 1960. By 1960, 75 percent of all families owned cars; 87 percent owned televisions; and 75 percent owned washing machines.

All of this led to the growth of the suburbs, encompassing some of the most important demographic and economic changes in postwar America. All suburbs were not alike. But within each suburban community, particularly within many of those which flourished in the 1950s, there was a striking level of uniformity and conformity.

The most famous example was what was called the Levittowns, the first of which was created on Long Island, New York. Between 1947 and 1951, developer William Levitt built a planned community, one of many mass-produced suburbs. Though relatively few communities were built by the same kind of methods that produced the Levittowns, many were built in ways that produced a similar homogeneity. Single-family homes, quarter-acre lots, driveways, garages, backyards, screened porches—that was part of the core of most suburbs. As Levitt once said, "No man who owns his own house and lot can be a communist. He has too much to do."[10]

Sociologists such as David Riesman studied the rise of the suburbs. He wrote, "The suburb is like a fraternity house at a small college in which like-mindedness reverberates upon itself." William Whyte, a writer for *Fortune* magazine, explained suburban society: "The suburb is classless, or, at least, its people want it to be. There is no elite, no wealthy, prestigious upper class. There are no shanty families, no clusters of the ethnically 'undesirable.'"

Perhaps the most important factor in changing the lives of Americans in the 1950s was television. The speed with which television swept America in the decade was a

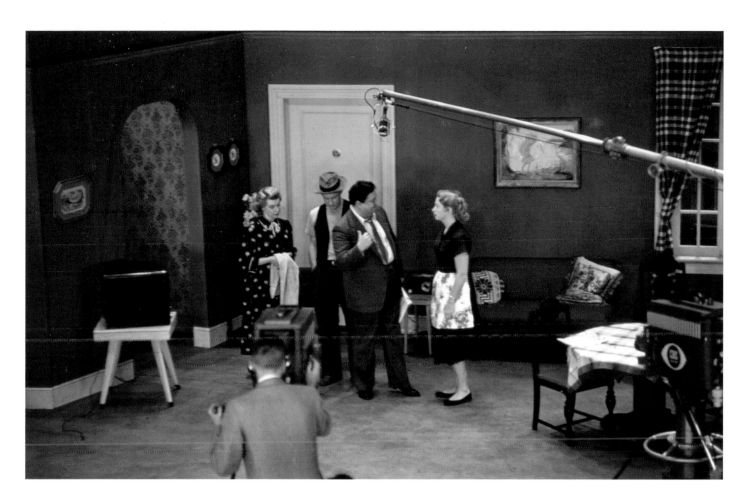

On the famous set of *The Honeymooners*, the Kramden apartment in Brooklyn. The unusual color scheme suggests that in 1955, when the show premiered, TV's black-and-white cameras would reproduce the drab surroundings more effectively.

remarkable story in itself. In 1946, there were 17,000 television sets among a population of 160 million people. By 1960, 87 percent of American homes had televisions. Within a decade, television had become one of the most important forces in America, providing a common cultural experience for almost everyone—so common that the broadcast networks allowed little controversy or conflict on the air. Television programs in the 1950s tended to bear the name of the principal sponsor: *The Pepsi-Cola Playhouse*, *General Electric Theater*, *The Dinah Shore Chevy Show*, *Alcoa Presents: One Step Beyond*—even *Camel News Caravan*.

If television programs were to be effective as advertising vehicles, especially with a single sponsor, they needed to have the broadest possible appeal. One advertising executive responded to a proposal for a television series dealing with the problems of urban

life: "We know of no advertiser or advertising agency in this country who would knowingly allow the products which he is trying to advertise to the public to become associated with the squalor and general down character of this program."[11]

Hence the characteristic programming of the late 1950s and early 1960s: Westerns, variety shows, quiz shows (until scandal brought about a hiatus), and above all, situation comedies. They were the quintessential expression of the middle-class view of American life. *The Honeymooners* of the mid-1950s, starring Jackie Gleason, with its childless, urban, working-class couples, was an exception—as was the 1950–54 *Your Show of Shows*, a satirical sketch comedy show.

By the mid-1950s, almost all of the sitcoms were set in the suburbs and featured white, middle-class, stable, nuclear families living in prosperous homes. The greatest situation comedy of them all was *I Love Lucy*, which began in 1951 and ran until 1957. In the beginning, Lucy and her husband Ricky lived in an urban, multiracial apartment. Lucy's neighbors and best friends were a childless couple, and much of the show revolved around her bumbling attempts to get a job. But in the late fifties, an offshoot of the original show *The Lucy-Desi Comedy Hour* (1957–1960), shifted to the Connecticut suburbs and turned into a conventional middle-class family program with Lucy, Ricky, and their child living like most other sitcom parents and confronting the same kinds of mostly domestic situations.

The world of television entertainment programming in the 1950s was, with only a very few exceptions, a placid middle-class world; and many middle-class Americans, seeing such constant confirmation of their own experiences and values on television, could easily conclude that those were the experiences and values common to all Americans.

And television—by reaching into virtually every segment of American society, even into the poorest and most isolated groups in the population—showed everyone, vividly and graphically, the way the American middle class lived: the affluence, the consumerism, the comfort. But it also reminded some Americans that they did not share in this affluent lifestyle. Television unwittingly became an illustration of the gap between middle-class expectations and those who lived in poverty.

AMERICAN POLITICS had been mostly Democratic for the twenty years between 1933 and 1953. But in 1952, the Republican Party won the White House for the first time since 1928. In that presidential election, Dwight D. Eisenhower, the general who organized D-Day, was the most likely candidate, so much so that he was courted by both parties. There were other generals who had performed with at least equal brilliance and effectiveness—Douglas MacArthur and George Marshall, among them—but none of them had Eisenhower's personal qualities: his public warmth; his friendliness; his geniality; his dazzling, highly photogenic smile, which became his political trademark; and his comforting, unthreatening public image. These helped him become president in 1953, and to remain popular throughout his two terms in the White House.

But Eisenhower was also appealing because he seemed to embody the stability and unity that characterized so many other areas of American culture in the 1950s. Eisenhower's approach to leadership was based on simple assumptions. He had a deep aversion to conflict and confrontation. He leaned instinctively toward consensus and conciliation, and he tried to avoid doing anything that would disrupt the harmony that he believed was essential to American society. He was deeply committed to capitalism and to capitalists, a champion of free enterprise, and a cheerleader for the business community in the hour of its great economic triumph. Eisenhower's presidency was an embodiment of the middle-class yearning for stability and consensus.

The 1950s were good times for middle-class white Americans who were content with their era. But for others, it was not a good time. Only five years after the end of World War II, another war—this one in Korea—ignited and continued for more than three years, drafting soldiers once again and leaving more than 50,000 Americans dead and many more injured. After taking office, Eisenhower brought the war to an end in six months.

The most obvious explanation for Korea was the Cold War and the fear of communism—fanned by opportunistic and demagogic politicians—that accompanied it. It also grew out of a homogeneous popular culture that had little patience with divergent views. Hollywood studio executives blacklisted writers, actors, and directors, not just because of the Red Scare but also because of their own dislike of those artists' politics. Newspaper and magazine publishers banished writers who were too stridently critical of the political and economic orthodoxy of their time. Television and radio executives refused to allow even mildly dissenting voices access to the air. The revered Edward R. Murrow, the first great television newscaster, found his career at CBS derailed after he broadcast a program in 1954 attacking Joseph McCarthy, even though by then McCarthy's influence was already in decline.

IN 1953, the political writer I. F. Stone, also a harsh critic of McCarthyism and of conservative politics, found it necessary to found his own political journal, *I. F. Stone's Weekly*, because none of his previous employers, including the *Nation*, would publish his work any longer. Years later, in the early 1980s, he published a collection of his writings from those years and titled it *The Haunted Fifties*.

For Stone and for many others, the fifties seemed haunted because the public culture of the time was so resolutely self-congratulatory and so stifling to alternative views. For them, the problems and injustices and dislocations of the time often seemed hidden under a haze of bright, cheerful, affirmative images of a prosperous middle-class nation happily embarked on a new period in its history, enthroned as the richest and most powerful nation in the world. But beneath the shining surface of the public nation of the 1950s lived another America—a shadow nation, or as I. F. Stone sometimes called it, a "subversive nation," which was gradually building up a critique of American society and politics that would burst into the center of national consciousness.

Most of all, African Americans spearheaded a change in American life. After living in poverty and segregation for many decades, they began to fight. In 1954, the Supreme Court of the United States gave them the tools: the Brown v. Board of Education decision, which overturned the 1896 Plessy v. Ferguson separate-but-equal ruling that sustained segregation. Brown, the product of many talented NAACP lawyers, some of them products of the historically black Howard University in Washington, D.C., made it clear that African American children had the right to attend desegregated schools. After African Americans ended segregation in schools in Topeka, Kansas, the focus of Brown, they fought in Little Rock, Arkansas, to include black students in Central High School. And Washington, D.C., opened white schools for black students. But more than one hundred members of Congress opposed the Brown decision, and Southern governors barred any changes in their states. Three years after Brown, in the fall of 1957, 22 percent of southern public schools still refused to allow black students to enroll. Progress was slow, as white southerners fought relentlessly against desegregation with what they called "massive resistance."

The most dramatic early event of the civil rights movement came in December 1955, when Rosa Parks refused a Montgomery, Alabama, bus driver's order to move to a seat in the back of a city bus. A grassroots boycott by African Americans of the city's system ensued and none used the buses for more than a year. Martin Luther King Jr., a Baptist pastor new to Montgomery and the son of a prominent minister in Atlanta, at first

On assignment in the South for a 1952 *Look* article "How Far from Slavery?" photographer John Vachon documented this sign of the times.

resisted taking the lead in this fight, but he soon accepted his role and became one of the most important proponents of nonviolence. The boycott opened a racial struggle that captured the moral high ground for King's supporters. By the end of the 1950s, the civil rights movement was becoming one of the most important movements in the history of the nation.

An incident of racial violence earlier in 1955 also contributed to the struggle. In August, Emmett Till, a young fourteen-year-old Chicago boy visiting relatives in Mississippi, flirted with a white woman. He was beaten, shot, and killed by the woman's husband, Roy Bryant, and his half brother, J. W. Milam. When Till's body was returned to Chicago, more than 10,000 people viewed the open casket, and photos of Till's mangled face were printed across the nation. A *Look* magazine writer, William Bradford Huie, would interview the men who killed Emmett Till after their acquittal, and in 1956, *Look* published his powerful account of the lynching. A year later, the magazine ran "The Real Little Rock Story," including details about the harassment of the black students as they entered the all-white high school.

It was not only African Americans who were beginning to fight. The restive left was also struggling to reveal the persistence of poverty in the midst of prosperity. Michael Harrington, a Catholic socialist, spent part of the decade researching and writing his powerful 1962 book on the subject, *The Other America: Poverty in the United States*, which both President Kennedy and President Johnson read. There was increasing resistance by women to the obstacles they faced in the workplace and in the larger culture when they attempted to move out of their roles as wives and mothers. There was a growing concern about the environment among scientists and ecologists who saw, much earlier than most Americans did, the dangers of heedless economic growth.

An advertising photo from 1953, created for a trade association called the Wool Bureau, features a male model in the decade's standard-issue gray flannel suit.

BUT EQUALLY IMPORTANT were critiques that expressed a series of anxieties and thwarted desires that were particular to the male culture of the time. There was a growing fear among men that the modern world threatened their autonomy, their independence, and their authenticity. Employees of large corporate organizations, the critics of the 1950s and early 1960s argued, learned to dress alike, to pattern their lives in similar ways, and adopted similar values and goals. They placed a high value on "getting along" within the hierarchical structure of the corporation. Complaints about the conformity and the homogeneity of the culture of organization became one of the staples of social criticism in the 1950s. Social scientists came to see in this culture a challenge to the capacity of individuals to retain any psychological autonomy. The organization, they argued, was a debilitating force, creating alienated conformists afraid to challenge prevailing norms. These were people who would take no risks, people who feared being different.

Corporate workers, critics argued, faced constant pressures to get along by going along. The sociologist David Riesman wrote in his influential 1950 book, *The Lonely Crowd*, that modern society was giving birth to a new kind of man. In earlier eras, most men and women had been "inner-directed" people, defining themselves largely in terms of their own values and goals, their own sense of their worth. Now, Riesman and others argued, the dominant personality was coming to be the "other-directed" man, who defined himself in terms of the opinions and goals of others, or in terms of the bureaucratically established goals of the organization.

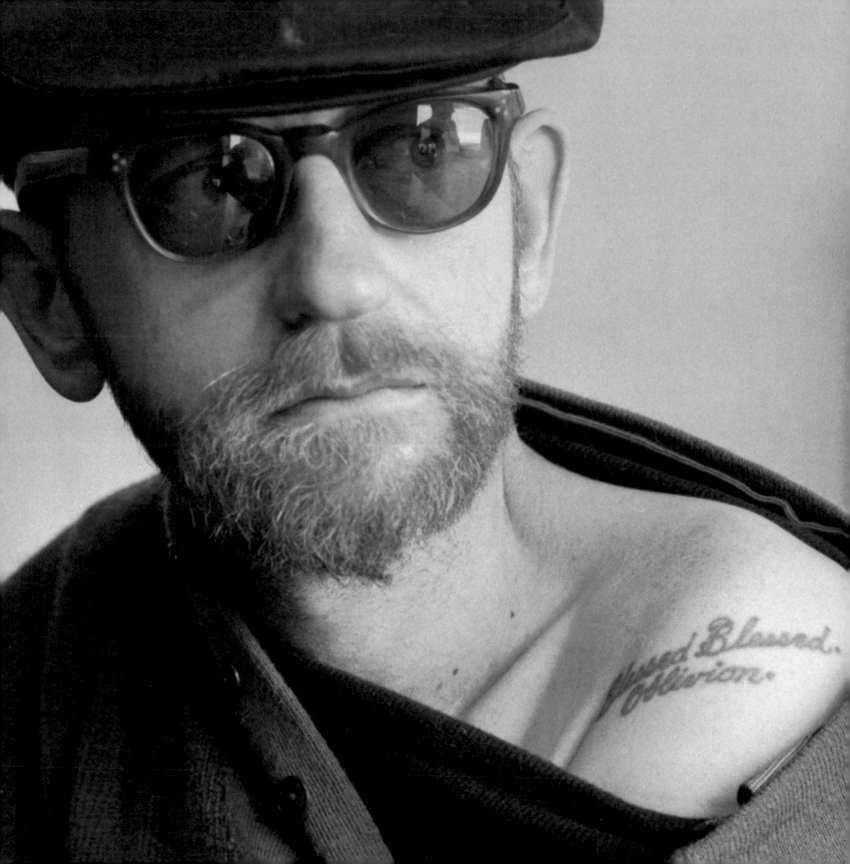

BUT PERHAPS THE CLEAREST EXAMPLE of disenchantment with and alienation from the middle class was not the work of these mainstream writers and intellectuals. It emanated from a group of younger writers and artists who emerged largely from the middle-class but chose to stand outside the mainstream of middle-class culture. They held that culture in contempt, ridiculing and repudiating not just the personal anxieties of organizational life, but also many of the fundamental premises of middle-class society. They were the men and women who called themselves "the Beats." They openly challenged the conventional values of middle-class American society: material success, social values, political habits. Many of them adopted an alternative lifestyle that emphasized rootlessness, anti-materialism, drugs, antagonism to technology and organization, sexual freedom, and a dark, numbing despair about the nature of modern society. But most of all the Beats were in search of "ecstasy," of a release from the rational world, of a retreat from what they considered the repressive culture of their time.

The poet Allen Ginsberg became one of the most influential figures in the Beat world, the man many people considered the founder of the movement. In 1955, he wrote a poem that became something of the credo of the Beat generation. Entitled "Howl," it attacked virtually every aspect of modern society as corrupt and alienating: "I saw the best minds of my generation destroyed by madness, starving, hysterical, naked, / dragging themselves through the negro streets at dawn looking for an angry fix, / angelheaded hipsters burning for the ancient heavenly connection to the starry dynamo in the machinery of night / . . ." It was an attack on American materialism, on American technology, on organization, on the suburbs, on militarism, on the very idea of progress; an attack on all the underpinnings of modern middle-class culture and society, even an attack on rationality itself.

This is what made the Beats seem so frightening and subversive to many more conventional Americans in the 1950s: their frank rejection of the disciplined, ordered life of the postwar middle-class; their open alienation from a culture that most people were lionizing; the way in which some ignored the careful boundaries of race that mainstream society still observed and made connections with black culture; their celebration of the sensual as opposed to the rational.

The Beats themselves attracted relatively little attention from the American mainstream in the 1950s and early 1960s, except as objects of ridicule and contempt. But they were significant because they were the clear antecedents of the counterculture that would emerge in the late 1960s.

In August 1958, *Look* took its readers on a trip to San Francisco to check out "The Bored, the Bearded, and the Beat" scene, personified here by Hubert Leslie. Author Jack Kerouac coined the term "beat" in 1948; in April 1958, columnist Herb Caen began referring to these new denizens of the counterculture as "beatniks."

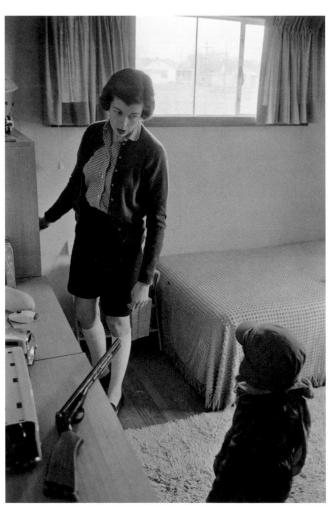

ANOTHER POWERFUL AND INFLUENTIAL CRITIQUE of the middle-class culture of the 1950s came from feminism. That critique did not become widely visible until the late 1960s, and its influence did not become profound until even later than that. But the problems and discontents of women were very much a part of the culture of the 1950s.

One sign was the publication of a book—researched and mostly written in the 1950s and generally regarded as a landmark in the rebirth of contemporary feminism: Betty Friedan's *The Feminine Mystique*, published in 1963. Friedan had graduated from Smith College in 1942, and in 1957, fifteen years later, married with children, living in suburban New York and working as a free-lance writer, she traveled around the country to interview her Smith College classmates about the state of their lives for what was supposed to be a soft article for a women's magazine.

Almost without exception, the women she encountered were married, with children, living in prosperous, upper-middle-class suburbs. They were living out the "dream" that affluent bourgeois society had created for women in the postwar years, what Friedan called the "mystique of feminine fulfillment," by acting out the expected roles of wives, mothers, and homemakers. They responded to questions about their lives with forced, chirpy reports of contentment—proud talk of husbands, children, and homes.

But Friedan pressed further. She found that behind this mystique, in virtually all the women she interviewed, there was a fundamental sense of uneasiness, frustration, and vague unhappiness that most women had great difficulty articulating. Friedan called this "the problem that has no name," a problem that even women themselves were unable to identify or explain.

But the real problem, Friedan said, was embedded in the nature of the gender roles society had imposed on women. The women she met were intelligent, educated, and talented, and yet they had no outlets for their talents except housework, motherhood, and the companionship they offered their husbands. "The feminine mystique," she wrote, "has succeeded in burying millions of women alive."

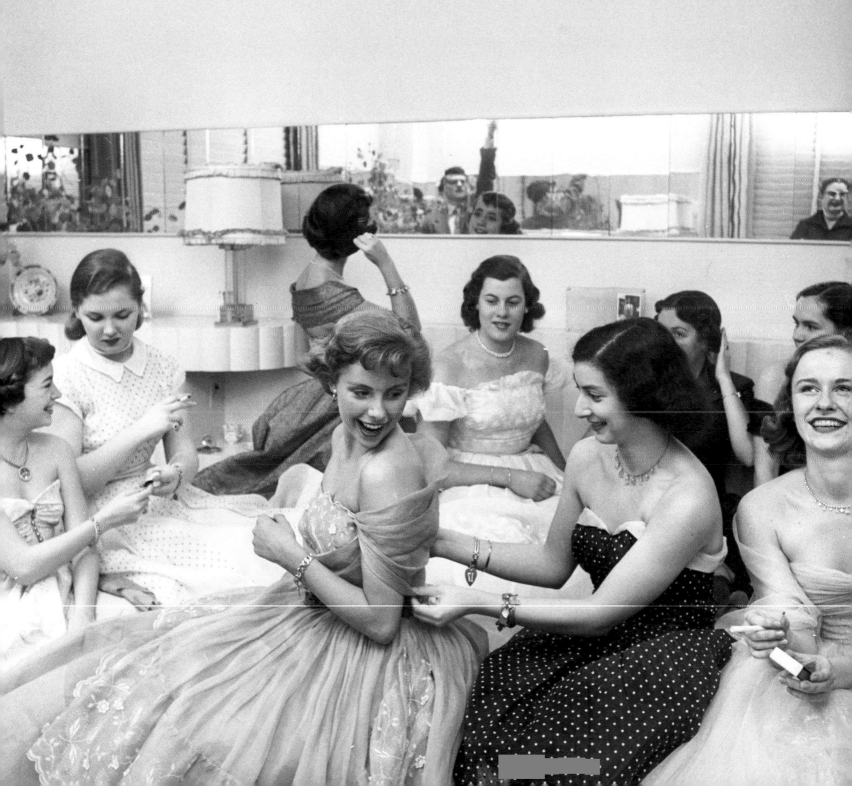

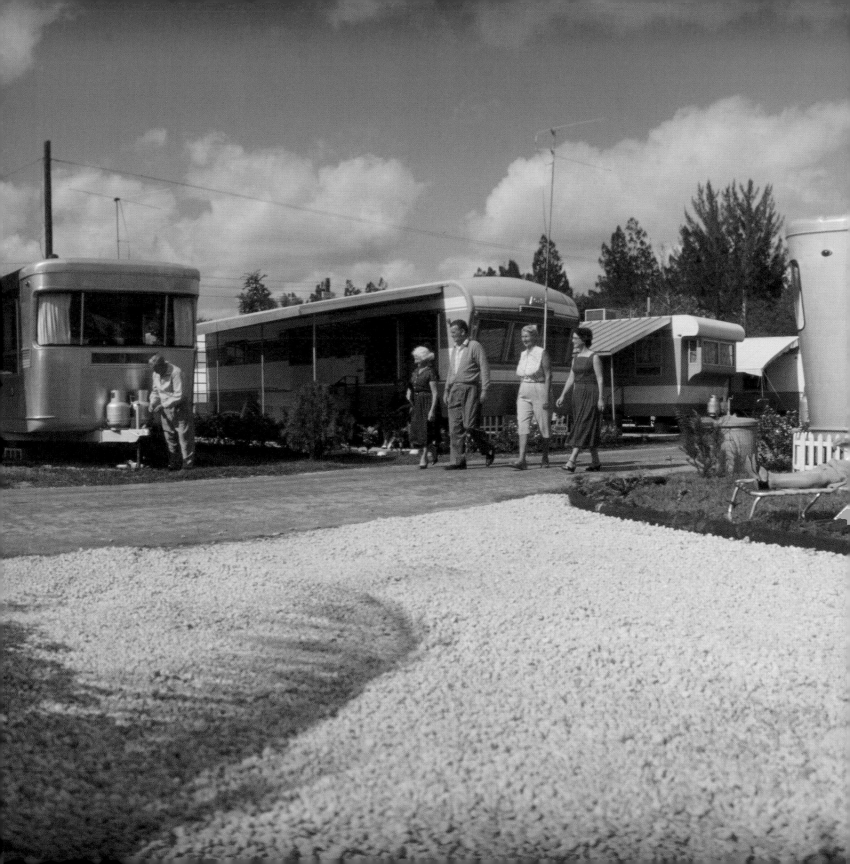

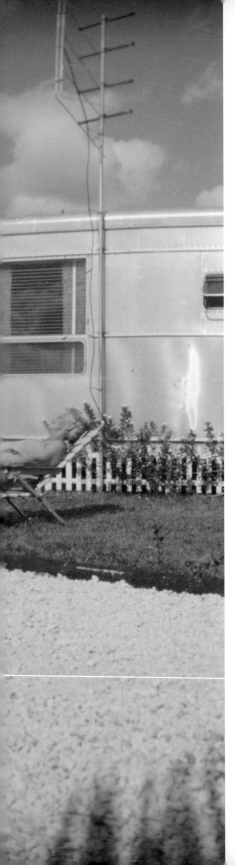

OUR IMAGE OF THE FIFTIES as the "Age of Ozzie and Harriet" is not entirely false. It was an image that many middle-class Americans accepted at the time, and it was a reflection of the way many of them lived. But it would be a mistake to accept the middle-class interpretation of American life in the 1950s at face value. Because to understand the realities of society in the 1950s is to acknowledge there were not only prosperous suburbs and the affluent middle-class; there was also persistent poverty, harsh racial segregation, obstacles for women to find meaningful jobs, and many other problems. The 1950s brought to us what we now call modernism, helping to make the America we still see. But there was much behind the modern world. It left many people still outside the new nation.

American life in the 1950s was in many ways a genuinely stable, confident, and tranquil time—at least for the middle-class. But to understand the realities of society in those years, we should recognize that what seemed so successful at the time was not fully accepted by many Americans—not just the poor, but also much of the middle-class itself.

Alan Brinkley
Allan Nevins Professor of History and Provost Emeritus
Columbia University

NOTES

1. Alan Nourie and Barbara Nourie, eds., *American Mass-Market Magazines* (New York: Greenwood Press, 1990), 226.
2. Gardner Cowles, Foreword, in *The Look Book*, ed. Leo Rosten, (New York: Abrams, 1975), 18.
3. "Look Out," *Time* (January 11, 1937).
4. Nourie and Nourie, *American Mass-Market Magazines*, 227.
5. Richard Hofstadter, *The Paranoid Style in American Politics* (New York: Knopf, 1965), 64.
6. John Kenneth Galbraith, *American Capitalism* (Boston: Houghton Mifflin, 1956).
7. Joseph A. Schumpeter, *Capitalism, Socialism, and Democracy* (New York: Harper & Brothers, 1942), 384.
8. Hofstadter, *The Paranoid Style in American Politics*, 42.
9. Max Ascoli, *The Reporter* 6 (1952): 360.
10. Thomas Sugrue, *Sweet Land of Liberty* (New York: Random House, 2009), 200.
11. Mark Crispin Miller, *Boxed In: The Culture of TV* (Evanston, IL: Northwestern University Press, 1988), 13.

By 1959, trailer homes like these in Florida were no longer the cramped affairs of postwar America and, in increasing numbers, were not designed to be hauled behind a car. Their proliferation in "parks" and "courts" filled a need for affordable housing.

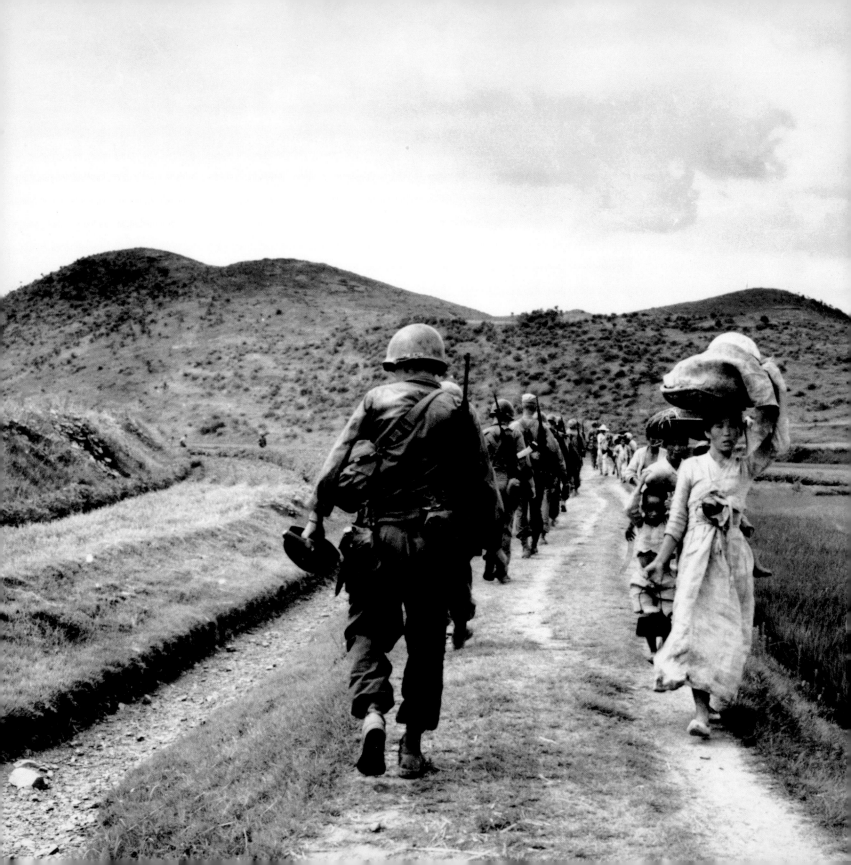

What Were We Thinking?

"Something extraordinary had certainly happened . . ."
—Edward Bellamy, *Looking Backward*

PREVIOUS PAGES: The U.S. sent troops to South Korea when forces from the North invaded in June. As this news photo shows, the result was a great dislocation of the civilian population. The war would sap America's confidence when it turned into a stalemate that dragged on for three years.

OPPOSITE: New York career girl Leila Hadley, personal assistant to cartoonist Al Capp (*Li'l Abner*), half dressed for her workday but fully engaged in preparing for it. *Look* ran this profile of a working single mother in its May 9 issue. The magazine often profiled the lives of everyday women during the decade.

THE LITTLE FLOWERED STRAW HAT on the head of the "Career Girl" has been deposited there before breakfast, for fun (*opposite*). *Look* says she's "a young lady in a hurry," but her destination's murky. "The chic, high-level, in-the-know" career girl living in New York is supposedly what "millions of young women" want to be, her "gloss" enhanced by inclusion in the *Social Register* and the fact that she's an assistant to a "name"—Al Capp, creator of the comic strip *Li'l Abner*. "It's not all flowers and first nights" for her, however, "or any of her high-pressure counterparts."

Social standing, such as association with a name—even if that of a cartoonist who draws buxom bimbos from Appalachia—isn't something available to most of those millions of young American women in and outside of New York. And this one has a five-year-old and is divorced, another categorical problem.

"Divorce, a woman's tragedy" announces a headline in *Look*, although the divorce rate is only ten out of every thousand women. But that word, *divorcée*, has power; it suggests a person from a foreign country. A divorcée must put up "a bright front" and go on dates, and insist "she has more peace of mind . . . than when she was married. But is she

OPPOSITE: A news photo of Ingrid
Bergman and her baby Robertino,
conceived during an adulterous affair
with director Roberto Rossellini and born
on February 2. In the ensuing scandal, a
U.S. senator denounced the actress as a
"free love cultist."

FOLLOWING PAGES, LEFT: Senator
Joseph McCarthy, seen in this news photo,
inaugurated his own era of suspicion
and accusation when he announced that
the State Department was infested with
Communists. He claimed to have a list of
names, but the numbers varied and the
details were fuzzy.

FOLLOWING PAGES, RIGHT: Milton
Berle was a veteran of vaudeville, radio,
and movies as well as television's first
major star. Berle's shtick—broad physical
humor and well-worn jokes—entranced
millions of viewers. Though his reign as
Mr. Television proved brief, he was still
on top in 1952, when NBC released this
publicity photo.

happy?" No, she's lonely, irritable, and "fair game." She's picked up bad habits from the ex, such as putting out cigarettes in coffee cups, and is usually "the awkward extra."

If divorce is a woman's tragedy, it must also be a child's. So why does any talk of birth control make everyone so nervous when Americans spend $200 million a year on contraception and teenage boys are carrying condoms around in their wallets, just in case? Birth control's related to sex and difficult to discuss, publicly or privately, and a birth control pill's still only a gleam in some scientist's eye. When actress Ingrid Bergman has a child by director Roberto Rossellini without first marrying him, she's denounced on the floor of the United States Senate and Ed Sullivan won't let her on his show (*opposite*).

THAT MILQUETOAST Alger Hiss is finally convicted of perjury after testifying before the House Un-American Activities Committee (HUAC), which was authorized to look into the existence of communism and fascism in the United States. For some reason the latter's only briefly been of interest to HUAC (an unfortunate abbreviation, which when pronounced sounds like a falling ax). Communism's the ideology of choice when it comes to threats, and in Wheeling, West Virginia, a senator from Wisconsin whom nobody' ever heard of claims in a speech to have a list of 205 communists working inside the State Department.

He's Joe McCarthy and he's eager, with dark hair and a winning smile (*following pages*). Reporters delight in the story, and in the senator's company; they all seem to be having a good time, but the list of communists isn't produced and none actually named. Still, McCarthy and Republicans see communism in government, in academia, in show business, even in churches.

In the summer, young Americans are sent to fight in Korea, in what's called a police action, although it certainly sounds like full-fledged war, with American boys dog-tagged but lacking the support, and potential glory, of their counterparts in the previous war (*see pages 30–31*). Why are we fighting—and dying—over there, and who's in charge of this mess, in which our store of bullets is being used—and depleted—to shoot masses of Chinese soldiers wearing weirdly padded uniforms?

Russia's enjoying the hell out of all this while we're paying for the conflict and reading about it in newspapers and watching it on television—when we can find someone in the neighborhood with a set. On television, it looks like the war's taking place inside an aquarium, and it feels unpatriotic to eat while learning about it. In the back of everybody's mind is our hydrogen bomb incubating over at the Atomic Energy Commission,

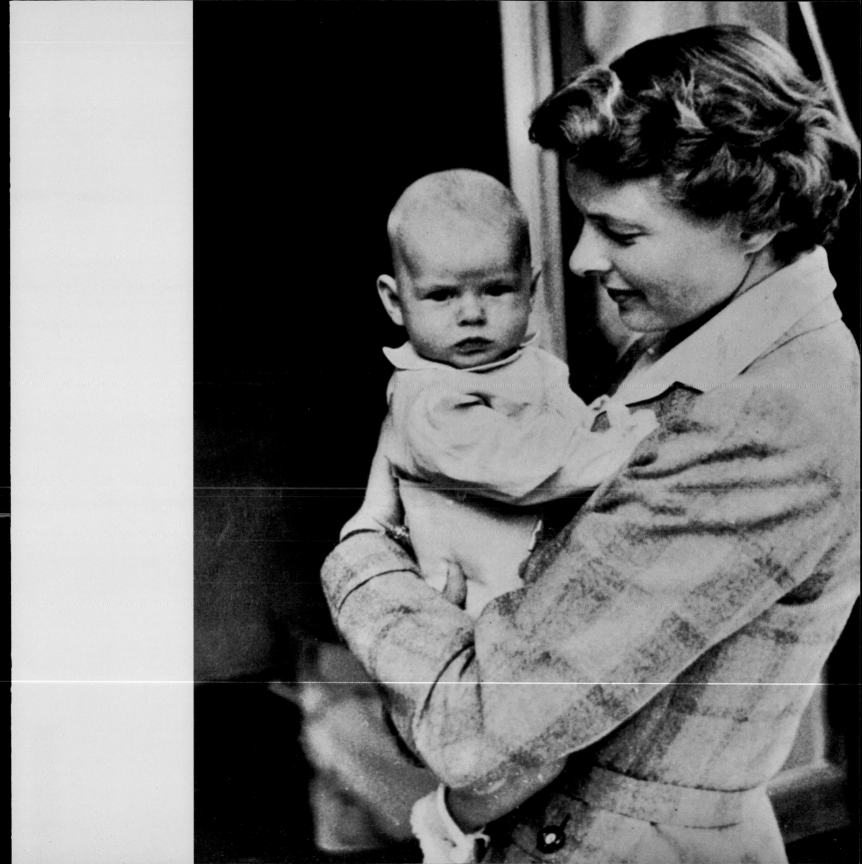

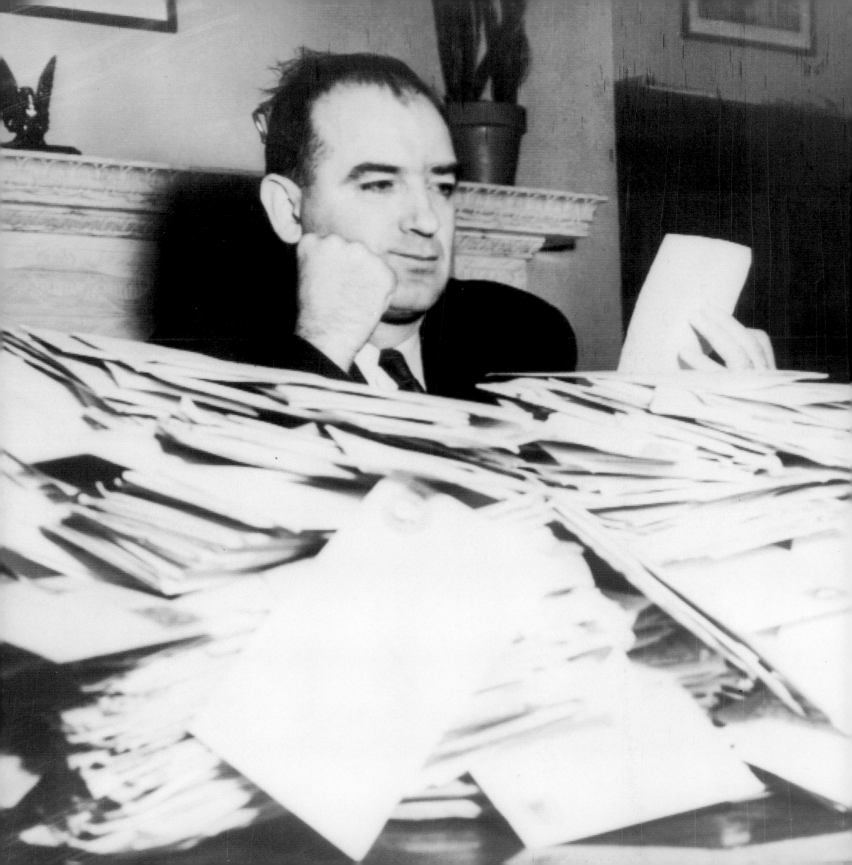

authorized by President Harry Truman, and those early photographs of nuclear blasts, gigantic golf balls teed up in halos of cloud and instant, radiant, annihilating light.

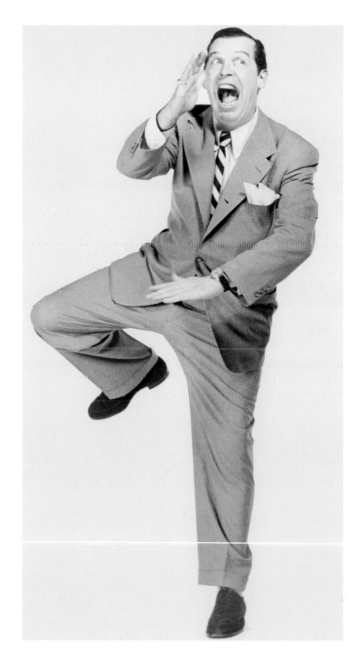

A DIFFERENT SORT OF DISCOMFORT comes from watching Milton Berle, who makes all of us squirm, but we can't stop looking at him (*left*). Or is it just the screen we're mesmerized by? Berle's muggings, desperate moves and equally desperate smile, howls and laughing fits, and cringe-inducing, worn-out vaudeville monologues—is this the future of television? If so, it's an addictive hell, but *Texaco Star Theater*'s getting 61 percent of all viewers, and other comedians are influenced: Sid Caesar and Jerry Lewis, but not Jack Benny or George Burns, who are radio holdovers.

At least something's going on in there; everybody trying to figure out what's supposed to happen on television. Most of it's intoxicating, and you can watch the worst of it and not have to participate, not even to judge. Judging suggests disapproval, and no one can disapprove of television when Americans are buying sets so fast. In 1950, the percentage of homes with a television jumped from 9 to 25. The Philco looks like a little, old-timey wooden icebox with an opaque, ovoid window, the Zenith a cyclopean marvel with a round black-and-white screen and metal knobs. There are one hundred stations in thirty-eight different states.

Women in television are mostly housewives, such as Gracie Allen and Molly Goldberg, supporters of their men in very positive, often noisy ways. At the conclusion of the last war, 800,000 women were fired from jobs in the aircraft, automotive, and other industries to make way for men. Women belong in the home now, using their "pretty heads" to advance their husbands' careers.

Skirts are long, underwear powerfully conforming, like the model in the story of a traveling saleslady specializing in foundation garments (*following pages, left*). Matrons look

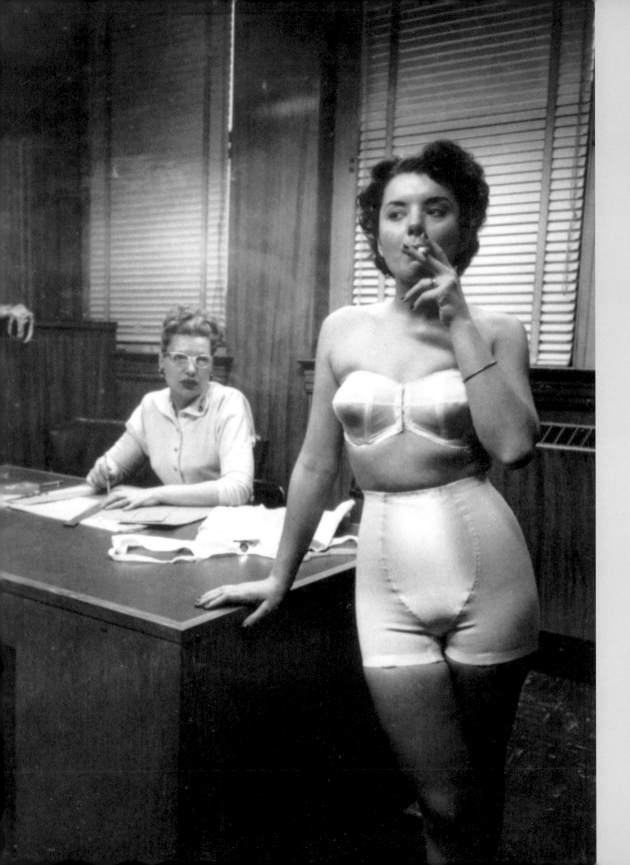

LEFT: A *Look* article on the daily life of a lingerie saleswoman featured photographs by twenty-one-year-old Stanley Kubrick, who was a staff photographer for the magazine before he turned to filmmaking in 1951. This unpublished picture was shot in 1949; the story ran in *Look*'s March 14th, 1950, issue.

OPPOSITE: Nineteen-year-old fashion model Ann Klem (left), shot by Kubrick for a *Look* feature titled "The Mid-Century Look Is the American Look," in the year's first issue. The magazine loved working its name into article titles.

matronly, but then so do teenagers, many of whom are taking up sewing two-piece patterns. More than half of single women and nearly a quarter of married women work, a big jump from 1940. Women on America's assembly lines look neither matronly nor, even if pretty, remotely like the women on magazine covers, who seem to have been poured into molds and dusted with pancake makeup, their teeth preternaturally white, their auroras of hair luminously, lusciously blonde, their good humor painfully intense.

A nineteen-year-old model, Ann Klem, featured in *Look*—long legged, lean as a sapling, scrubbed—"works hard . . . rides, dances, sings in a choir . . . Can't wait to get married (she's already got her man)" (*previous pages, right*). The eagerness to be whatever's expected is palpable: pleasant, dutiful, brassy, happy, confident, but also serious ("Learn while you sleep" and "How to Improve Your Canasta"), well-nourished (meat's "beautiful protein"), impervious (with miracle drugs—penicillin, antihistamines, sulfa), reflective ("Are You the Woman Your Husband Married?" and "Can We Afford Truman?"), even troubled ("A Socialist U.S.A?"). In the background you can almost hear disembodied laughter, but exactly who is laughing? What's the joke?

MEN'S ROLE MODELS are all over the map, too, from the remote, buttoned-up, golf-playing general who wants to be president to Ed Sullivan, the wooden presence in shiny suits with his trained dogs, acrobats, and talented babies; from brainy professor Carl Van Doren to a pudgy Gene Autry stranded in the midst of proliferating toys, part of the flood of new things to buy, so many they overwhelm men and women, delighted to buy but never able to quite get quite enough of what seems required (*opposite*).

Singer Perry Como, described as the "Super Song Salesman [who] loves a laugh," looks like kneadable dough, in sharp contrast to a man like Rocky Graziano, aka "the Rock" (*see page 45*). Not as solid as he was when he and Tony Zale fought three memorable bouts in the late forties, he was still the recent winner of a ten-round decision over a younger fighter lacking Graziano's visceral, celebrated need to demolish.

Graziano's license was revoked for not reporting a bribe and "running out" on a scheduled bout, and then reinstated. A suggestion of Christian as well as pugilistic iconography in that photograph, more Mary Magdalene than Christ, the shawl-like towel draping the Rock. His face is a palimpsest of boxing's—and life's—challenges: broken nose, scar tissue in the eyebrows, tired eyes. He's the white comeback kid in one more world threatened with radical change, where athletes increasingly compete according to their abilities instead of the color of their skin.

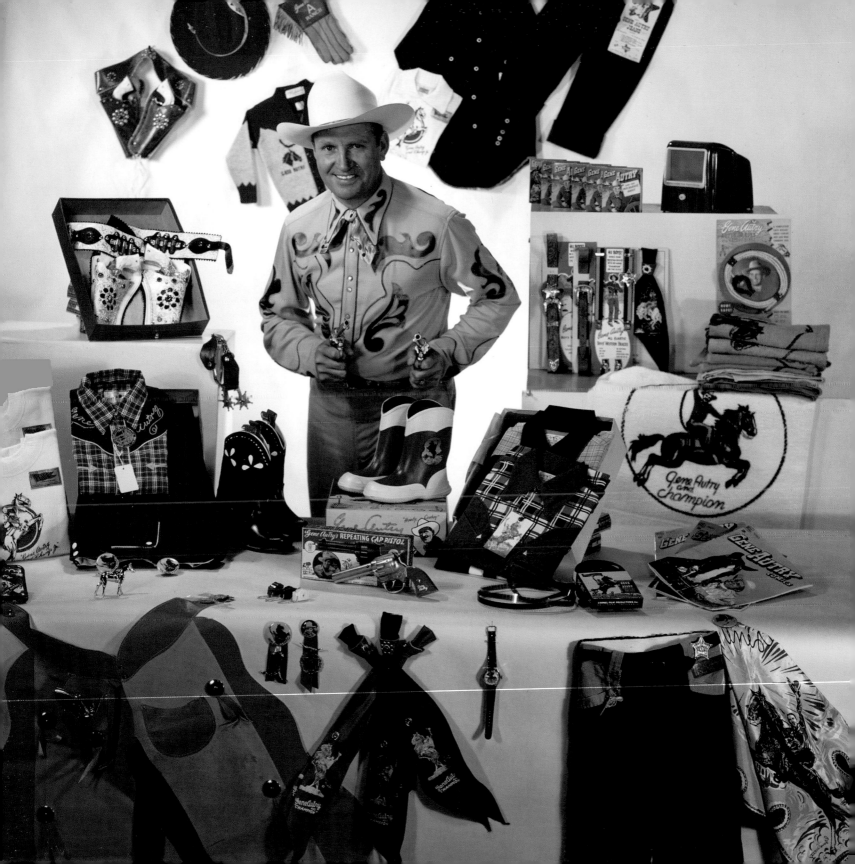

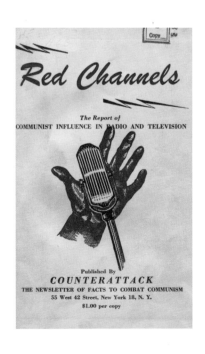

The second baseman for the Brooklyn Dodgers, Jackie Robinson, 1949 National League leader in batting average and stolen bases, plays himself in a Hollywood biopic with young actress Ruby Dee as his wife, Rachel. But only four other major league clubs—the Cleveland Indians, St. Louis Browns, New York Giants, and Boston Braves—have integrated since Robinson's debut in 1947. In Washington, Republicans in Congress need the help of southern Democrats to defeat Truman's civil rights agenda, and southern senators and congressmen don't want the nation integrated. And they don't want to be reminded of official racism that is the Jim Crow laws, let alone by a good-looking black ballplayer no one can keep from stealing bases.

Jackie Robinson may have integrated baseball, but Hollywood is another business entirely. Movies reflect an unsettling, almost entirely white cinematic America in a way they haven't before. *The Asphalt Jungle* belongs to the old, comforting order of low-class white criminals in their own world, with heavy Sterling Hayden and a striking young actress, Marilyn somebody. But there's a new type of troubling actor very much in our world, an actor such as Montgomery Clift (*following pages, left*).

What's he looking at in that photo, anyway? Not at us, that's for sure. At nothing's more like it. But nothing is what Americans don't want to see, although many of us are intrigued by actors who look distracted, overly serious, unpredictable, impossible to ignore, *bad*. Clift's kind of puny and wears a wrinkled white T-shirt instead of something with a collar; he's sucking on a finger, behavior unimaginable in a Bob Hope or a Bing Crosby, who's often photographed with a perfectly normal Chesterfield between his fingers, his lazy eyes focused archly and familiarly on the lens. His version of "Chattanoogie Shoe Shine Boy" peaks at number 4 on the charts, but it's hard to imagine Clift singing anything.

Are these new actors influenced by any ism? Could existentialism have something to do with the fact that the glass of milk in front of Clift is untouched? You get the feeling he doesn't intend to drink it, not exactly un-American, but different. Like those paperbacks. On the breakfast table!

A tract called "Red Channels: The Report of Communist Influence in Radio and Television," produced in Manhattan, appears in the offices of network executives, advertisers, sponsors, and others with links to the entertainment world (*left*). "Proof" is all circumstantial—annotated histories, including organizations the actors, writers, and directors belonged to and petitions they signed—but no ownership of the charges is acknowledged. Still, alarmingly prominent people are accused of being "red," among them Orson Welles, Leonard Bernstein, Arthur Miller, Lena Horne, Judy Holliday, and Artie Shaw.

Actress Jean Muir is announced for the role of Mother in the NBC-TV show *The Aldrich Family*. When the network and General Foods, the sponsor of the show, receive calls and letters based on her listing in "Red Channels," the show is cancelled. Newspapers, magazines, television networks, elected officials report some accusations but don't look into them. Everyone seems to agree that there's a threat out there, but what exactly?

Senator McCarthy's face is changing before our eyes, the smile going, a fleshiness appearing around the jawline, pushing those eyes back into caverns. He still hasn't produced the List, but charges are more frequent now, his targets on the run. *Look* wants to be of assistance and runs an article, "Let's help people quit being REDS," next to an ad for Stopette spray deodorant, in the same issue with pieces about aspiring actress Betsy von Furstenberg ("born in a castle") who sits contentedly under a Picasso (*see pages 48–49*), and evangelical stem-winder Billy Graham ("God's Ball of Fire") (*see page 47*).

RESEARCH AND DEVELOPMENT have enabled us to eat anything we want any time of year—*Look* crows that "America Erases Food Seasons"—and a good breakfast costs only fifteen cents. But Americans aren't eating enough of them, although food is increasingly available, processed, standardized. "This is the American Loaf," *Look* proudly announces. "In the last generation 95 percent of our bread-making has moved from home and hearth to bakeries, to revolutionize American homemaking." Flour, sugar, shortening, "and added enrichment guarantees white slice, brown crust, and food value."

The average yearly salary in America is $2,992, but many make less, often much less. The GNP has almost tripled since 1940, to $294 billion. Now a card's being issued by Diners Club that allows you to buy stuff when you don't have any money, inspired by a man who ate in a restaurant and discovered that he had forgotten his wallet. Now, *that's* different.

So are the new comic strips, not exactly Dick Tracy and Superman. *Peanuts* features a strange little guy without self-confidence named Charlie Brown; in *Pogo*, Walt Kelly's animals live in Okefenokee Swamp and say things that are both funny and ambiguous.

THEY'RE WORKING ON A VACCINE FOR POLIO, that terrifying crippler of children. A forty-four-year-old woman with polycystic kidney disease receives a kidney transplant in Evergreen Park, Illinois. Now, that's progress. "Multi-testing" is being tried in several cities around the country to pinpoint Americans' chronic ailments, including

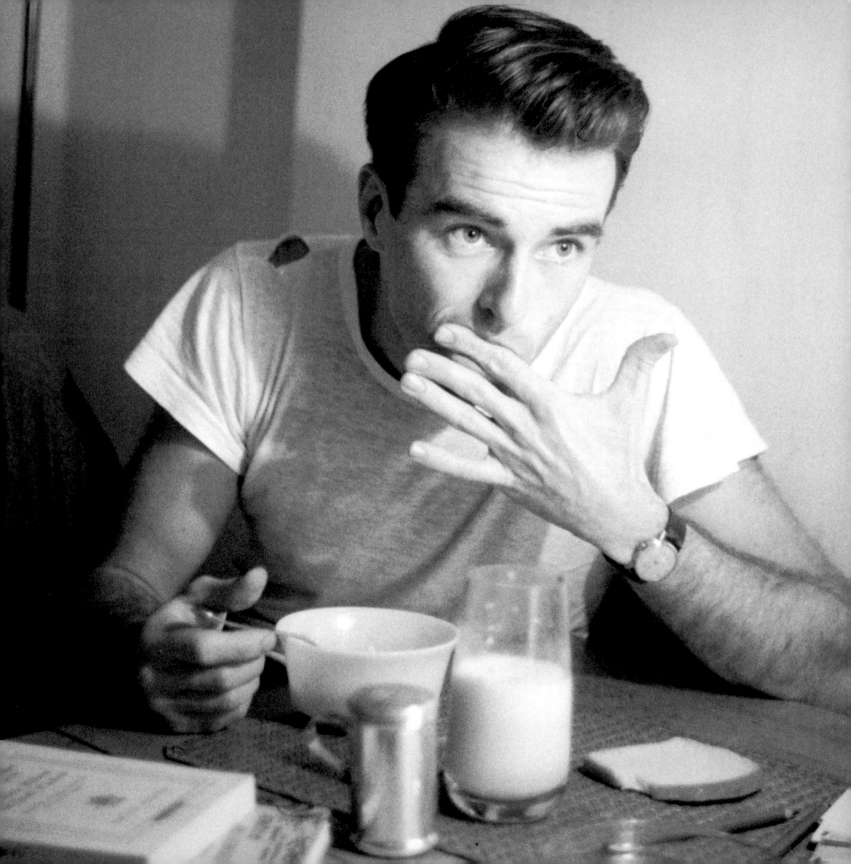

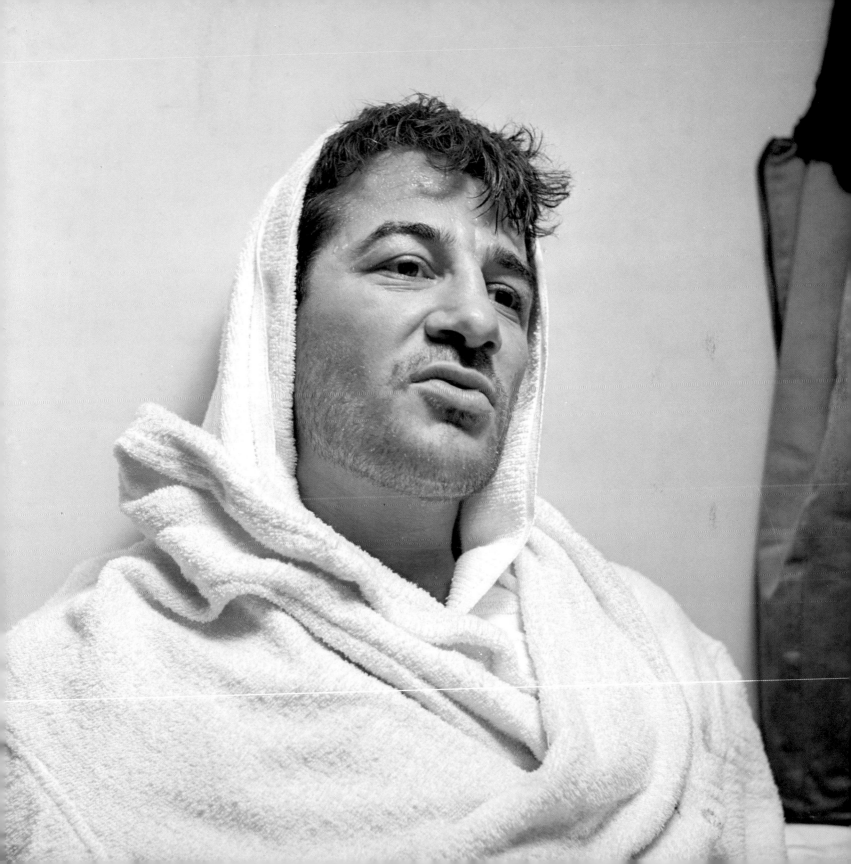

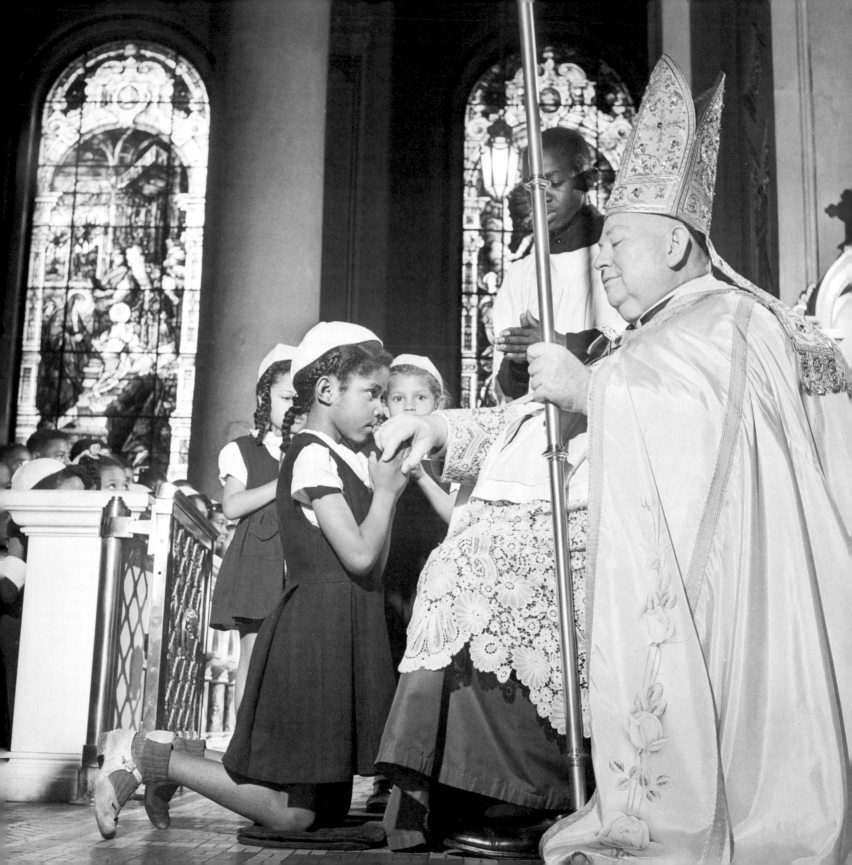

tuberculosis and heart and respiratory diseases. Special clinics are set up for women's problems, too.

You can't help but notice that black people are mostly missing from photographs of the tested. Also from statistics about the health of people living in our cities, where blacks are restricted to certain neighborhoods, either economically or legally, sometimes both. But black people won't go away; their lives are unimaginable and so the subject remains doubly troubling.

A bishop in racially segregated Alabama raises money for local black people and allows black girls to come to Mass and to kiss his ring (*opposite*). The Nobel Peace Prize is awarded to Ralph J. Bunche, the first black recipient, and Gwendolyn Brooks becomes the first African American to win a Pulitzer Prize. Extraordinary things are definitely happening in America, but understanding them, and how they came about, is more difficult than it should be. Or is it just us?

Betsy von Furstenberg, subject of a July 18 *Look* cover story, "The Debutante Who Went to Work" (as an actress). She was photographed by Kubrick with her "old beau Buddy Joyce" at a society party.

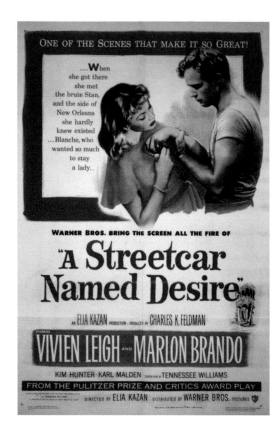

ONE OF THE SCENES THAT MAKE IT SO GREAT!

....When she got there she met the brute Stan, and the side of New Orleans she hardly knew existed ...Blanche, who wanted so much to stay a lady...

WARNER BROS. BRING THE SCREEN ALL THE FIRE OF

"A Streetcar Named Desire"

AN ELIA KAZAN PRODUCTION · PRODUCED BY CHARLES K. FELDMAN

STARRING VIVIEN LEIGH AND MARLON BRANDO

KIM HUNTER · KARL MALDEN SCREEN PLAY BY TENNESSEE WILLIAMS

FROM THE PULITZER PRIZE AND CRITICS AWARD PLAY

DIRECTED BY ELIA KAZAN DISTRIBUTED BY WARNER BROS. PICTURES

ABOVE: *A Streetcar Named Desire*, the most acclaimed movie of the year, featured Marlon Brando re-creating his stage role as the brutish Stanley Kowalski. Brando exuded a new, raw kind of energy at odds with the decade's bland male actors.

is only one question: When will I be blown up?" He adds, "I believe that man will not merely endure: he will prevail."

If he's blown up?

IN JANUARY, *Look* offers its first television awards for the benefit of America's 10 million set owners who're increasingly selective in their viewing, even if they have only four channels (ABC, CBS, DuMont, and NBC) to choose from. "Girls still look stocky and cameramen still cut off heads now and then," *Look* reports, "but, technically, television has grown up." (Indeed, in September, President Truman makes a speech in San Francisco that's beamed coast to coast, a TV first.) *Look* says old trouper Jimmy Durante made the best debut, on NBC's *The Four-Star Revue*, Wednesdays at eight (*see pages 50–51*), but Sid Caesar's still the funniest, his material "derived from the commonplace." *Your Show of Shows* debuted in February 1950, and Caesar and his cohorts—Imogene Coca, Carl Reiner, and Howard Morris—become as familiar as members of our own families. TV is watched by lots of kids, too. "Aw, gee, can't we ever play outside?" complains a boy in Rye, New York, but his friends prefer watching the tube.

John Cameron Swayze's best in public affairs because he "manages to bring world events home," but Ed Sullivan's the best emcee and Milton Berle's "still Mr. Television." The "New Brood of Comics" includes a suave Dean Martin and a puckered-up Jerry Lewis, currently on view in *The Colgate Comedy Hour*. A new kind of film and stage actor has arrived, too, including the young Marlon Brando, who throws people around in the movie *A Streetcar Named Desire*, by that writer with the state for a first name (*left*). It's set in seamy, steamy New Orleans and also stars the actress lovingly remembered from *Gone with the Wind*, Vivien Leigh. Now, as Brando's sister-in-law, she's crazy; what happens isn't right, but you can't stop watching.

Plenty of talk about "a serious blonde who can act," Marilyn Monroe is described by *Look* as "effortless mistress of the slow, calculated walk in the tradition of West, Harlow, Turner." She has the freshest face in Hollywood—unless that's Leslie Caron, making her film debut, dancing opposite Gene Kelly in the year's big musical, *An American in Paris* (*opposite*). Marilyn reportedly gets up every morning for half-hour, dirt-track runs in Levis and a halter top, keeping things simple from the waist up. Doris Day's in now, too

RIGHT: Leslie Caron made the year's best first movie impression in *An American in Paris*. Her screen debut won an Oscar for best picture, and Caron won plaudits for holding her own opposite a formidable costar, Gene Kelly. This unpublished photo was taken in 1951 for an article that ran in February 1952.

FOLLOWING PAGES, LEFT: Doris Day translated her popularity as a big band singer in the forties into frequent movie appearances in the new decade— five of them in 1951, when *Look* ran a feature on her in its December 4 issue. Like Leslie Caron, Day's appeal leaned toward wholesome.

FOLLOWING PAGES, RIGHT: Mitzi Gaynor, a dancer with formidable gams, was to Korean War soldiers what Betty Grable had been to GIs in World War II—a top pinup. *Look* photographed the star in 1951; the article ran in May 1952, but the photo was never published.

(*following pages, left*). The singer and actress, dubbed "the Tomboy with the Voice," is a "hepcat of song-and-dance" with cute freckles. In five movies this year (four of them musicals) and cutting hit records, she's still the gracious hostess, keeping a plate of cookies ready for visitors. But it's hard to imagine her running on a dirt-track in a halter.

Somewhere in between Marilyn and Doris is that old American standby, the pinup girl. Dancer-singer Mitzi Gaynor's wearing stockings, something GIs have requested in lieu of naked legs (*following pages, right*). Also, they have written to say they prefer that at least one of Mitzi's legs point at the ceiling or, as in this case, the bed's canopy. Just

out of her teens and already with three films to her credit, Mitzi's willing to amuse them, it seems, being both good-looking and stylish. In high heels with at least the tops of her thighs bare, she's the girl to come home to.

Despite talk about women's freedom, sex education remains controversial and confusing. Dr. Alfred Kinsey, the sex researcher, has been taking a hard look at American women, following up on his 1947 bestseller about sexual behavior in the American male. Kinsey's supposedly had more intimate conversations with more types of people than any other person on earth, including artists, bankers, "tramps, prostitutes and social registerites, race-track touts and college professors." He has, according to *Look*, also caused many communities to be "pestered by imposters" and possesses the country's "biggest sex library" but is revealing nothing about his latest subject.

If women do get pregnant, there's another doctor in the house, Benjamin Spock, with his simple book on infant care, published five years ago and still hailed as an "undisputed guide." Because people are settling down to have kids, *Look* reports "The Family's Coming Back," despite temptation and the rest of it, with 40 million American households and a decline in divorce.

"A WIDE-OPEN TOWN REFORMED OVERNIGHT." That was the outcome of Arkansas's Senator Estes Kefauver's bringing his investigating committee to New Orleans to look into organized crime. In 1950, the Kefauver hearings in Washington drew a huge daytime TV audience, so large that Americans in New York and elsewhere with TV sets were too distracted to get much done. Now the courageous senator's closing "gangster-owned casinos" by forcing a shifty-looking man, Carlos "the Little Man" Marcello, to testify, along with restaurateurs and club owners with names like "Diamond Jim" Moran and "Dandy Phil" Kastel. "Because nobody cared, the mobsters took over." A sober note. The feeling is that it can happen anywhere, and probably does.

Even college basketball's not immune. Indictments for fixing games are handed down in January, several to players at the City College of New York, which last year became the first team to win both the NCAA and National Invitation tournaments. It's reported that some $150 million is bet on basketball every year, and "spoiled" stars who have grown used to the evils of subsidization "can be easy prey for the briber." *Look* worries the next sport on the "fix list" might be football.

The pretty blonde sharing an open Cadillac convertible with a million oranges looks about as far from bribes and subsidization as you can get (*following pages, left*).

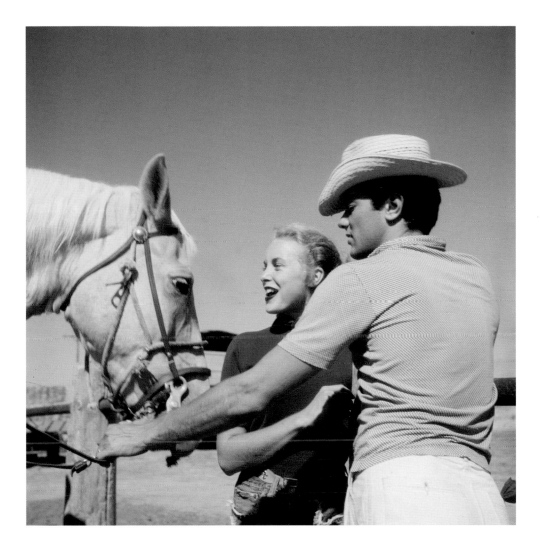

She must be Miss Orange Bowl, wearing a one-piece bathing suit and a smile, her hair permed, as wholesome and warm as the sun that somehow obliterates even her shadow. But you can't help wondering how much all those oranges weigh, who picked them, and where they're headed.

Americans bowl a lot—and we are in the midst of the golden age of the sport, with its increased popularity as well as advances in bowling-lane technology. He must enjoy it, but the guy in mid-stride looks deadly serious, as if this is a challenge to be mastered (*following pages, right*). He looks almost dainty in his little white shoes, one foot in the

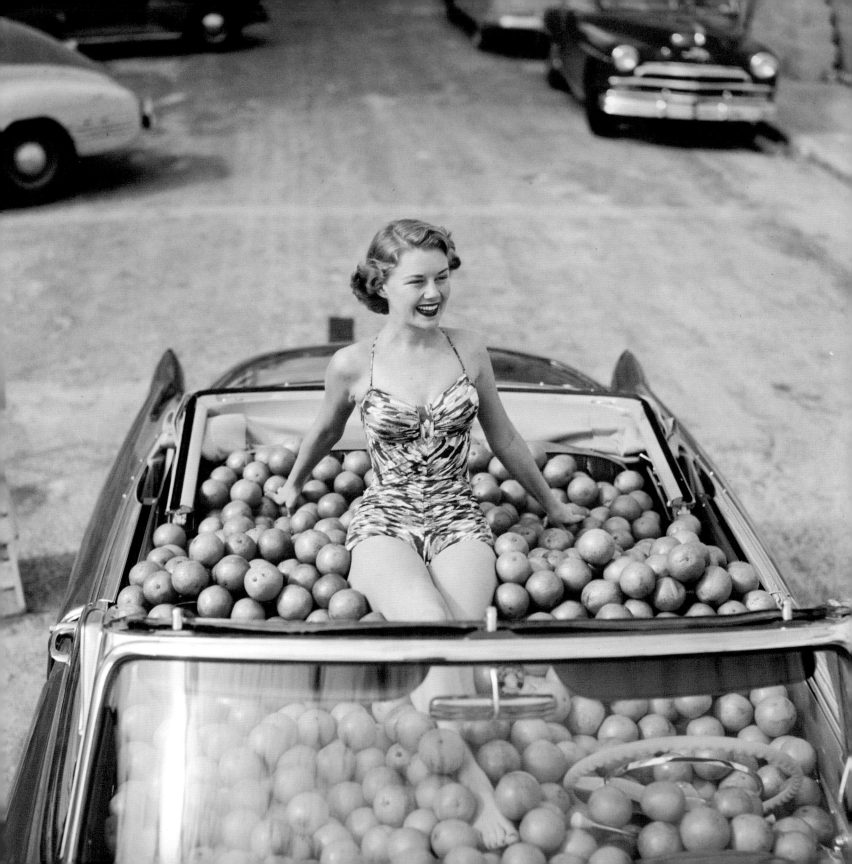

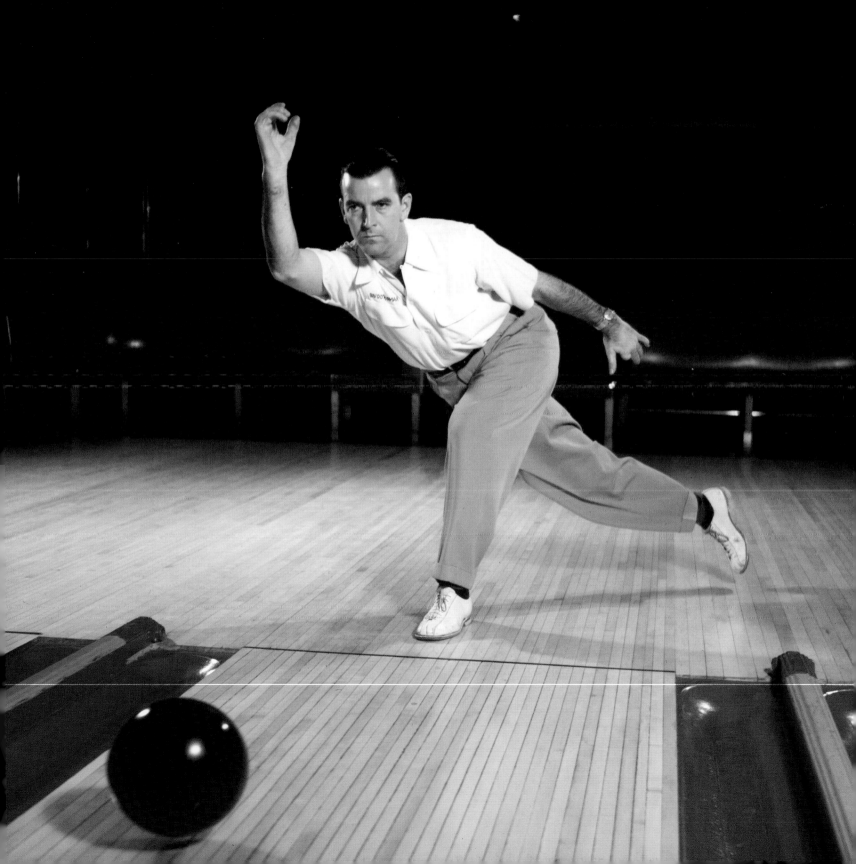

air, but he's thick around the middle and his lips are tight, the visual message that his black plastic orb has been forcefully launched on the straight and narrow and it'll lead to a strike, or else.

For something to be fun you have to work at it. Up-and-coming movie actors Janet Leigh and Tony Curtis, married in June, want to go horseback riding (*see page 59*). Tony has hold of the bridle, but he looks scared and that straw hat is ridiculous. The calmest living thing in the shot is the horse itself, despite all that tack.

The headline asks "What's on America's Mind?" and the photograph shows a rural town meeting, remarkable for both the openness of the faces and the hidden quality of what lies behind them (*below*). The guy in the mackinaw's holding some papers, and a cigar, and he points a finger at . . . who? He's amused, and so is the man seated beside him: white-haired, bespectacled, wearing soiled overalls, he's a working man with eyes upturned, a figure out of the past. The woman on the other side refuses to be distracted from her knitting, and we don't know what's on her mind, either, only that it's something.

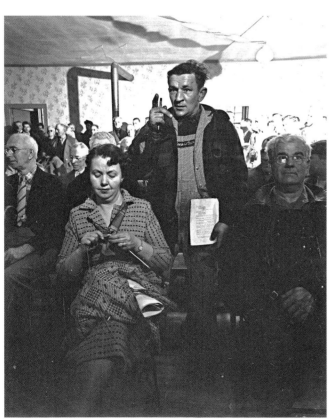

If these people are typical, then America's well intentioned, slightly baffled, and worried—maybe about the war. It feels so different from the last one, both in the way it's being fought and what it's supposed to accomplish, although there are similarities. Like those Quonset huts thrown up to house military personnel after World War II, which ended only half a dozen years ago. The self-assurance Americans felt then has evaporated, and those Quonsets—ingenious once but now penal-looking, like something you'd find behind the Iron Curtain—are still being used. And that little kid standing amid litter, he could be somewhere far from America, in a place that's neither warm nor well supervised (*opposite, top*).

Two soldiers—one black, one white—enjoying a smoke together are each wearing a star on the shoulder (*following pages*). The white guy looks a bit sloshed, the black guy skeptical but friendly. They're either coming from or going to Korea, waiting for something to happen, some next step to be taken— like everybody else. The soldier in the train station with his wife and son are putting on brave faces (*opposite, bottom*). He could be on his way out, but they won't let on that they're anxious he won't come back in one piece.

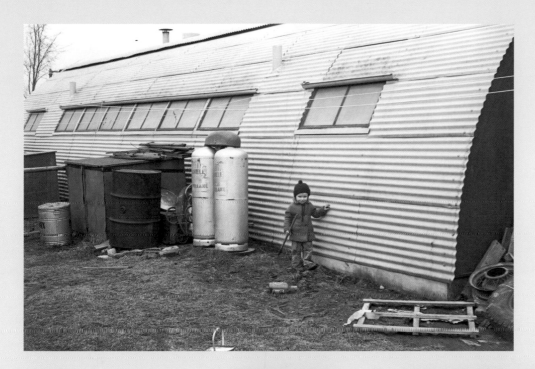

ABOVE: *Look* dispatched four photographers to all forty-eight states for "What's on America's Mind?" This unpublished shot of a World War II–era Quonset hut and its tiny inhabitant reflects the grimmer side of the postwar years.

RIGHT: In this unpublished shot of a waiting room, a soldier, his wife, and their son are poised for the next bus or train, which is likely to separate them for some time. One year into the fifties and the Korean War, America was replaying scenes from the forties and World War II.

FOLLOWING PAGES: Another unpublished photo from the "America's Mind" series offers a look at soldiers who were serving during the Korean War in the recently integrated U.S. Army.

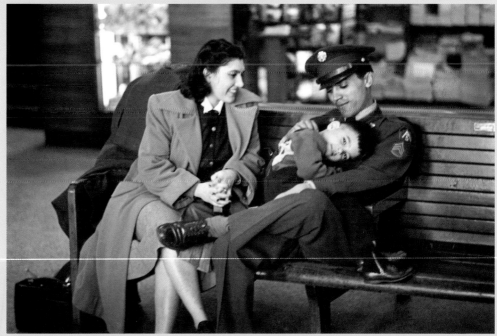

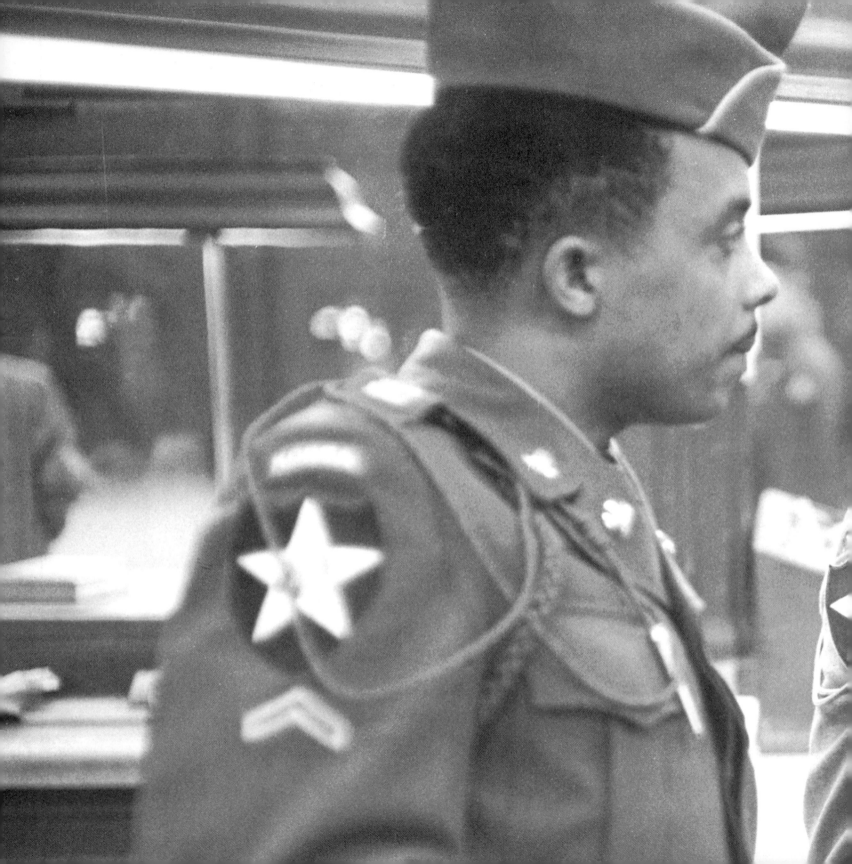

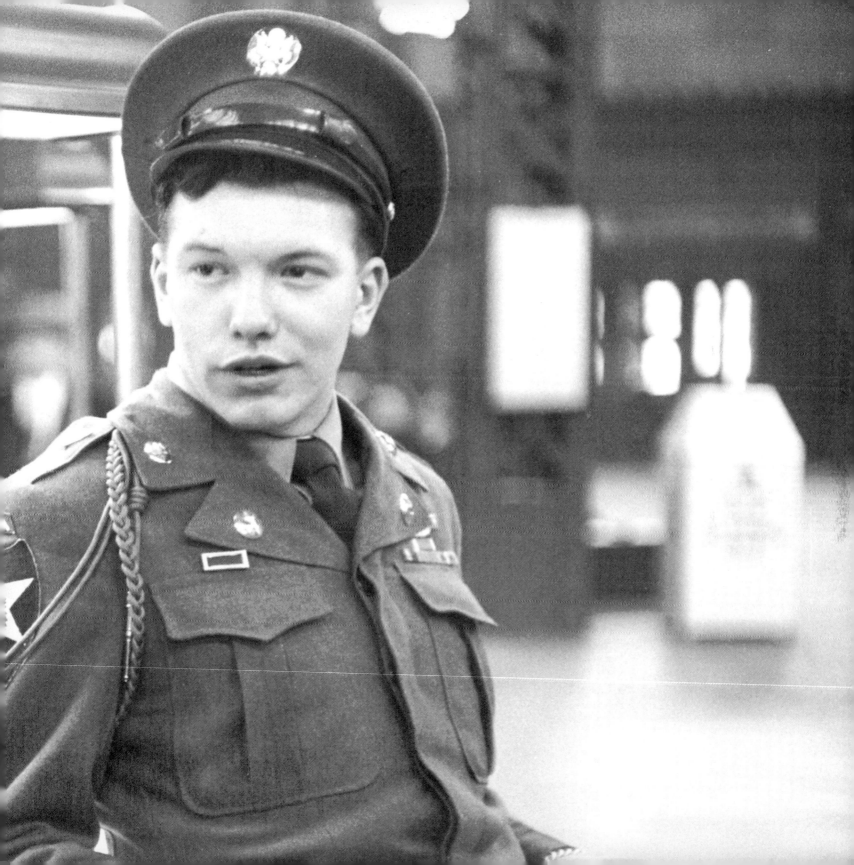

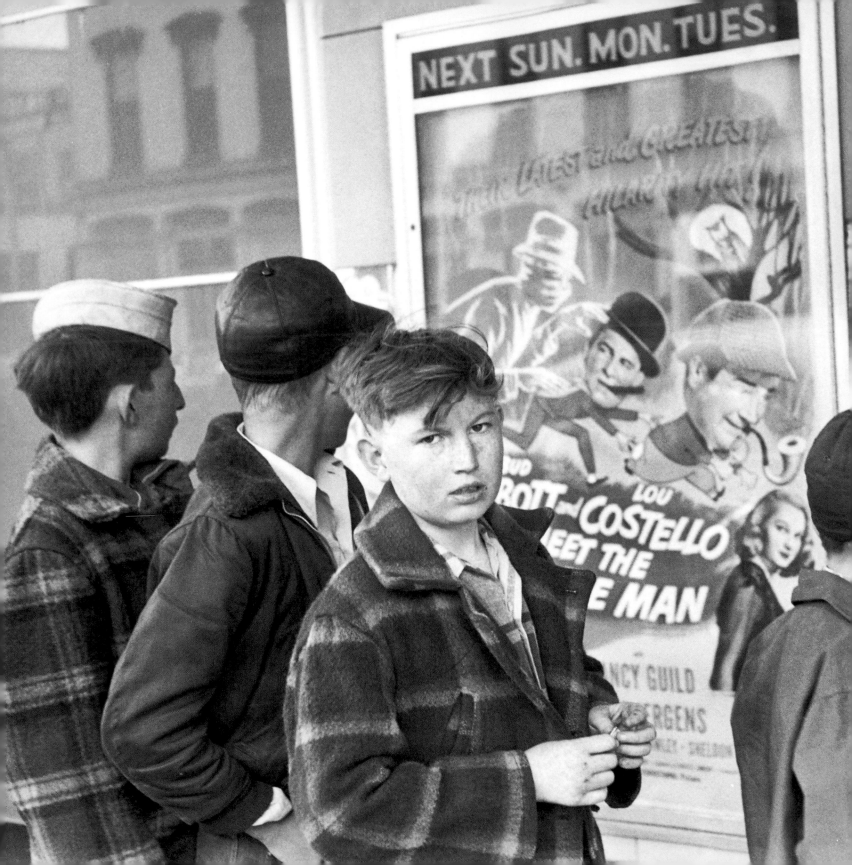

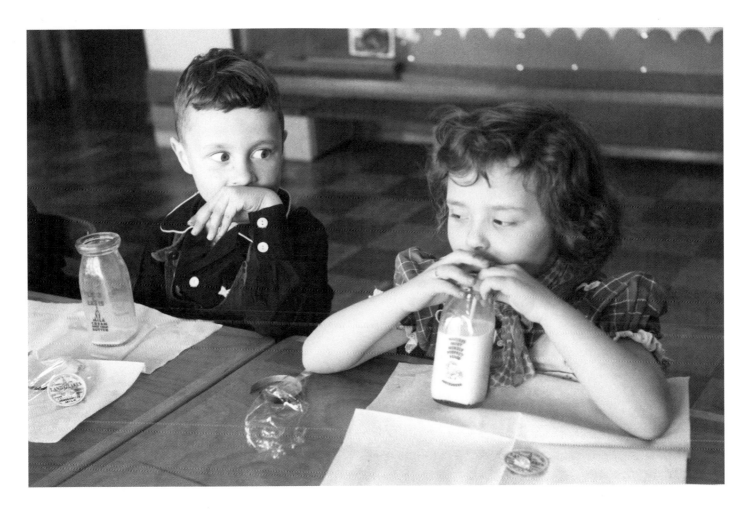

ABOVE: Baby boomers flooded elementary schools, which supplied them with lunches and those all-important bottles of milk seen in this photograph from the "What's on America's Mind?" series of articles.

OPPOSITE: Children count in the series "What's on America's Mind?" as these Saturday matinee aficionados can attest. The team of Abbott and Costello, advertised on the poster, were still popular in the fifties, though their best films were behind them.

Around the country, men are joining up or putting together aircraft engines, while their wives and children look for bargains at sales. There's a crowded, tentative quality to everything—merchandise, people—suggesting determination but not the joy we're supposed to feel when buying something. Kids—one wearing a sailor's cap at an angle, a reminder of our nearly overlapping wars—are waiting patiently to get into Saturday afternoon movies, thinking about the Abbott and Costello show that's coming up (*opposite*). But the kid looking directly at us is one big question mark. Where's his cap, and what's he seeing out there in the world? How's his life going to turn out?

The milk in those little bottles on the school lunchroom table has been provided by the government to keep young Americans strong (*above*). The little boy has finished

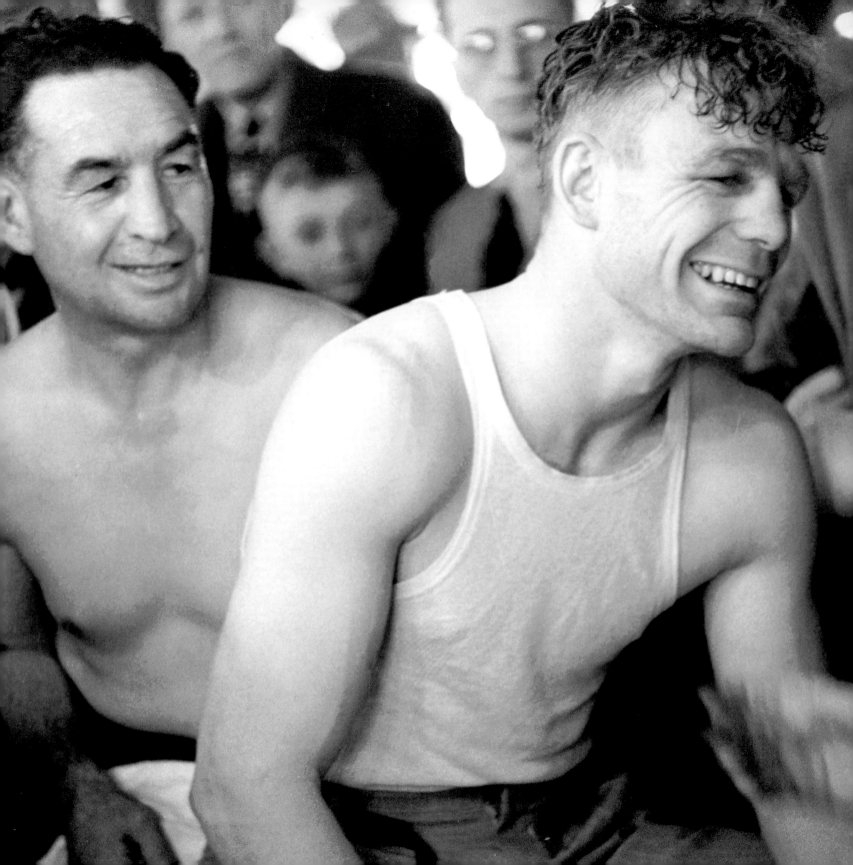

his and the little girl tarries, maybe to get his goat. He looks enchanted with her, and she sympathetic. But they both could be asking themselves: What happens next?

Americans are getting married and having babies, but we're also watching even more television. In addition to the usual shows, there's a lot of boxing, the sport more popular than ever these days, maybe because it's a measure of our toughness and willingness to take on the world. Boxing's a loner's sport, an aspect, too, of the faces of the prizefighters weighing in; everybody's isolated in anticipation. The fighter's stringed undershirt reveals good biceps and a lack of modesty (*opposite*). He's a good-looking guy with an open face and an all-American jaw, the kind of guy you instinctively trust but who will put you flat on your back if he has to.

That phalanx of parked cars in the rain looks impenetrable, indestructible, those postwar grilles with their thick bars built to withstand bugs, animals, one-hundred-mile-an-hour speeds—anything (*following pages*). Where are all the drivers? The only person we see is a man walking away from us on reflective, rain-slicked pavement, one hand in his pocket. He's purposeful, but where's he going?

In another photo from the "America's Mind" series, we can see that boxing—professional or amateur, as shown here—was, along with baseball, America's favorite sport. Regularly televised fights made boxers household names.

In this final photo from the "America's Mind" series it's clear that the cars of the day eschewed sleek, aerodynamic design for a more formidable, almost menacing look. In the American mind, your castle was your home, and your fortress, your car.

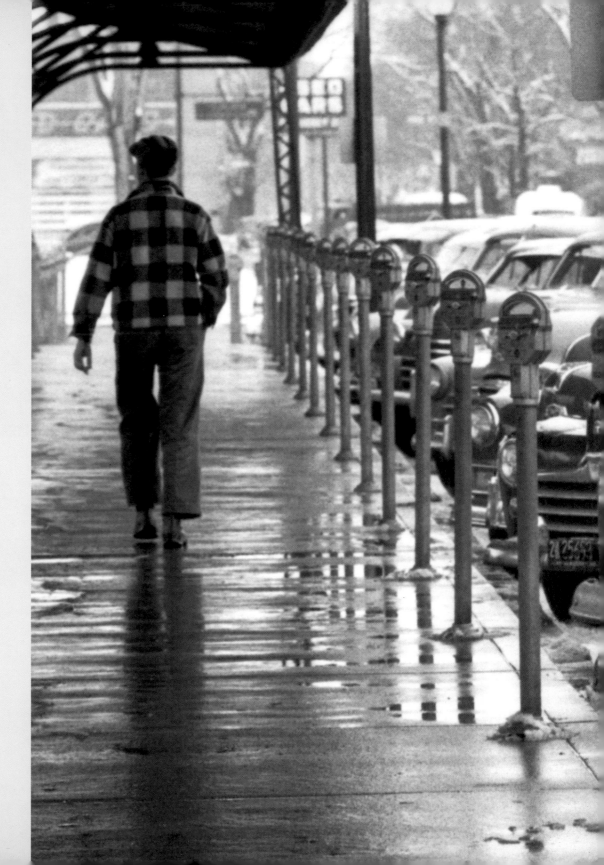

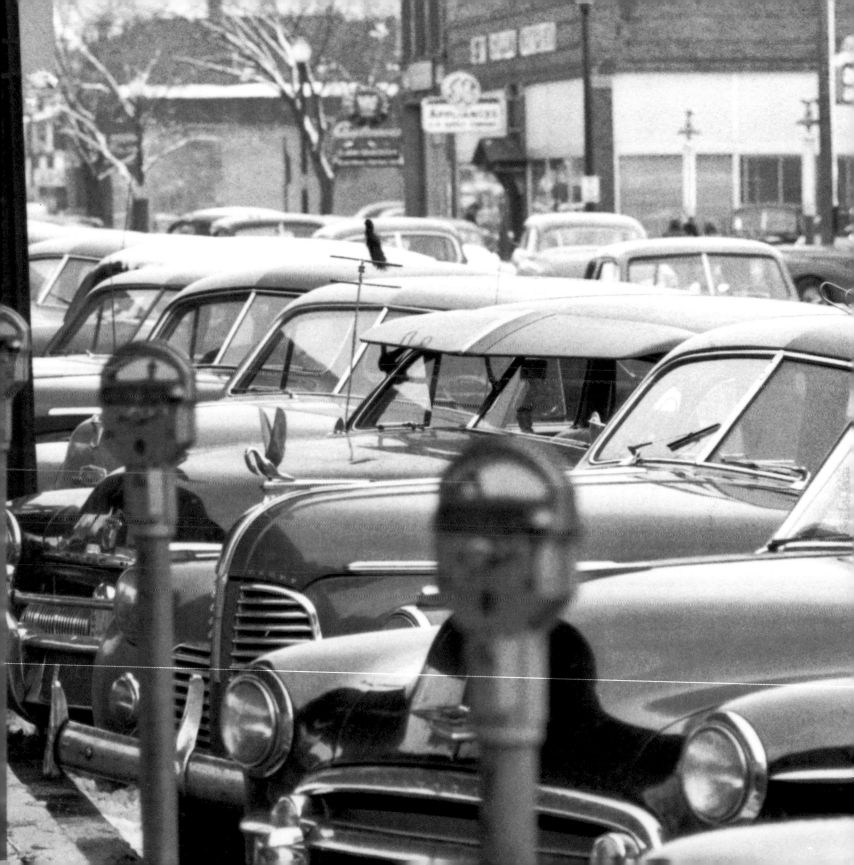

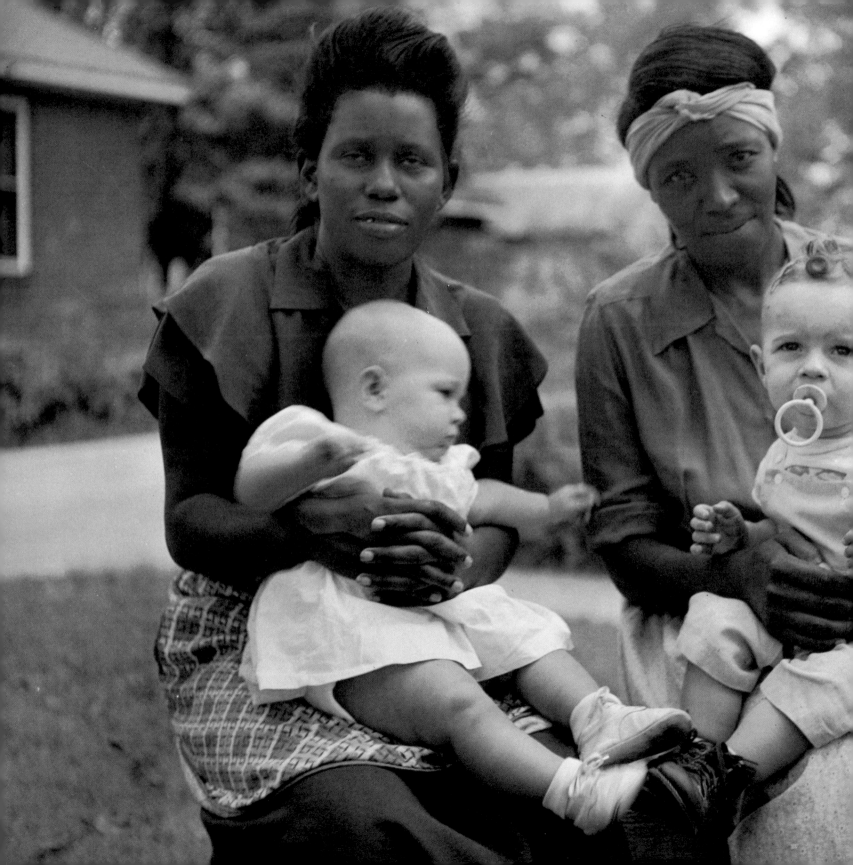

1952

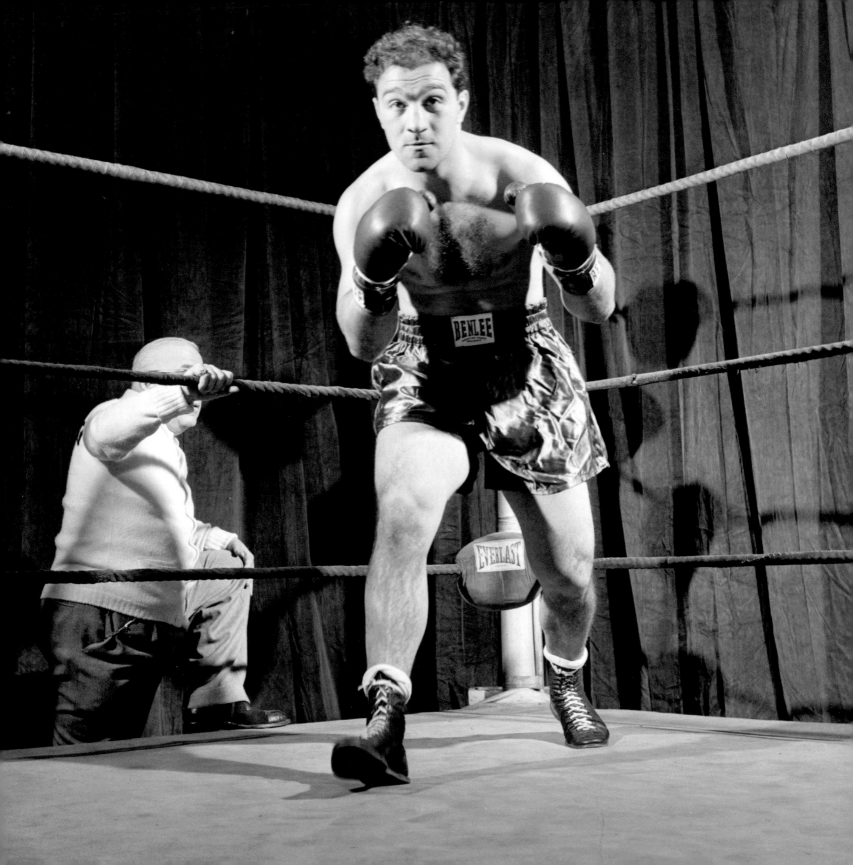

Keep Swinging

"America is still a land of promise, especially during a political campaign.
—*MAD* magazine

MICKEY MANTLE IS THE YANKEES' NEW STAR, and there's another Rocky in the national ring, this one with the last name of Marciano (*opposite*). Also known as "the Brockton Rock," he's twenty-eight, described as a "brawling puncher, courageous, ambitious . . . his two hands trained on the championship." Also "grizzly-bear strong," he can take punishment. Hard head blows only make him blink. In October 1951, his left hook dropped former champ Joe Louis, Rocky's thirty-third knockout in thirty-eight straight professional wins. In September 1952, he wins the heavyweight championship, but the face behind that out-thrust glove looks tired.

We want to blink querulously, too, after blows from Reds, racists, and critics. We're punching back, but we're not hitting anything.

IN THE SOUTH we're not all that far from the days of slavery, according to a shocking article by a black reporter named Carl Rowan. Born and raised in Tennessee and now a staff writer for the *Minneapolis Tribune*, Rowan goes home on assignment for *Look* to

PREVIOUS PAGES: In its January 15 issue, *Look* published "How Far From Slavery?," for which black writer Carl Rowan returned to his homeland in the South, accompanied by photographer John Vachon. As the title suggests, they found a region clinging to the ways of the past. In this photo, Vachon captured two nannies with their charges.

OPPOSITE: A new Rocky, last name Marciano, dominated the ring. He won the heavyweight championship in September and would retire undefeated four years later. Frank Bauman captured the Rock's relentless style for *Look* in 1952 for an article that ran in January 1953.

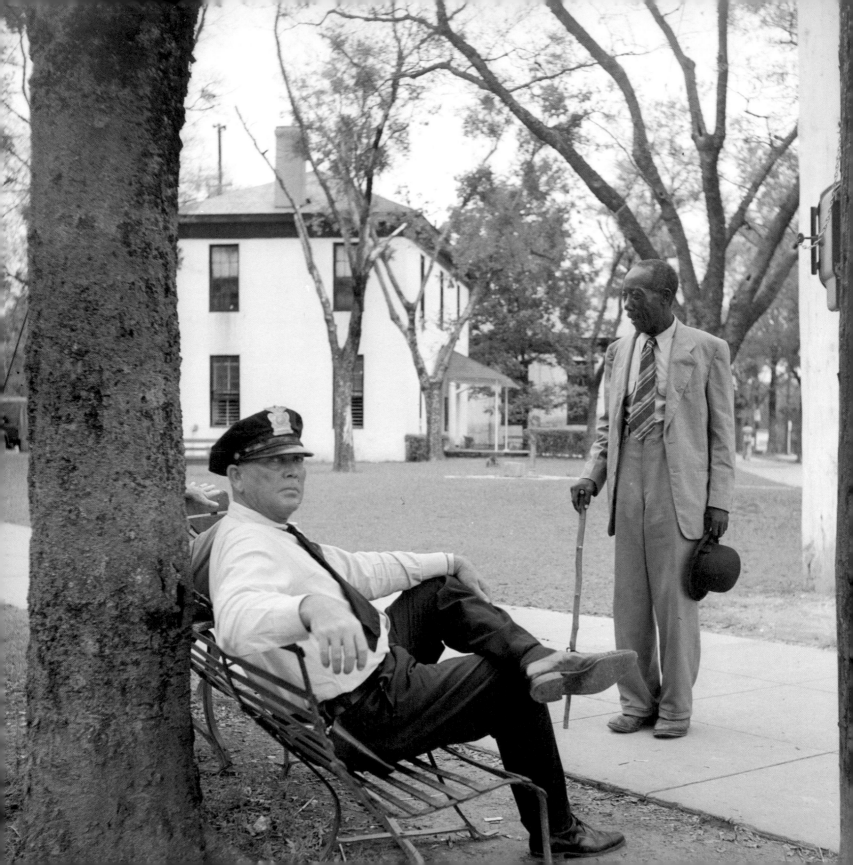

find "the color of my skin counted above all things" as well as "dismal squalor." His "old wounds" were opened, and it's easy to see why: black kids without shoes and white babies with new ones sitting on the laps of black women (*see pages 72–73*). Those nannies' expressions say more than any of their words could, and not just about inequality and race but also about perseverance and . . . could that be irony?

The Imperial Laundry Company somewhere in the South advertises, WE WASH FOR WHITE PEOPLE ONLY (*see page 20*); and right in the nation's capital, Rowan "was told that I must stand to eat at a five-and-dime store counter." Up in Baltimore, slums are being razed, displacing black families, yet where they'll go is anybody's guess.

A southern newspaper editor, Hodding Carter, doubts that blacks "will find a Promised Land" anywhere in the North. He cites a July 1951 riot in Cicero, Illinois, after a black family tried to move into a white neighborhood and was attacked by a white mob. National Guardsmen were brought in to restore order.

COMMUNISTS, according to *Look* in its first issue of the year, have a "Blueprint for Terror." "Reds," it is said, "with cold and ruthless efficiency . . . froze the minds and actions of . . . Seoul. It could work in New York or Chicago," although they aren't saying how. And U.S. Army Major William D. Clark reminds us that he "Saw Them Die in Korea," meaning soldiers in that war that won't go away.

Our surgeons are still operating there in unsanitary field conditions, and the combat unit that evacuated one soldier by helicopter looks more like a work detail, with everybody in coveralls and not a weapon in sight (*following pages, right*). In the third year of a seemingly endless war, Korea's portrayed as a tragedy for us and for the Koreans. No fewer than twenty-eight West Point grads have died in Korea in the last two years (*following pages, left*), and a poignant article on the war's effect on civilians includes photos of Korean children that are reminiscent of the last war and its concentration camps.

Now we hear that Russia has, in addition to the A-bomb, a "B-Bomb" (which stands for "bankruptcy"—get it?) that can ruin America financially by forcing the country to keep up with them militarily. Americans fearful of the aftermath of an A-bomb attack are told to warn children not to eat irradiated sandwiches and drink irradiated milk. That's pretty obvious, but how will parents know if food's been irradiated? How will they know anything?

Inside Russia, the standard of living is on the rise and the military enjoys a nuclear advantage, after the Russians discovered that making a bomb "is easier than they thought."

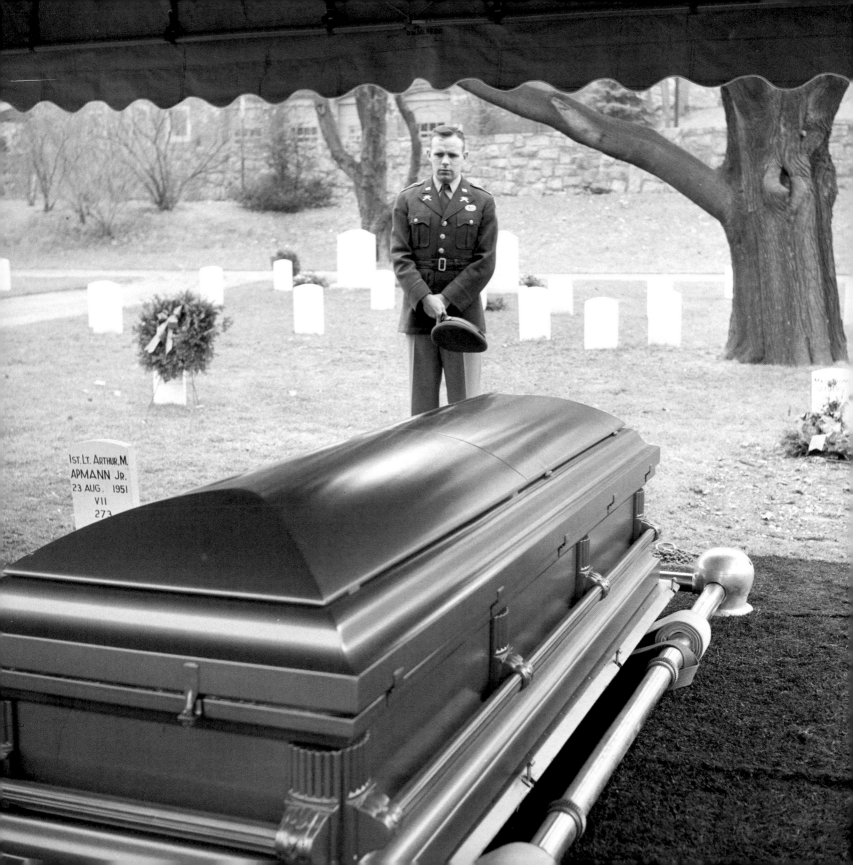

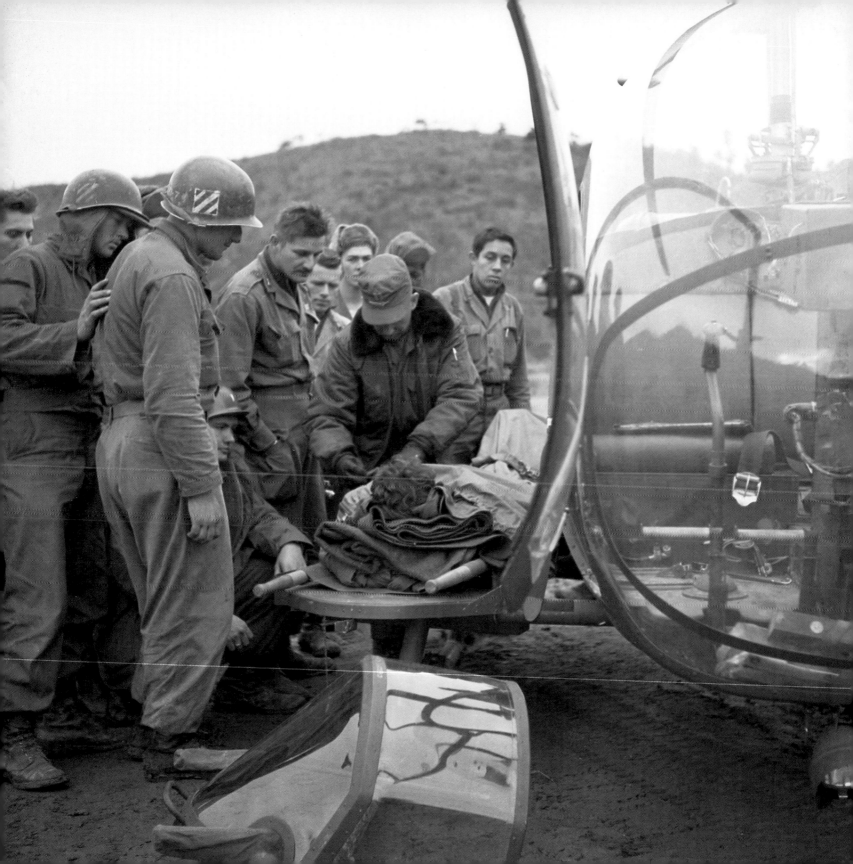

The Truth About
FLYING
SAUCERS
WHAT IS A JEW?

Look

JUNE 17, 1952

15¢

ROGERS HORNSBY

writes:

"It's Still
Baseball,
Ty Cobb!"

A BLUNT DEFENSE
OF THE MODERN GAME

ZSA ZSA
The Great
GABOR

Jane Greer in Black and White

ABOVE: Zsa Zsa Gabor on the cover of *Look*, June 17, 1952.

OPPOSITE: *Look* ran many articles on women's fashion and style, among them an October 7 cover story, "Hair Now Gets Double Exposure," on the new phenomenon of adding "jewels, streaks, froufou" to one's tresses, as shown in a series of double-exposure photographs.

FOLLOWING PAGES: Stocking up, fifties style, meant owning a sleek freezer, and supermarkets met the demand with new and expanded frozen food sections offering a bewildering array of products to make meal prep time faster and easier for the busy homemaker. *Look* photographers shot this and many other generic photos in 1952 for an article that ran in January 1953.

The nineteenth congress of the All-Union Communist Party meets to devise a new five-year plan. A reporter ominously offers, "We may well find this period even more difficult . . . than the nightmare of the last five years." Great.

MEANWHILE, happy, well-fed contestants in a beauty pageant wear one-piece bathing suits. They're all smiles, and wholesome looking, but they're not, well . . . beautiful. Although pretty, with full figures and nice hair, they don't look like they've had a lot of exercise. Stuff like that's beginning to matter, according to a sex-appeal poll. For instance, we are told that men like "tall blondes (also brunettes and redheads) in sweaters" and "like them to have some brains."

Zsa Zsa Gabor's telling readers of *Look* what's wrong with American men, with asides by Marilyn Monroe (*left*). Zsa Zsa thinks a man "loses his virility" if he wears an apron, but not Marilyn, who likes "men in or out of aprons." Sex appeal's obviously complicated. Actress Arlene Dahl's dyeing her bathing suit to match her red hair, which also looks dyed. Hair now gets double exposure these days, with women seen at mirrored tables reflecting a range of styles and hues. Women are said to change their hair from day to day with "new colors, streaks, jewels and accessories," and no man could argue with the results (*opposite*).

Still, women in America are having problems: divorce, lack of domestic help, and pills. *Look* reports on a "Sleeping-Pill Menace," which snares "unsuspecting victims into addiction" to barbiturates, but there's another pill which offers a different kind of relief: "Oral contraceptives," claims *Look*, "simple, low-cost and physically harmless—may soon become readily available," although "rigid control" is needed. All of this, mind you, is "trivial in comparison with the political and moral storm that is certain to follow." *Look*, for once, is ahead of the curve; it'll be another two years before pills are made available to control conception, with the accompanying storm.

Improved design is everywhere, even in refrigerators, freezers, and containers for the food to go into freezers (*following pages*). These fit better in the space, and so you can buy more of them. There's something ghostly about all these appliances, as if they're

56 47

BIRDSEYE CUT GREEN BEANS	BIRDSEYE FRENCH STYLE GREEN BEANS	SNOW CROP CUT GREEN BEANS		SNOW CROP FRENCH CUT BEANS	SNOW CROP ASPARAGUS SP'RS	BIRDSEYE CUT WAX BEANS		BIRDS EYE BRUSSEL SPROUTS	SNOW CROP RHUBARB	KALE	SNOW CROP RASPBERRIES	BIRDSEYE SLICED PEACHES	
39¢	24¢	24¢		24¢	50¢	26¢		34¢	23¢	23¢	37¢	29¢	

floating in outer space—and also about the new trailer homes: long, metallic, sleek, fitted out with space-saving nooks for life on the road, or just parked somewhere.

Americans will spend $800 million over the holiday season on presents, and now the so-called experts have decided, among other things, that children need larger toys (*see pages 94–95*). Those six-to-eight-year olds need Radio Flyer wagons, and early teens need maps and chemistry sets. There's money around, and people need advice on how to use it. And there's a strange kind of worry there, too, because in the years ahead, according to a survey, there will be "more to spend, less to buy."

There is also big business in little books, and it is both revolutionary and racy: pocket-size paperbacks with "eye-catching covers for connoisseurs of literary leg art" and everyone from readers of Emile Zola and Homer to mystery fans who can't get enough of writers such as Mickey Spillane and Erle Stanley Gardner. Crime's starting to look glamorous, even when violent. People love the quote from a California newspaper story about bank robber Willie Sutton, who, when asked why he robs banks, said, "That's where the money is." Gardner, creator of Perry Mason, claims in *Look* in May that Sutton stashed a lot of loot before he went on trial for a 1950 heist in Queens. In spite of a poor guy murdered after he identified Sutton from an FBI poster, Willie Sutton's some kind of offbeat hero.

So is Willie Loman, the character portrayed by Fredric March in the film version of *Death of a Salesman*, a man, one reporter notes, "deranged by failure and self-delusion that seems to be unique to our times." A different kind of antihero is the nameless narrator created by first-time novelist Ralph Ellison, whose book about the sad plight of an American black man has that haunting title, *Invisible Man* (*see page 86*).

DEAN MARTIN AND JERRY LEWIS have been appearing in person at the Paramount Theatre and the Copacabana in New York, doing what some call slapstick with sex appeal (*following pages, left*). Although Lewis with his finger up his nose isn't very sexy. Neither is Martin's hand in Lewis's mouth. Management at the Paramount had trouble getting the customers to leave so others can fill the seats and pay the performers' weekly fee of $50,000. Between shows, Dean and Jerry take to an upstairs dressing room, open a window, and shower their fans on the street with autographed pictures. *That* clears the theater in a hurry.

Maybe stage performances aren't doomed, particularly since a Federal Communications Commission freeze in 1948 on new TV stations. (An early rush to license stations proved unworkable, with too many stations located too close to each

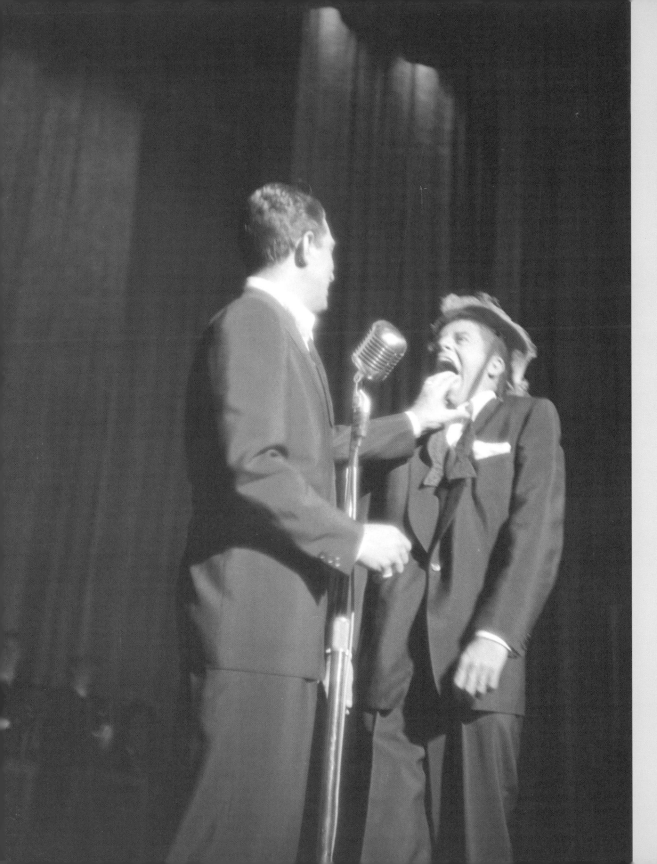

LEFT: Comic duo Dean Martin (straight man, singer) and Jerry Lewis (anything-for-a-laugh clown) were the original kings of all media, working nightclubs and New York's Paramount Theater, doing television, and starring in movies. *Look* profiled them in the April 22 issue.

OPPOSITE: Jackie Gleason was as hot as anyone on television this year, headlining a new show on CBS. Gleason, featured by *Look* in a December 2 article, would squeeze his outsized personality into the small screen with even greater success than Milton Berle.

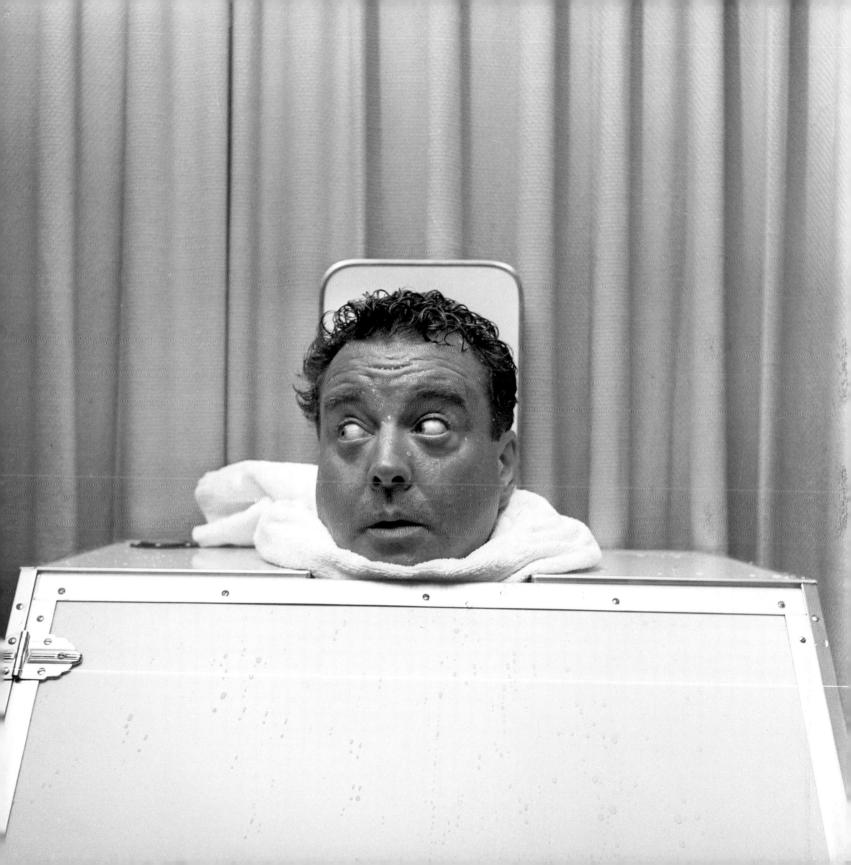

other, resulting in interfering signals.) Though two out of three American families still don't have TV in 1952, the freeze is finally being lifted. Most shows are produced in New York, but it's increasingly obvious that there's TV talent out west, too. A huge building for CBS productions, called Television City, is going up in Hollywood, with what's called a "sandwich-loaf design that can be sliced to extend building in future expansion of the industry."

A new Hepburn named Audrey, a fresh-faced princess, is playing her first leading role in *Roman Holiday* (*following pages, left*). Audrey may be new, but she's no Marilyn, who's showing us how to do the most basic of things (*opposite*). Like walking. Marilyn's full figured besides; she's got her arms outstretched to the world as if to say, "Anything's possible. Come along with me!"

Jackie Gleason's become "TV's big boy," helping to fill—really fill—CBS's "big horn of plenty" with a weekly show that includes a popular sketch titled *The Honeymooners*. The shot of Gleason in the steam box is funny, but also disturbing, as if he's being swallowed by some overheated version of a giant TV set (*previous pages, right*).

The only female star who seems like she will last forever is Lucy, who claims she doesn't care how she looks in front of a camera—and we don't either (*following pages, right*). At home, she makes comedy out of domestic problems. She's happily playing with her husband, Desi, and their new baby, Lucie Desiree. The number one male-star holdover in this "dawn of the plutonium era" is John Wayne, who's in movies including *The Quiet Man* (as a boxer returning to his native Ireland) and *Big Jim McClain* (as a HUAC investigator rooting out commies in Hawaii). But the surprise is the number two team—that's right—goofy Jerry and straight man Dean.

POLITICS IS RIGHT UNDER THE SURFACE of show business, and most everything these days. Director Elia Kazan, testifying before the House Un-American Activities Committee, names writers and other people once affiliated with the Communist party, but playwright Lillian Hellman refuses to name anyone. Silent film legend Charlie Chaplin, under suspicion, leaves America in disgust.

ABOVE: The book of the year—and arguably the decade—was Ralph Ellison's debut novel, *Invisible Man*. Gordon Parks shot this portrait of the author two years before, in 1950.

OPPOSITE: Not everyone requires a lesson in "How to Walk," but for *Look*'s cameras in the August 26 issue, Marilyn Monroe was happy to oblige.

FOLLOWING PAGES, LEFT: Audrey Hepburn, caught in a candid moment by *Look* for its October 21 issue, won an Oscar for her starring debut in *Roman Holiday*.

FOLLOWING PAGES, RIGHT: *Look*'s Charlotte Brooks snapped Lucille Ball at home with daughter Lucie Desiree; the photo for a November 18 article was never published. In its first season (1951–52) *I Love Lucy* was number three in the ratings; it was number one for the next three.

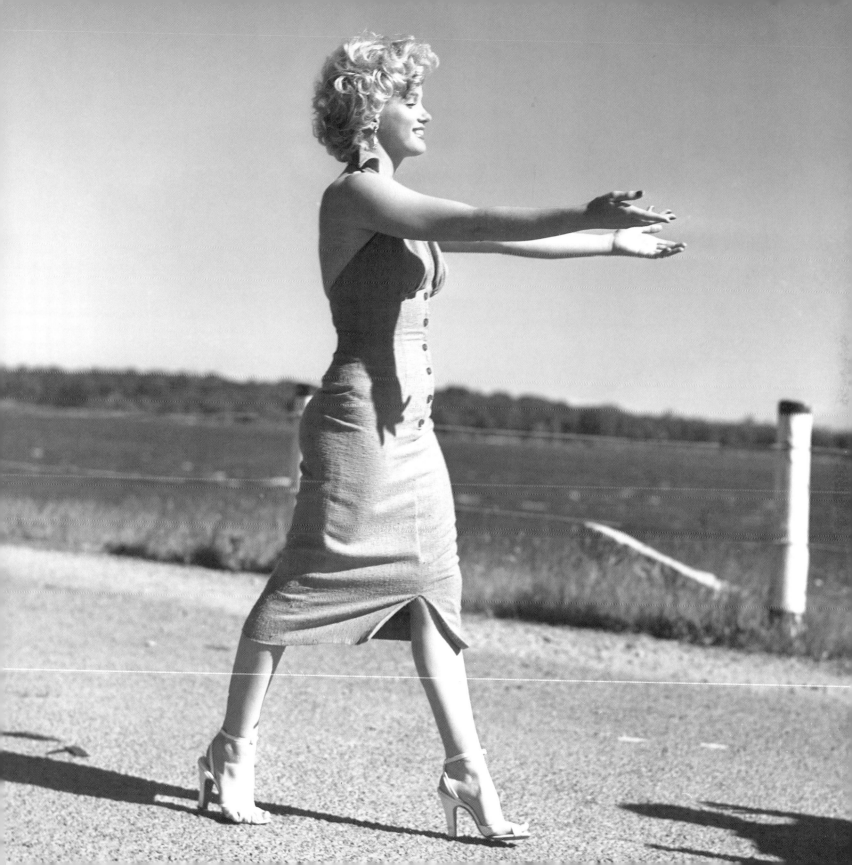

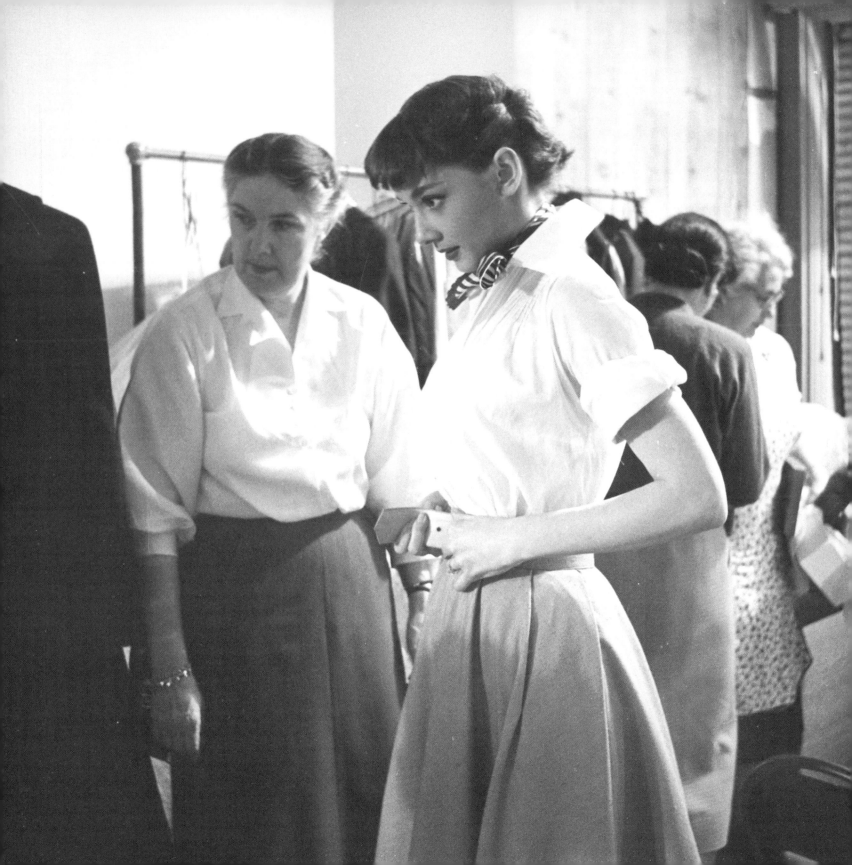

The presidential election's coming up, and the governor of Illinois, Adlai E. Stevenson, is running against war hero Dwight D. Eisenhower, who stands in that Cadillac convertible, besieged by the crowd and confetti (*opposite*). In a double-breasted suit, Eisenhower looks like a business executive, not a soldier, and there's an alleged feud between Ike and MacArthur to worry about (that is, if you're a Republican), since General MacArthur might come to the convention to take on Eisenhower and his opponent Taft for the nomination. But he doesn't.

So why is Senator Richard Nixon picked to be Eisenhower's running mate? Good question. Perhaps it is his youth (he is only thirty-nine while Ike is sixty-two) or his record as an implacable foe of communism. Probably that strong jaw, too, although the turned-up nose is weird, and the remoteness in those eyes makes you look again (*following pages*). Will this guy really appeal to weary voters who, as one reporter notes, "have never known anything but inflation, corruption, inefficiency, war, and the threat of new wars"?

Philosopher Bertrand Russell's thinking about the chance of a new war and estimates the odds at six to four. Socialist and perennial presidential candidate Norman Thomas openly taunts the major parties for not saying whether or not they're for disarmament, McCarthyism, tax cuts, foreign aid, welfare, and farm subsidies. And black voters are telling both presidential candidates that without their constituency's support, the election will be lost. They provided Truman with his victory, but they aren't committing to the Democrat standing in the Ford convertible and wearing a hat, which pretty much says it all: Stevenson's supporters are ardent, but there aren't enough of them.

Meanwhile, the Pentagon's spending eight billion bucks a month and has almost four million men in uniform, and so why, with all these reports coming in about

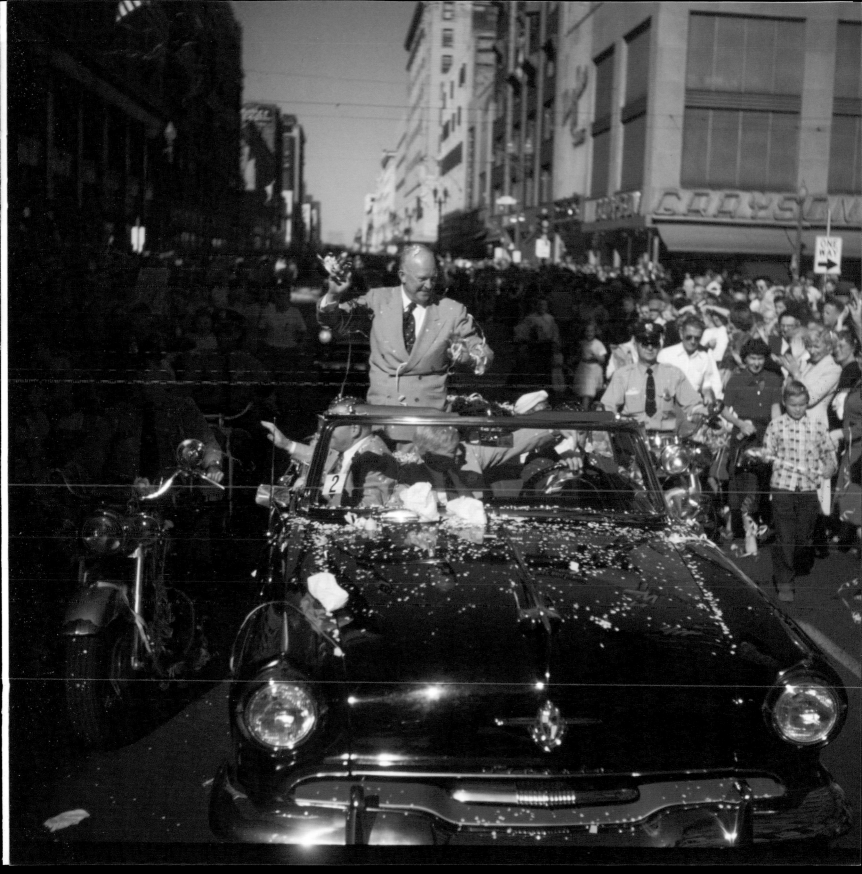

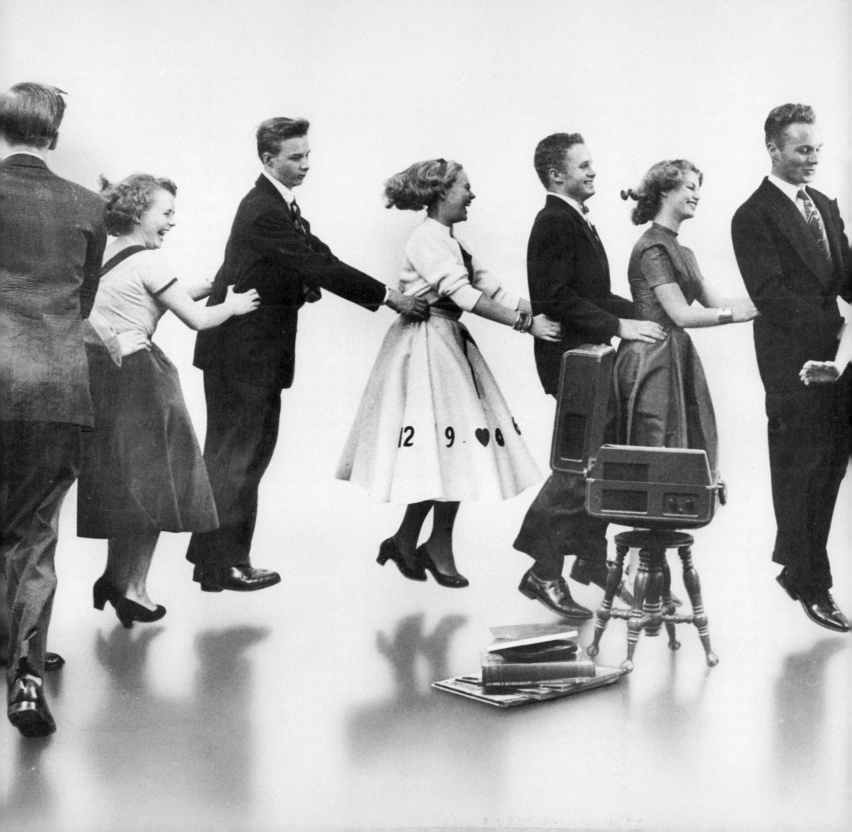

1953

Somebody Up There

. . . sing: land of Abraham Lincoln and Lydia E. Pinkham,
land above all of Just Add Hot Water And Serve— . . .

—E. E. Cummings, "Poem, Or Beauty Hurts Mr. Vinal"

POLIO CASES HAVE MORE THAN DOUBLED in a year, from 20,000 to almost 58,000, and Americans are lining up for gamma-globulin injections (*opposite*). But in this unpublished photo taken in July, it looks more like a wake than a mass inoculation. They press together on the sidewalk, the kids not knowing where to look. The one woman facing the camera, her arm through a purse strap, is worried, and suspicious. How did this happen to us? Who's responsible? The crowd's apparent patience is belied by the tension in all the crossed arms, conversation in abeyance; no one's smiling, and the care with which they've prepared—women in heels, men in hats, little girls in Sunday dresses— reveals the respect paid to this, the great domestic fear.

Polio could afflict any of these well-mannered children and remains the most frightening disease imaginable, a specter made worse by the mystery surrounding it. Reinforcing all this is a photograph of the iron lung and the anonymous child in its embrace (*following pages, left*), a prisoner of both the disease and its treatment. He or she lives a horror show of confinement, the shadowy figures of doctor and nurse solicitous, but also in the grip of something neither can cure or ameliorate.

If it's not polio, then it's youth running wild and making older Americans more than a bit nervous. Teens and young adults are dabbling in pastimes as frightening as drugs and drag racing. Many young men have their heads in the guts of cars, not school books (*opposite*). Cars are all-American, after all—even when driven too fast by drivers who, with cigarette packs rolled into their T-shirt sleeves, destroy perfectly good Detroit products to reflect their different view of locomotion and the society through which they're traveling; and even when teenagers emulate them and push the needle on the family speedometer into forbidden territory.

The bunny hop, a dance created last year by San Francisco high school students to a record by big band leader Ray Anthony, offers American youth an acceptable way to be rebellious. Act crazy if you have to, but do it responsibly: in a group, with preordained moves and a clear line of progression, even if it leads nowhere. Kids wearing suits and ties, long dresses and heels, chastely hold the waist in front of them (*see pages 96–97*). Relieving inner tensions, they jump in step, but the dance is curiously static: a line of linked, levitating young people, embracing abandonment on cue with the requisite show of enjoyment.

Americans must stay positive no matter what, says the Reverend Dr. Norman Vincent Peale (*below*). His book, *The Power of Positive Thinking*, is camped out on the *New York Times* best-seller list. Peale's always talking

ABOVE: Severe cases of polio required breathing with the help of an enormous, scary-looking ventilator, which became known as the iron lung, seen in this unpublished photo taken for the October 20 issue.

RIGHT: Norman Vincent Peale, pastor of New York City's Marble Collegiate Church since 1932, found himself a national celebrity for his book *The Power of Positive Thinking*, a *New York Times* bestseller for 186 weeks. *Look* photographed him for its September 22 issue.

about the tremendous—or "tray-men-dus"—potential of assumptions: that your objectives are worthy and possible, that there are right ways and wrong ways to do things and not much in between, and that you have to *do* something more or less nonstop. His role in this process is simple: "to remind people of the great things that can take place in their lives through the power of God." [Source: LOOK, Sept. 22, 1953, p. 91.]

Publishing's as varied—and contradictory—as ever. Very different advice from Peale's comes from a new men's magazine called *Playboy*, said to contain nude photographs of Marilyn Monroe, although it's hard to find a copy. Dr. Alfred Kinsey's book, *Sexual Behavior in the Human Female*, finally appears, with a view of women's desires that nobody wants to discuss in detail. Another famous, mostly unread book by the French writer, Simone de Beauvoir, called *The Second Sex*, is finally translated into English, and that oddball poet, E. E. Cummings, who has often written unflattering things about America, is, of all things, an honorary guest professor at his alma mater, Harvard.

IN SEPTEMBER, the first family of Massachusetts gathers together for the marriage of their oldest sibling, Senator John F. Kennedy, to socialite Jacqueline Bouvier. In a photograph of the family taken by Toni Frissell on the big day in Newport, Rhode Island, the bride and groom barely make it into the bottom of the frame, Senator Jack's smile just glimpsed, like his head and all that soft, vulnerable hair. Jackie, too, is weighed down, amused by her massed sisters- and brothers-in-law, the hilarity of the occasion attested to by an impressive assembly of Kennedy teeth (*above*). Whatever the joke is, it must be really funny. We're happy to laugh along, but why do we have this sneaky feeling we're never going to get it?

The New York Yankees win their fifth straight American League pennant and World Series, thanks in no small part to the combined batting, managing, and pitching talents of Mickey Mantle, Casey Stengel, and Whitey Ford (*opposite*). The orderliness of baseball offers a refuge from a confusing, chaotic world. The layout of the field is reassuring, as is the methodical stepping up of individuals from uncertainty to possible glory, and the progression of innings, all inured to communists and war and famine.

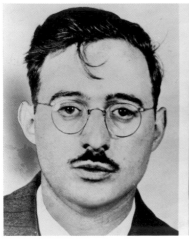 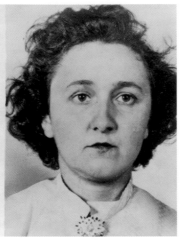

ABOVE: Executed in June for stealing atomic secrets, Julius and Ethel Rosenberg achieved a kind of immortality as, some would insist, falsely accused martyrs of the Cold War.

OPPOSITE, LEFT: In the last full year of his anti-Communist crusade, Senator Joseph McCarthy was starting to show signs of wear, even as he accused the liberal-leaning *New York Post* of being "next to and almost paralleling the *Daily Worker*." A *Look* article, "The Power of McCarthy," ran in the June 16 issue, and a black-and-white version of this photo was used.

OPPOSITE, RIGHT: The cover of *Look*, November 3, 1953.

Joe McCarthy's been made chairman of the Senate Permanent Subcommittee on Investigations, meaning he's the official inquisitor commanding what *Look* calls a "ring" of supporters and associates in Washington, forever on the lookout for communists. Something looks different about Joe McCarthy after three short years of pursuing Reds (*opposite*). Hair loss, for one thing. And that winning smile's long gone, replaced by an unhealthy pallor and an accusatory manner more frightening than reassuring. The papers in his hand are branded with the condemnatory word all Americans have heard before and are hearing again and again: *subversive*.

The term no doubt applies to the likes of Julius and Ethel Rosenberg, who gave defense secrets to the Russians and were sentenced to death by a court in 1951. Their impending executions have sparked widespread protests by people who think the sentence is too harsh, and it does seem vaguely un-American. But the world's still a very dangerous place after all. We can't be too careful, and so the Rosenbergs are executed in June. Joseph Stalin may have died in March, but Russia's still exploding hydrogen devices, proving they, too, have the big bomb. The truce in Korea's a joke, and the Supreme Court's William O. Douglas journeys to Vietnam, where he's checking out another war with communist implications, afraid America may have to take that one on, too.

The truth is, the Rosenbergs look more pathetic than dangerous (*above*). He's a sad sack in glasses, with a pitiful mustache and a face more comedic than revolutionary; she's the tough cookie—with thin lips and a frank, unwavering gaze. They could pass for a struggling couple most anywhere in America, except they're dead.

THERE'S A CONTEST for the most ideal American family on television, which includes ABC's new comedy *Make Room for Daddy*, starring Danny Thomas in the title role (*following pages, right*). Thomas's antics are amusing but he can't hold a candle to the Nelsons. *The Adventures of Ozzie and Harriet* started on the radio in 1944 and in 1952 became a television show. In a photograph shot for *Look* for a May article titled, "Ozzie and Harriet's Ricky and David," Mom sits in a wing chair with young Ricky (age thirteen), while Dad leans on the back with older David (age seventeen), both parents

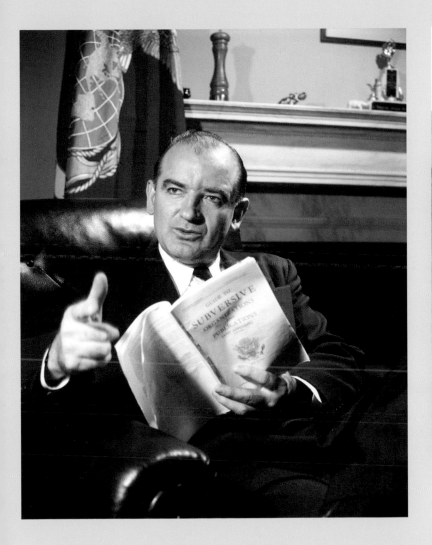

LOOK

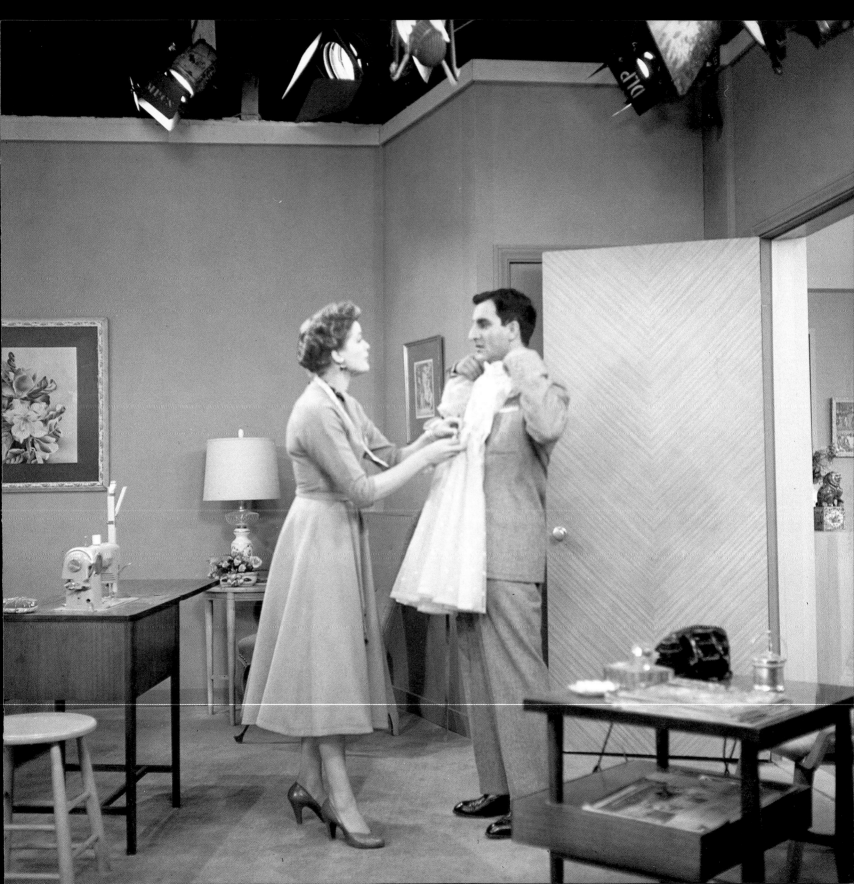

PREVIOUS PAGES, LEFT: The ultimate family comedy show: *The Adventures of Ozzie and Harriet*, starring Ozzie and Harriet Nelson, with their sons David and Ricky. The show ran for 409 episodes on the radio and fourteen seasons on TV.

PREVIOUS PAGES, RIGHT: Comic and singer Danny Thomas, seen with Jean Hagen, debuted in the family sitcom *Make Room for Daddy*, playing, of all things, an entertainer balancing career and domestic obligations. *Look* photographer Robert Vose took this photo on the set; it was never published.

RIGHT: Jack Webb created and often wrote *Dragnet*, TV's reality-based cop series, drawn from the files of the Los Angeles Police Department. The show's terse dialogue evoked both admiration and parody. The September 8 issue of *Look* ran a story on Webb with photographs by John Vachon.

smiling, the boys noncommittal, the family tightly bunched in defiance, however, of any real discord (*previous pages, left*). Ozzie's in a suit and tie—he's an executive, although what he supervises is unclear—and Harriet wears a string of pearls, a white circle collar, and a red sweater. Her permed hair is also red, the dominant color in this smoldering shot of unquestioning togetherness. The boys may not be thrilled, but they're here, which seems to be the point. Rickie's flattop is greased for the occasion, and David's traditional little wave teased up, just like Dad's.

A darker televised vision of America comes from NBC. *Dragnet* is a real-life—or seems to be—police procedural using "similitude" to achieve authenticity (*above*). Its scripts are based on real cases from the files of the Los Angeles Police Department, as an announcer intones at the opening: "The story you are about to see is true. Only the names have been changed to protect the innocent." It stars Jack Webb as Sergeant Joe Friday; Webb's the essential anti-actor, with a wooden Indian demeanor and a voice that, no matter what the provocation, will not be inflected. Friday's line, "Just the facts, ma'am," though never actually uttered on the show, catches on firmly when Stan Freberg's satirical recording, "St. George and the Dragnonet," uses it as a refrain and goes to number 1 on the charts.

RIGHT: *Look*'s July 28 issue captured chimpanzee J. Fred Muggs, mascot of *Today*, NBC-TV's pioneering morning news and entertainment program. He frequently upstaged human host Dave Garroway.

FOLLOWING PAGES, LEFT: Bob Hope, photographed for *Look* rehearsing a 1953 program in this unpublished picture, was among the many entertainers who carried over his act from radio and the movies to television. He managed to outlast all his contemporaries, however, in part by concentrating on specials and avoiding a regular serles.

FOLLOWING PAGES, RIGHT: To stave off competition from television, Hollywood tried going widescreen with the CinemaScope production *The Robe*, starring Richard Burton and Jean Simmons, in one of 1953's biggest films (literally). (*Look* photographer Maurice Terrell was on the set in 1952.) 3-D was another gimmick, but neither stanched the flow of audiences out of theaters

TV'S POPULARITY HAS EATEN INTO MOVIES, imperiling established careers. Bob Hope has dipped a toe in the waters of the small screen with a short-lived variety show (*following pages, left*). The chimpanzee known as J. Fred Muggs, who appears as emcee Dave Garroway's simian foil on the new early morning news and entertainment program, *Today*, is more entertaining than the older movie stars (*above*).

But Hollywood's fighting back against "the tube," and the weapon this time is Twentieth Century-Fox's CinemaScope, a process that uses something called an "anamorphic" lens to film for a much wider screen. The first CinemaScope movie, *The Robe*, has plenty of people filling that screen, and a fittingly important subject: the crucifixion of

OPPOSITE: When *Look* visited Pittsburgh in 1953, it found a city in transition, trying to shed its image as a sooty, shabby, steel town for something cleaner and greener. *Look*'s photographer captures the darker side of the shift. As this unpublished photo shows, the town had a ways to go.

Christ. It stars Richard Burton as the military tribune Marcellus and Jean Simmons as Diana, his childhood friend and now the ward of the emperor Tiberius (*previous pages, right*). Burton's an impressive actor with a British accent, wearing armor and hugging the wall while trying to decide what to do with Jesus, who is under arrest and awaiting execution; Simmons is wearing a cloak and hugging him, trying to help. It's a touching shot full of colorful spectacle and historic angst that, no, you're not going to see on a tiny television screen.

IN DECEMBER, Bert Parks, host of CBS Television's quiz show, *Double or Nothing*, sits with a gorgeous blonde model on what appears to be a magic carpet laden with gifts—a sumptuous display of modern devices that includes a vacuum cleaner, an electric mixer, a coffee percolator, and a little portable television. The photo from *Look*'s story, "American Dream of Christmas," shows the model wrapped in what appears to be a gauzy curtain, revealing some leg, her back to Bert who, at the far end of the carpet, leans against a new clothes drier and points to the sky (*left*).

But the "American Dream of Christmas" won't touch all of America. Pittsburgh, for example, is still undergoing what city leaders call the Renaissance, an attempt to transform a smoky, shambling steel town into something sleek and modern (*previous pages, left*). And in the Arizona desert, the Navajos are trapped in cycles of poverty and isolation (*previous pages, right*).

So what's Bert Parks pretending to see up there? Whatever it is Bert's looking at, it must be looking back at him and all these new products everyone wants— needs, we're told—a lofty spectator well aware of the special, often confusing, sometimes dark and wonderful place that is America.

Oh, of course, it's us he's pointing at. The consumer.

TV host Bert Parks and an unnamed
model pose with holiday goodies for
Look's December 1 article, "The American
Dream of Christmas." They're sitting on
a "magic carpet"; the "sky" behind them
was added later for publication.

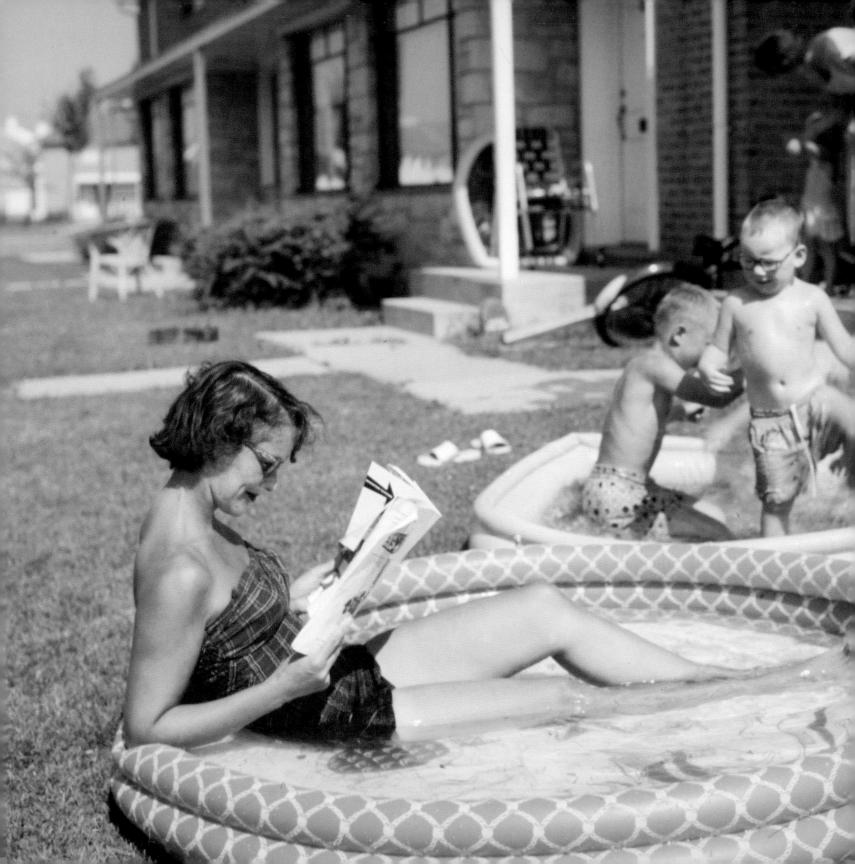

1954

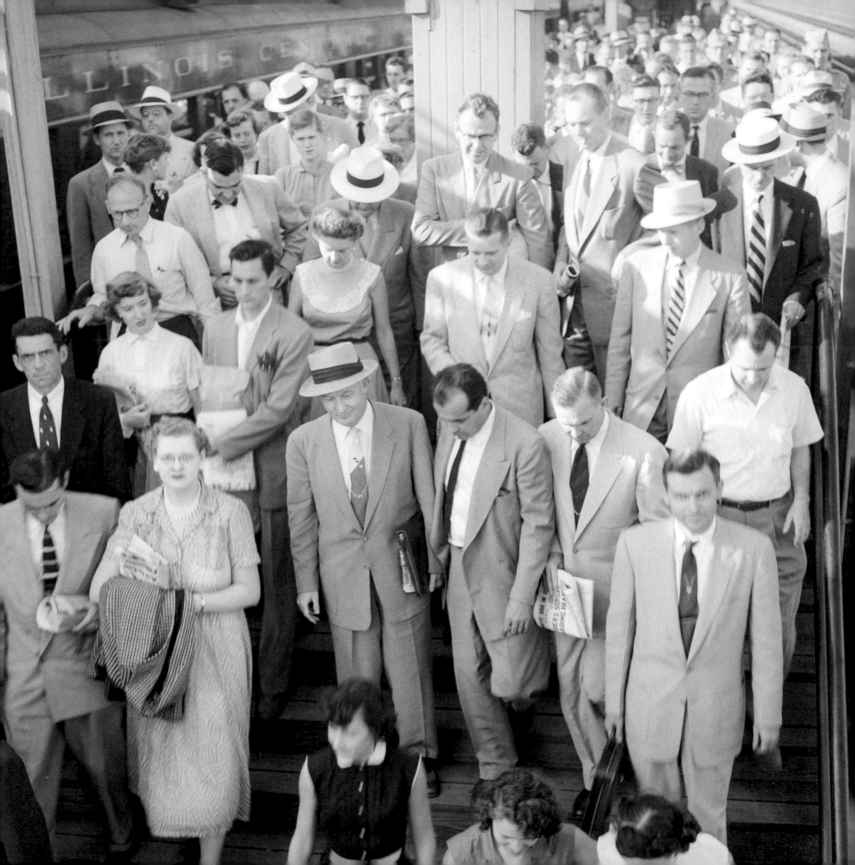

Are You Now or Have You Ever Been

"Mama she done told me, Papa done told me too . . ."
—From the song "That's All Right,"
Elvis Presley covering Arthur "Big Boy" Crudup

PREVIOUS PAGES: A Park Forest, Illinois, pool party shot (but not used) for the "All-American Cities" article, which ran in the February 9 issue.

OPPOSITE: At the Park Forest train station, commuters alight from a train bringing them home from work in Chicago and its closer-in suburbs. *Look* photographer Bob Sandberg took this iconic shot.

FOLLOWING PAGES: A two-tiered beauty pageant in Park Forest in the Feburary 9 issue. This photo was never published.

THOSE HATS . . . not the fact that so many men wear them, but their uniformity—squarely positioned, broad brimmed but not too broad (*opposite*). Looking good matters, although none of the men on the train platform seems aware of mirrors or anything else that might interfere with their orderly procession into Park Forest, Illinois, one of *Look*'s "All-American Cities." The hats vary slightly with different dents, crowns, colored bands—but collectively comprise a vast, ambulatory canopy above the town's—and nation's—manhood, protecting it as much from powerful forces difficult to comprehend as from rain and sun.

"Let the face determine brim width," *Look* advises the man in search of a hat. "Correct business attire demands a hat," and buying and wearing one meet the two clear, overriding social concerns in the dead center of the American century: conformity and consumption.

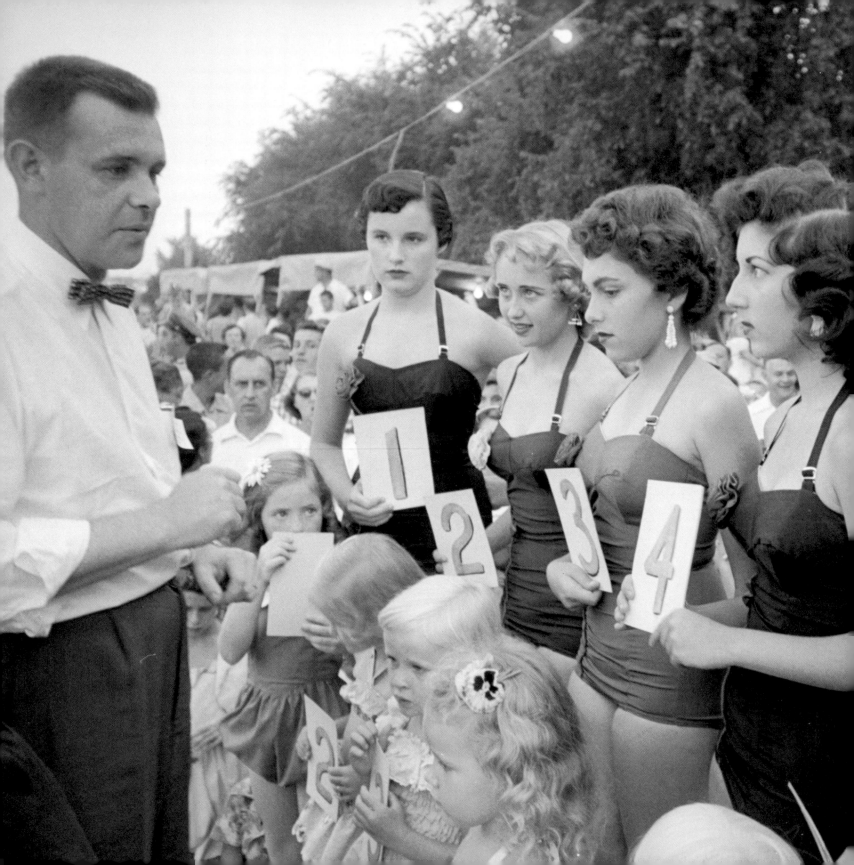

Elsewhere in Park Forest a familiar summertime suburban scene plays out (*see pages 118–119*). There's an empty blow-up pool, leaning against the wall on a neighbor's porch; it's hot in Park Forest, and everybody's going to make the best of it when they get the chance. The kids in the portable pool are rambunctious, but not too; their bodies are bright in the sun, the shadows starkly defined. There's something touching about the little boy's eyeglasses, like his seriousness: he's going to have fun, period. Mom has her own pool and is reading a magazine, either enjoying or improving herself, maybe both. The bright, plaid one-piece bathing suit becomes her.

For some time America has flirted with the still-shocking notion of bikinis, but the one-piece prevails in a Park Forest beauty contest (*opposite*). The contestants, in earrings, are very serious, staring at a slight man who, with crew cut and propeller bowtie, bears a resemblance to Dr. Kinsey, author of the controversial books about sex. But this guy's just a judge who takes his duties to heart, part of a grim tableau of expectation and authority, the collective complexion almost as white as the judge's starched shirt.

THERE'S A SEVERE DROUGHT IN THE GREAT PLAINS, now in its fifth year, with memories of the Dust Bowl still vivid. *Look* photographer Charlotte Brooks captures conditions there with a picture of two girls carrying their puppies (*following pages, left*). The girls, deep in conversation, wear saddle oxfords, jeans with folded cuffs, and their shirttails out. One has dirt on her knees, testament to all-American outdoor play, and has her fingers dug ruminatively into her hair. Both are heedless of the sear dead plant beside them and the skeletal windmill in their wake; overhead hangs a numinous, otherworldly cloud in an otherwise blemish-less sky—either salvation or scourge.

The phrase, "Under God," is now part of the Pledge of Allegiance; *The Adventures of Rin Tin Tin* resurrects the German shepherd dog of silent movie adventures for a television series set in the frontier West (*following pages, right*), Marilyn Monroe marries—and divorces—Yankee great Joe DiMaggio . . . all in the space of nine months; and an unknown white singer with a strange name and a voice more like a black man's is making promising commercial recordings down in Memphis, of all places.

The Supreme Court has ruled in the Kansas case, Brown v. the Board of Education, that segregated schools are unlawful, but what will the effect be? Janis Gossett's family picked up and left Texas in search of a better life and school for their daughter, eventually settling in Phoenix, where problems persist but nothing on the scale of what's expected in the South (*see pages 124–125*). In a sea of white faces, she's the black face that stands out

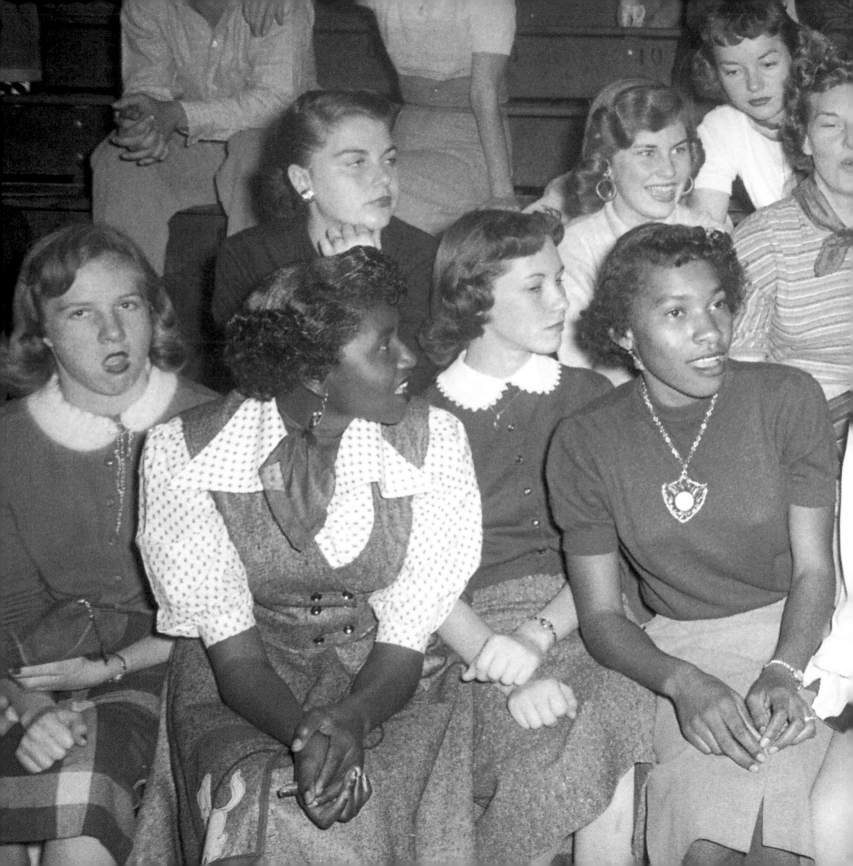

in a series of high school tableaux: pep rallies, basketball games, lunchrooms. It's smiles all around, but you wonder if other black kids will have it that easy.

Meanwhile, Jackie Robinson's a national hero, again making the National League's All-Star Game team. Singer Nat King Cole is making his own kind of hits, his mellifluous, tantalizing voice registering in more white than black ears. Mahalia Jackson, hailed as "the World's Greatest Gospel Singer," makes her first recording for prestigious Columbia Records (*above*). And in October, LOOK features Daniel "Chappie" James, Jr., just last year becoming the first African American to make squad commander in the U.S. Air Force (*opposite*).

FRANK SINATRA is releasing two albums this year—*Songs for Young Lovers* and *Swing Easy!*—for his new label, Capitol Records (*following pages, left*). He also wins an Oscar for his role in the movie, *From Here to Eternity*, based on the World War II novel by James Jones. In it, Sinatra's character Private Angelo Maggio is killed in a knife fight on the eve of Pearl Harbor, but the actor himself never actually went to the war and doesn't look like either a singer or a soldier in that white, buttoned-up sweater and black hat that looks like a toreador's. Sinatra's expression suggests that he doesn't know why he's wearing it.

The popular entertainer and piano player Liberace is getting a lot of exposure on television, and so are the lavish, formal settings of his performances—lit candles!—and

RIGHT: While serving in the Air Force during three wars, Daniel "Chappie" James Jr. broke down several barriers. In its October 19 issue, *Look* pointed out that he was the first black squadron commander. He later became the first black four-star general in any branch of service.

FOLLOWING PAGES, LEFT: It was a very good year for Frank Sinatra, who won an Oscar for his performance in *From Here to Eternity* and released two records, his first in four years, on his new label, Capitol. Milton H. Greene's portrait never ran in *Look*.

FOLLOWING PAGES, RIGHT: *Look* labeled Grace Kelly the "Most Wanted Woman," as she appeared in five films this year, including two Hitchcock classics, *Rear Window* and *Dial M for Murder*, plus *The Country Girl*, for which she would win an Oscar. This photo was never published by the magazine.

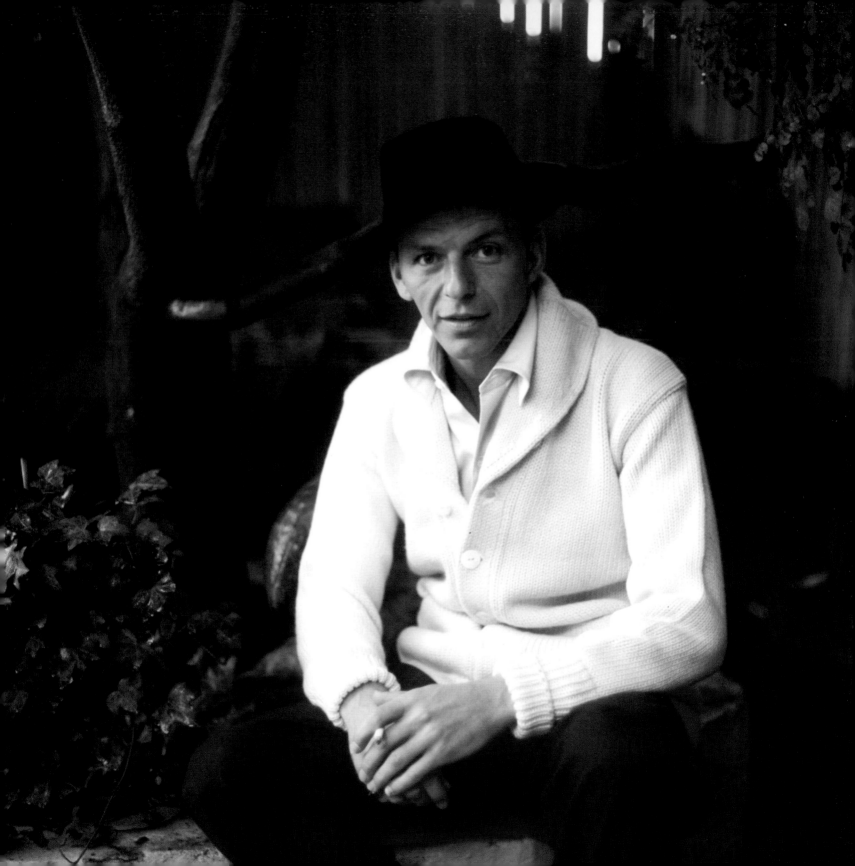

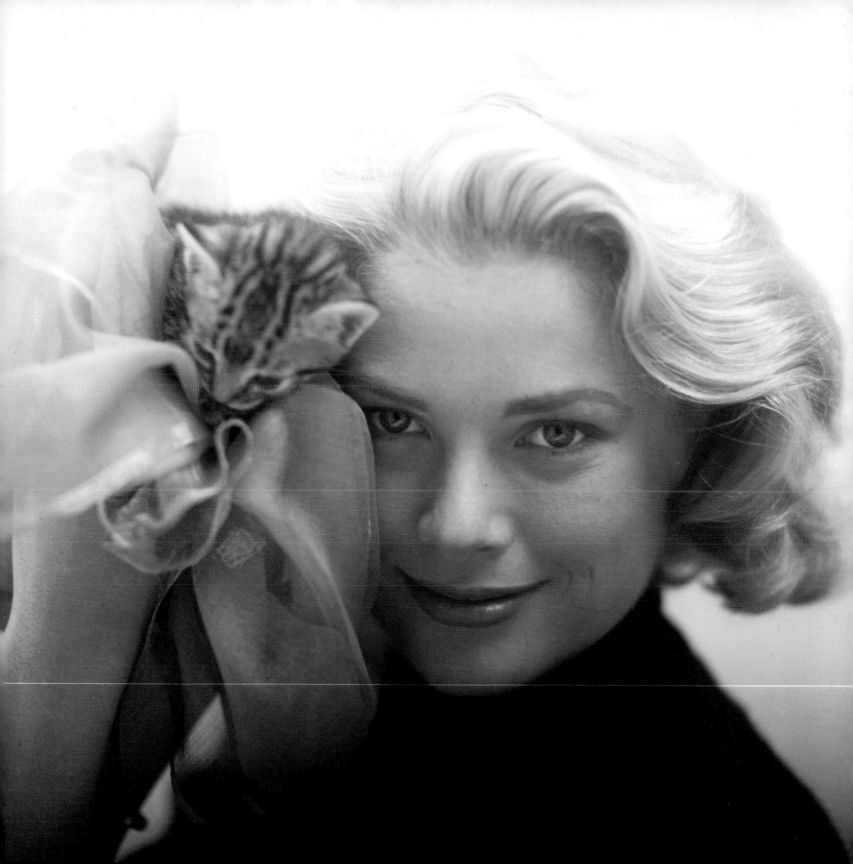

RIGHT: Liberace, subject of an October 19, 1954, *Look* cover, was a new kind of piano man, one who, decked out in jewels and furs, played white pianos on ornate sets. Television brought him millions of new fans, many of them older women impressed with his devotion to his mother.

FOLLOWING PAGES, LEFT: Making his starring debut in *East of Eden*, James Dean came off as the younger brother of Marlon Brando and Montgomery Clift. He put a moody, vulnerable spin on his character, the troubled Cal Trask of John Steinbeck's novel. *Look* took pictures of him in 1954 on location in rural California, but they never ran in the magazine.

FOLLOWING PAGES, RIGHT: Marlon Brando (seen here with Karl Malden), won an Oscar for his performance in *On the Waterfront*, a timely tale of labor corruption on the New Jersey docks. Photographer Arthur Rothstein was on the set to take these candid shots of a legendary performance.

his outfits (*opposite*). Liberace's more famous for his colorful jackets and ties than for his music, which is about as far from Mahalia Jackson's as you can get.

Everybody pales next to Grace Kelly, the blonde star of no fewer than five movies this year, including *Rear Window* and *Dial M for Murder*, both grippers by that pear-shaped director, Alfred Hitchcock. Kelly's trying to be sexy but can't quite bring it off; there's something so inherently decent about her that even when vamping for a photographer, she just comes off as a good sport. The photo with the kitten held next to her face says it all: she's beautiful, composed, talented . . . herself (*see page 129*).

Judy Garland's from another world, only partly because of *The Wizard of Oz*. Unlike the patrician-born Kelly, she was raised as part of a sister act in vaudeville. Now she's in a musical remake of *A Star Is Born*, playing a young performer whose rise eclipses her older actor husband's fame. Fresh faced, antic, and vulnerable, she's sporting big, brown, flat eyes that are searching for something beyond the camera. Looking at Judy, you can't help but wonder what that is, and if she's ever going to come back to earth.

These movie stars seem to change faster than the rest of us; they get older quicker, disappointing us just by failing to look precisely as they did the first time we saw them. Marlon Brando's a good example, this year playing a failed prizefighter named Terry in a gritty story called *On the Waterfront* about dock workers and brutal labor bosses (*following pages, right*). He's still handsome, his muscular performance riveting, but he's aged, both in fact and on the screen. We're reminded that it wasn't yesterday when he burst onto the scene in *A Streetcar Named Desire* and that the simpler world reflected in New Orleans' charming decay is long gone.

On the Waterfront highlights union corruption and the plight of the working man at a time when strikes are occurring regularly in America. In Wisconsin, employees of a company called Kohler, a plumbing parts manufacturer, are on a big strike that looks like it will last (*see page 134*). The movie shows the unions in the worst possible light, but also how vulnerable workers are on their own, without the unions. It costars Eva Marie Saint, and was written by Budd Schulberg and directed by Elia Kazan.

Kazan's also making *East of Eden*, to be released next year. It's based on the novel by John Steinbeck and stars James Dean, who's replacing Brando as America's favorite young actor. The photo of Dean taken on the set also shows, in the background, a wooden apparatus for loading vegetables, an elemental California farm scene that has little in common with the star's almost girlish good looks: curly hair, broad forehead, and soft mouth. But the chin is strong, and the shadows under overhanging brows are full of doubt and

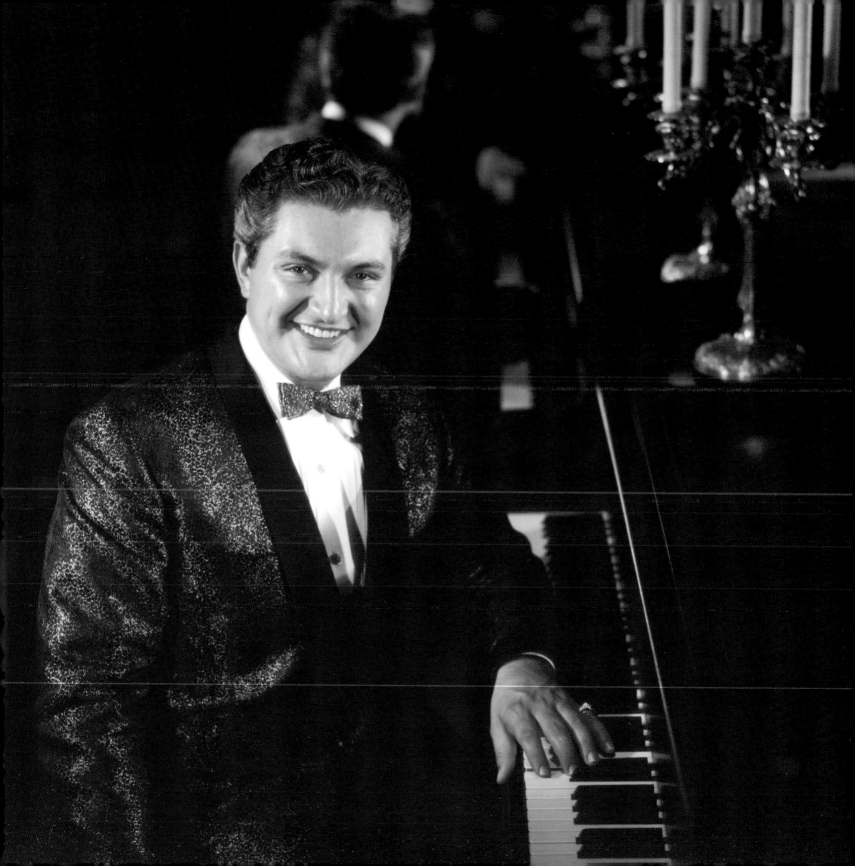

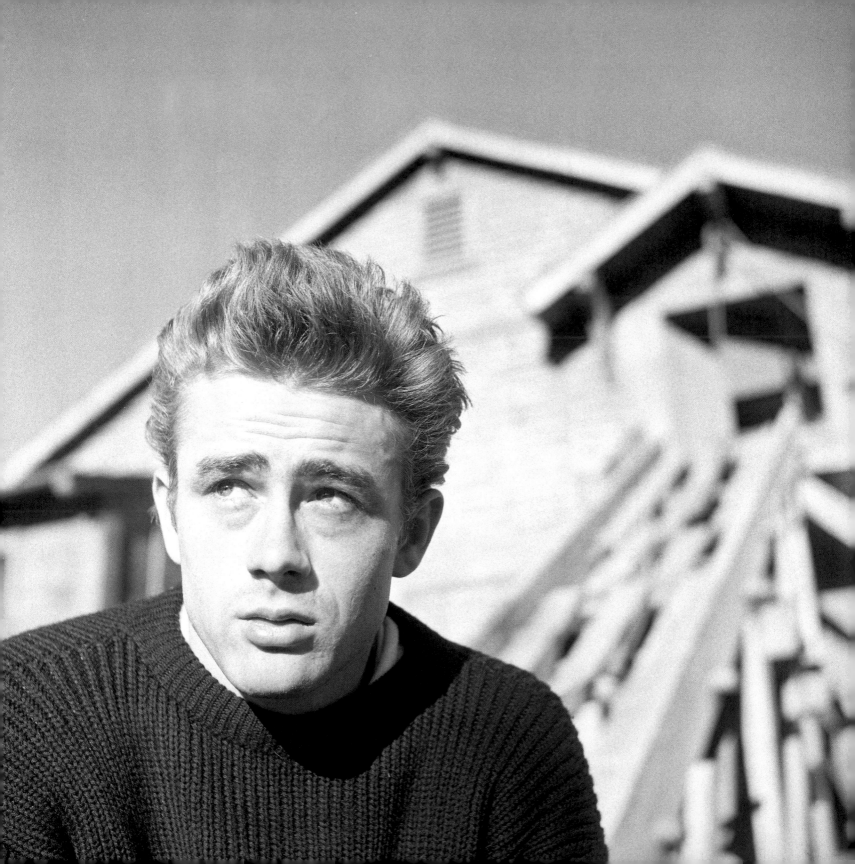

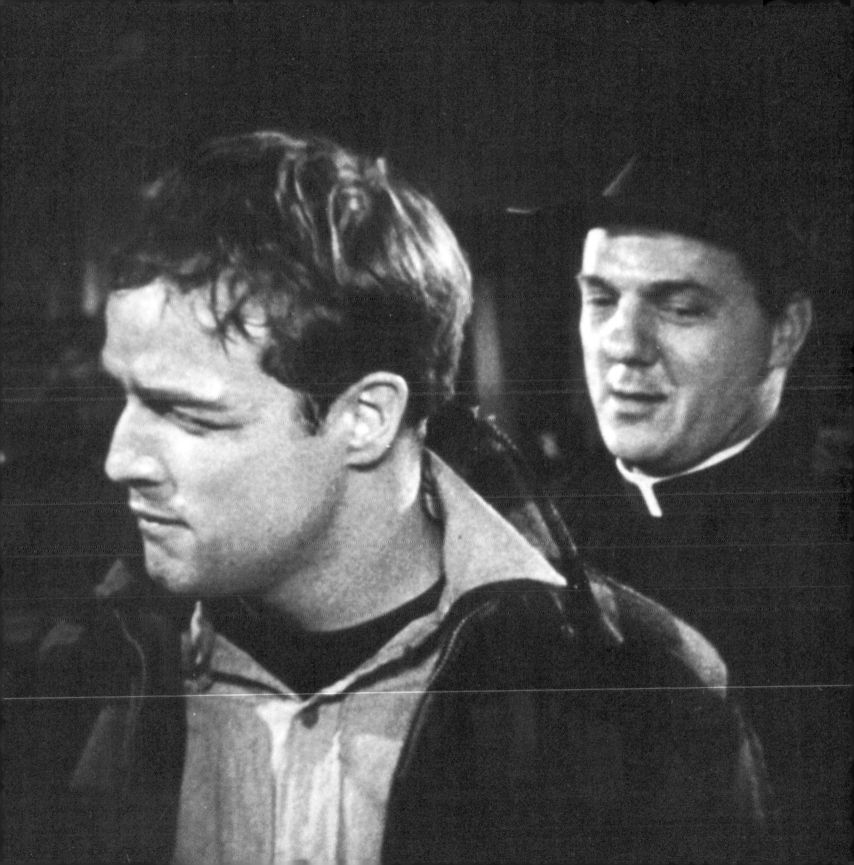

RIGHT: In real-life labor news, workers at the Kohler plant in Wisconsin went on strike in 1954, and though the company managed to continue to operate, the dispute dragged on into the 1960s, finally settled by court decisions. *Look* took these photographs in the strike's second year.

brooding, an intriguing contradiction between his features and his expression that keeps the rest of us off-balance, not knowing what he's thinking (*previous pages, left*).

Movie stars have been replaced altogether by Walt Disney in his animated films, which are so successful that he's transforming the idea of entertainment in America. His new television series, *Disneyland*, is apparently a success, and he's opening a real Disneyland in Southern California next year, a kind of park with rides and characters based on the drawings. Disney's ultimate plan apparently includes the world, judging from the photo of him and Mickey Mouse, who sits atop a globe (*see page 138*). Mickey looks, well, freakish, and although Disney's smiling, sort of, his demeanor and thin mustache have as much in common with a car salesman as a cartoonist.

THE FRENCH GARRISON at Dien Bien Phu in French Indochina has fallen to the forces of Viet Minh communist revolutionaries. Why can't the French handle it? Everybody instinctively knows they won't, and we'll have to help in some way, even if the communists are still a long way from America. In April, attempting to explain the importance of the struggle of the French forces, President Eisenhower talks in a press conference about a "domino" effect in Southeast Asia if another country there turns communist. But Korea's still a sore spot for Americans, who would just as soon not have another war and yet feel powerless to prevent it.

Joe McCarthy, foremost scourge of communists in America, is taken on by the foremost broadcast newsman, Edward R. Murrow, hero of the airwaves during the Nazi blitz on London (*following pages, right*). Murrow's closing line—"Good night, and good luck"—is also his signature signoff on television. Murrow criticizes both McCarthy's methods and his claims of a widespread communist conspiracy in America. Most everything about Murrow—his thick, dark, chiseled hair; angular face; dour expression—is in contrast to McCarthy, whose moonlike visage and five-o'clock shadow are now well-known to Americans. So are the wisps of hair that fall over his forehead as he denounces people in the State Department and the military in that relentless monotone. After Murrow's broadcast, he calls the newscaster "the cleverest of the jackal pack," which is hard for anybody to believe. More important, McCarthy fails to address any of Murrow's criticisms; the patience and sympathy of Americans is peeling away from ol' Joe.

Another of McCarthy's critics, Margaret Chase Smith, senator from Maine (*below*), is opposed in this year's Republican primary election by a man backed by McCarthy. Murrow's broadcast may be the popular tipping point of the reaction, but if McCarthy's

RIGHT: Senator Margaret Chase Smith of Maine, who valiantly spoke out against McCarthy in 1950, found herself four years later in a primary battle against a McCarthy-backed candidate. She won handily, further evidence of McCarthy's waning influence. This was the lead picture of the senator in the June 15, 1954 article about her.

OPPOSITE: On March 9, CBS newsman Edward R. Murrow's *See It Now* took on Senator Joseph McCarthy and his anti-Communist crusade. *Look* shot a television screen showing the men conversing on the telephone during the historic broadcast.

FOLLOWING PAGES, LEFT: Walt Disney and his most famous creation were clearly set on world domination, with a new television series and a Southern California theme park, both named Disneyland, under construction. *Look* covered it all in its November 2 issue.

FOLLOWING PAGES, RIGHT: *Look*'s annual feature on Christmas focused this year on the ever-escalating race to put as many lights and decorations on the exterior of one's home as possible, as shown in this unpublished photograph.

claims do all prove false, the real hero is Senator Smith. The picture of traditional Republican decency in her corsage and single string of pearls, she's the one who made the first anti-McCarthy speech back in 1950. Even with McCarthy's support, her adversary gets buried five to one.

People are devoting more attention—and more of the paycheck—to Christmas decorations. But the lights in the photo in *Look*'s annual Christmas feature are too harsh, and the landscape is devoid of people (*following pages, right*). Santa's sleigh taking off from the lawn looks more like an invasion, the decorative lights like explosions reflecting in the icy ground. And that bank of windows looking into a living room with the white Christmas tree reminds us not of a real house but of a television screen, drifted with snow. Good night and good luck, indeed.

1955

Men and Boys

"Gonna rock, rock, rock till broad daylight . . ."

—From the song "Rock Around the Clock," Bill Haley and the Comets

THE HONEYMOONERS has now been a sketch on *The Jackie Gleason Show* for four years, and it's been so popular, they're making it into a series all its own. This intimate glimpse into the lives of two couples in the same Brooklyn apartment building is supposed to be about domesticity in urban America, but it seems to be more about affection, perseverance, and the absurdity of ambition at the bottom of the economic ladder.

Ralph Kramden, played by Gleason, volcanically rages at Ed Norton, played by Art Carney, but quickly runs out of steam, his dreams and endless frustrations hilarious and touching (*opposite*). Carney's vest, T-shirt, and hat with the upturned brim are as alien to the suburbs as Gleason's busman's jacket, like the grim efficiency of the walkup flat garishly painted to provide contrast for the black-and-white cameras (*see page 17*). Carney's patience is saintly, as if he instinctively accepts the limitations that Gleason can't, the two characters just lovable, hapless boy-men. They're yoked in an emerging portrait of an alternative American male who has nothing in common with the supposedly real men we see in the car and clothes ads.

143

A new TV character is Captain Kangaroo, who also wears a uniform but evinces a goofiness far exceeding that of Gleason and Carney (*left*). The kids all seem to like him, yet you can't help but wonder what they're seeing, as the befuddled captain fumbles with a telephone and generally tries—and fails—to deal with a world dominated by stuffed animals. That men in uniform don't know what they're doing? That adults are inherently incompetent, and maybe even delusional?

Oddly, that notion is reinforced on the adult level by many shows, including *The George Burns and Gracie Allen Show*. It has been on the air since 1950 and is still popular, but George and Gracie, who are more or less playing themselves, seem silly, even childish (though he smokes cigars all the time). Are they prime-time Captain Kangaroos? Is Phil Silvers, playing the scheming Sergeant Bilko, too? At least we know what we're supposed to think about the popular TV character Bozo the Clown (he's a clown). He's been around since the 1940s but now one of the actors who portrays him, a guy named Larry Harmon, plans to license him, like a make of washing machine.

And then there's ventriloquist Paul Winchell and his sidekick Jerry Mahoney: one's a man full of platitudes, the other a dummy always saying things he's not supposed to.

Maybe things will change with the debut of *The $64,000 Question*, inspired by "the $64 question," the top prize offered on the popular radio show called *Take It or Leave It*. Maybe we're going to start getting real answers from mature grownups who live in the real world and have knowledge and integrity.

People on the musical side of TV programming all seem to be looking to the past. Who can't watch Dinah Shore's familiar radiance fill up the screen once a week, her hands reaching out to us in ghostly white gloves? Tony Martin and Eddie Fisher have their own shows, too, singing the pop hits of yesteryear. Meanwhile, Duke Ellington's on the road with his band, playing baseball between gigs, putting up with segregated hotels and eateries, his sound still fluid and mesmerizing but untethered now and old-fashioned (*see pages 140–141*).

Musical tastes seem to be moving away from the Dorsey Brothers, too, who are trying to bring back the swing era with their new TV series *Stage Show*, when something entirely different is building in America. And that Broadway show about a baseball fan's pact with the devil, *Damn Yankees*, also sounds stale, even though Gwen Verdon, as Satan's temptress-assistant Lola, performs a striptease to try to seal the deal (*following pages, left*).

The music on people's minds is altogether different, though hard to describe. Like the song, "Rock Around the Clock," that pumped-up recording that runs under

the credits for a controversial new movie, *Blackboard Jungle*. *Look*'s article, "A Movie Tackles Teen-Age School Terror," shows stills from the film, which is about a teacher, played by Glenn Ford, facing down a class full of hoodlums until one of them, played by a charismatic black actor named Sidney Poitier, crosses over to his side. The violence in the film—boys smashing a teacher's valuable record collection, one student attacking a female teacher in the library stacks—causes the U.S. Ambassador to Italy, Clare Boothe Luce, to have it withdrawn from the Venice Film Festival for what she considers a negative portrayal of America.

Irving Berlin is in another musical category altogether. He wrote the score for *White Christmas*, starring who else but Bing Crosby. It was the top-grossing movie in 1954, but the show is about Christmas, and so what do you expect. The bespectacled, 66-year-old Berlin comes off more an accountant than a composer of popular music.

LOOK NEVER MISSES A BEAT when it comes to following the careers of Hollywood's young female stars. Grace Kelly's learning to fence for her new role in *The Swan*, looking as much like a nurse as a dueler. That about sums her up: a gorgeous, standup girl, with maybe a touch of wildness that's trying—but not too hard—to get out. She's dating Prince Rainier of Monaco, whom she met when while filming Hitchcock's

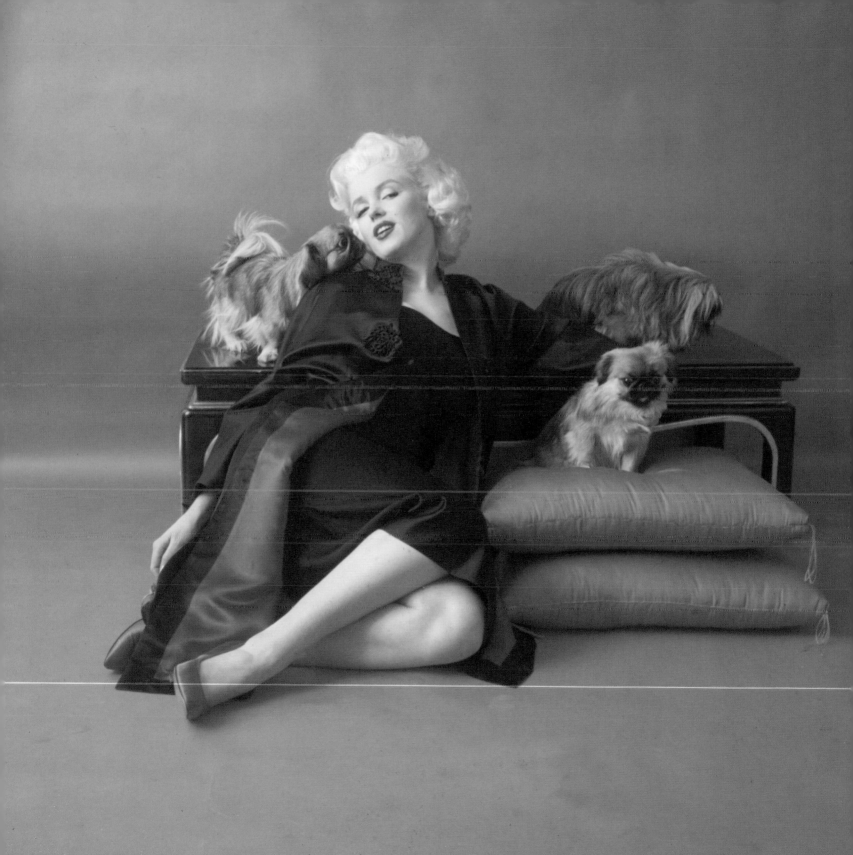

To Catch a Thief on location. Their relationship may be more than Hollywood noblesse oblige, it may be the end of something else—like her career.

A more mature Marilyn Monroe has surfaced in another photograph, this one showing her clothed, with Chinese furniture and three Pekingese (*previous pages, right*). None of that stuff makes Marilyn look any less provocative—or less dangerous—her white legs and the lurid red background a kind of visual pant. Her royal purple gown's lined with pink satin, and she's about as sexy looking as she could get without being starkers.

The fact is that passion is turning into some kind grotesque ritual. In an article titled "What Is Normal?," young men—*Look* refers to them as teenagers but they seem to be already on the edge of middle age—are playing spin the bottle, crawling around on the floor in suits and ties and kissing—and getting kissed by—girls in party dresses (*left*).

Another portion of the article deals with male neuroses, although that's not what they're usually called. More common is "male behavior." For example, what's the proper show of sibling affection? And why is some man feeling alienated from his family? How should a real man take a reprimand from his boss? Is it that nobody ever thought about this stuff before, or just that nobody's ever come right out and asked?

SEATING IN MIAMI'S ORANGE BOWL IS SEGREGATED, as is most of America, and not just the South (*following pages*). While blacks continue to make headlines in the sports pages—Hank Aaron is in his second season, compiling a .314 batting average, with 27 homeruns and 106 runs batted in—black men are still getting killed by white men. A fourteen-year-old visitor from Chicago to Mississippi, Emmett Till, is found in the Tallahatchie River, beaten and shot, a heavy fan tied around his neck with barbed wire. His accused murderers are acquitted. And black women are still sitting in the back of the bus—that is, unless your name is Rosa Parks and you live in Montgomery, Alabama.

Medgar Evers, young African American working for the National Association for the Advancement of Colored People, goes to interview the widow of a man shot for no good reason: Clinton Melton was working at a gas station in Glendora, Mississippi, when a dispute with a white customer erupted. Beulah Melton is the mother of four kids and holds two on her lap, her face averted, trying to answer Evers' questions, as are a lot of people (*see page 152*). Her stoicism seems the only hope for those little children. She will die in April 1956 in a car accident, before the trial, at which three eyewitnesses to the murder have no effect; the jury acquits Clinton Melton's killer after four hours of deliberation.

RIGHT: Mississippi NAACP official Medgar Evers interviews Beulah Melton, widow of a Glendora, Mississippi, man murdered in December at a filling station. Clinton Melton's white killer, Otis Kimball, was set free. On the day of the murder, Kimball was driving a car that belonged to J. W. Milam, one of the men acquitted three months earlier in the killing of Emmett Till.

THE FUN FAIR CALLED DISNEYLAND, completed in Southern California by Walt Disney, with large profits in mind opens in July—the latest development in Walt's cartoon-inspired, alternate America, full of fantastic constructions inspired by his interpretation of time-honored fairy tales as well as his own characters stepping off the screen (*opposite*). As many parents as kids are expected to visit—and maybe more, suggesting there's not much difference between the two when it comes to fun.

Los Alamos, New Mexico, is, in a way, the dark version of Disneyland, manufactured not for fun but rather mayhem—to be visited upon some other country, of course. In fact, some Los Alamos signage suggests a "theme" park: wiggly arrows, precise commands about wearing badges and taking photographs, and air-raid shelters (*following pages*). Looks like scientists and maybe tourists can takes breaks by riding a merry-go-round, or strolling under the trees with a view of the desert. The local movie theater marquee says the film to accompany a reissue of *Gone With the Wind* is *Atomic Invaders Versus the Mounties*, which is funny but also creepy. And the joke is that this twelve-part

RIGHT: Walt Disney supervises construction of the Disneyland theme park, which opened in Anaheim, California, on July 17, with a heavy promotional push from the same-named TV show.

serial from 1953 was originally titled *Canadian Mounties vs. Atomic Invaders*—the Los Alamos theater gave the atomic invaders top billing.

At the Brookhaven National Laboratory on Long Island, scientists are working on something called the "Atomic Food Experiment," irradiating seeds in a search of a positive alternative to just making bombs with the technology. A sign says, "DANGER High-Intensity Radiation," not much of an appetite booster. Neither is that tube full of seeds being held by a very serious young man in a white coat, yet a family is trying to live on plants grown from them. Chances are, the boy looking up at them is not thinking about Cheerios (*see page 156*).

People are a lot more interested in surviving a blast. Nike missiles have been installed in Lorton, Virginia, about twenty miles south of Washington, D.C. (*see page 157*). They are scary looking, both up close and at a distance, bristling with metal fins and directed we-don't-know-where. All we Americans do know is that there are dangers out, or over, there, where evil-looking, eavesdropping equipment has been discovered in American embassies.

A *Look* spread on Hiroshima ten years after the atom bomb was dropped on it reveals still-gutted buildings, women standing over a pile of rubble, a bare tree in the background (*following page, right*). Another photo shows Japanese kids on bikes, and a monument with the single word PEACE. While an article about the sunshine state,

BELOW: *Look* sent photographer Maurice Terrell to Los Alamos, New Mexico in 1955, but the pictures were never published.

OPPOSITE: A shot by *Look* photographer Bob Sandberg from a tenth anniversary story about the atomic bomb drop on Hiroshima for the June 14 issue.

FOLLOWING PAGES, LEFT: At Brookhaven National Laboratory on Long Island, a scientist shows off a tube of irradiated seeds that will produce the food of the future.

FOLLOWING PAGES, RIGHT: News photos show a new Nike missile installation in Lorton, Virginia, not far from the nation's capital.

PAGES 158–159: While on assignment in Florida, *Look* photographer Phillip Harrington found this retro-themed, Indian-style roadside motel known as the "Wigwam."

Florida, says you can retire there on $2,000 a year. There's a polo field and model Gigi Reynolds in a one-piece. But there's catfish to be had, like in the rest of the South, and trailer homes and abandoned houses and clothes on the line, like in most of the rest of America. Also Miami Beach and Wigwam Motels and Weeki Wachee Springs divers (*see pages 158–159*). So, what exactly do you do in Florida on two grand a year, especially if you don't dive or play polo?

That's the thing about photographs: keep looking and you'll find something completely different. All over America.

1956

Tell the Truth

"... what for centuries had been looked on as the meanest greed, a rising middle class would interpret as the earthly manifestation of God's will."

—William H. Whyte, *The Organization Man*

IT'S A NAME NOBODY EVERY HEARD OF, even in Memphis where he was first recorded. "Elvis" seems more astrological than Southern, a cornpone Dionysian deity from the wrong side of the tracks with hair that defies gravity and an angelic voice that is both entrancing and disturbing (*opposite*). He seems to have arrived on earth as he did on television, in baggy slacks and a jacket straight out of swing, with lyrics and a beat as odd as his name, his physical beauty contorted and in thrall to some violent sensuality. No wonder parents secretly fear this guy and Ed Sullivan won't allow the television camera to venture south of his belt buckle.

Elvis is, for openers, literally unhinged, his hips and knees gyrating on celestial strings we can't see, his music both primitive and hauntingly familiar. Whatever he's singing, he means it, gripping the shaft of the microphone like a weapon, one hand splayed for balance, his eyes clamped shut under dark, overhanging brows and his mouth skewed not in scorn, but rather in pain. Five of his 45-rpm singles have hit the number 1 spot on

the charts, including "Love Me Tender," the title song for a Civil War movie starring this inexplicable, weirdly crooning presence from Tupelo, Mississippi.

Rock-and-Roll is the sound America's kids are listening to, and they're not playing spin the bottle when they do. Instead, they're moving on dance floors in ways unprecedented, attached to those same celestial strings, inspired by Elvis and Bill Haley and other murky, hard-beat artists, whose music is blamed for behavior at odds with the traditional.

Yet at a teenage dance party in Kentucky, there are still girls who wear crinolines and boys tuxes as they foxtrot (*opposite*). They're modeled on avatars of the past, in vivid contrast to the gyrating, shirtless guy in the audience at a Bill Haley concert in Hershey, Pennsylvania (*left*). As the kids say, that cat is *gone*.

The sound is Southern, which means black. Shouldn't more credit be given to earlier African American musicians? If so, the fact's lost in the new music's popularity, more attention being paid to the reactions to the Supreme Court's decision to end school desegregation, which is two years old but still reverberating.

ABOVE: An enthusiastic fan at a Bill Haley and His Comets show in Hershey, Pennsylvania, illustrates what attracted the young to rock and roll—and dismayed many of their parents. Haley's "Rock Around the Clock" became the anthem of the new genre, which *Look* reported on in its June 22 issue.

OPPOSITE: In its January 24 issue, *Look* ran two articles on American teenagers, calling them a "generation in the spotlight."

FOLLOWING PAGES, LEFT: In the wake of 1954's Brown v. Board of Education school desegregation decision, *Look* turned its focus southward, asking, "What Is a Southerner?" in its April 3 issue. A series of portraits of everyday life included this picture of a black maid braiding a white girl's hair.

FOLLOWING PAGES, RIGHT: After the August 1955 murder of Emmett Till in Mississippi made national headlines and the two killers were acquitted by a jury in sixty-seven minutes, they confessed in detail to the crime in the January 24 issue of *Look*. J. W. Milam, one of them, posed with his family; the photograph did not appear in the magazine.

LOOK'S PHOTOGRAPHS FOR AN ARTICLE entitled "What is a Southerner," show an unsmiling white kid having her pigtails braided by a black maid (*following pages, left*), and a boy sitting on a kitchen counter with his finger in the cookie dough, next to a large black maid in a bandana who could have come straight off the set of *Gone with the Wind*. What comes across is black servants dressed to be photographed, doing what they're told to do—that is, taking care of children and trying to look pleased doing it—and white children aware of the masquerade, bored and about to get peevish. What's missing is the parents.

J. W. Milam, one of the men who admits to murdering Emmett Till but was never convicted of the crime, sits on the back stoop of his clapboard house in Leflore County, Mississippi, petting his hound dog, reminding us of a song by Elvis (*following pages, right*). A writer from *Look*, William Bradford Huie, has written up the details of the crime from interviews with Milam and the other killer, his half brother, Roy Bryant. This is a white version of the rural squalor we usually associate with black sharecroppers. Could such violent racism in the South be related not just to ignorance but also to competition for jobs, and to self-esteem?

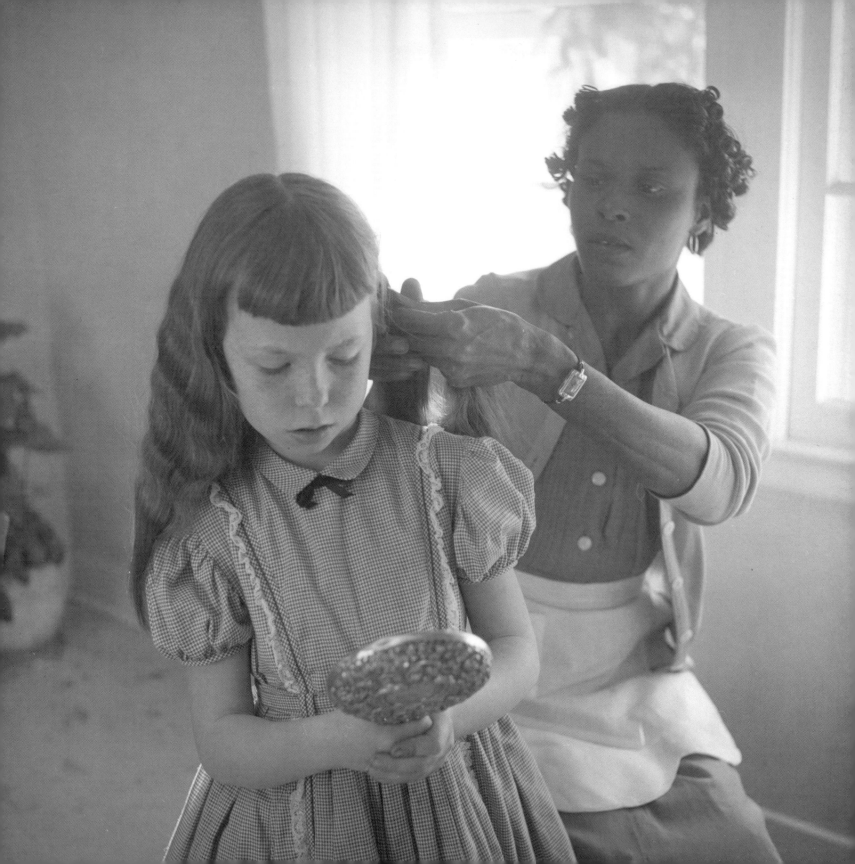

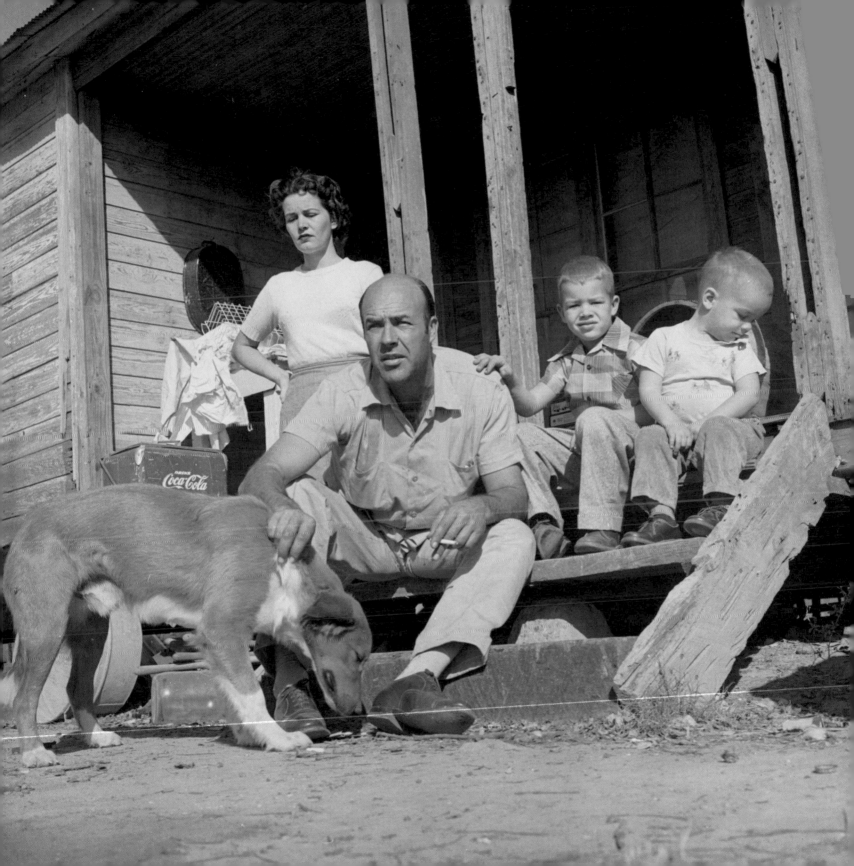

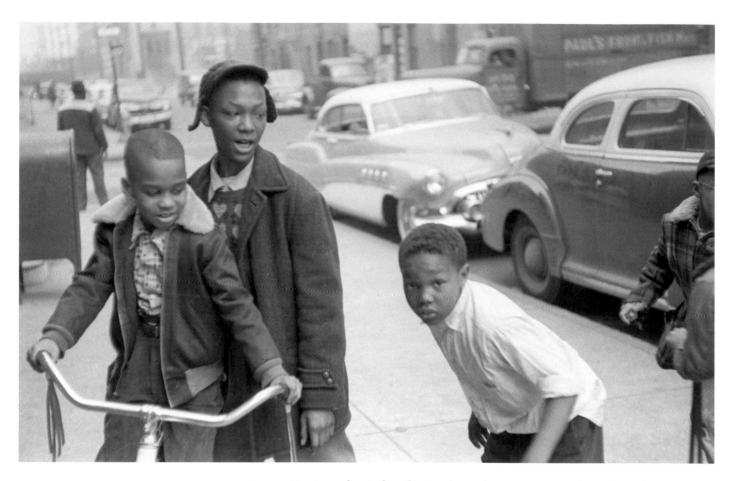

ABOVE: "Jim Crow Northern Style," in *Look*'s June 26 issue, detailed how blacks in northern cities faced discrimination, especially in housing. The feature focused on the Jackson family of Philadelphia and their eight-year-old son Douglas, seen here (left) with some of his friends.

Segregation's not limited to the South. In the nation's capital, residential housing in the suburbs is expressly for whites fleeing the city. In Philadelphia, desegregation of schools exists, but it's somehow not in the spirit of the Supreme Court decision. And the real sticking point here is housing; if a hardworking black family like the Jacksons, featured in a *Look* article titled "Jim Crow Northern Style," can't move out of the inner city to a better neighborhood with better schools because of unspoken color lines in certain neighborhoods and communities, the odds against success are long (*above*). Can Jim Crow exist north of the Mason-Dixon line and, if so, is it still Jim Crow?

In other neighborhoods in Philadelphia, kids are violating a 10:30 p.m. youth curfew imposed last year, and generally defying authority all over America. Increasingly, there are opposite poles in America: one for the parents and one for the kids, although no one knows exactly what the latter one is.

ABOVE: Even as Elvis and other rockers grabbed the spotlight, the old guard continued to make music. Singer Perry Como (center), whose career got a big boost from television, hosted bandleaders Spike Jones and Guy Lombardo in December on his weekly show. Shot in 1956, this photo was taken for an April 1957 article but never published.

This basic contrast—between past and present, between traditional and modern— exists in the performing world, too. Spike Jones, Guy Lombardo, and Perry Como all seem outmoded now that Elvis has arrived (*above*). Como in his red button-up sweater could be a singing bellhop in a twenty-year-old Broadway musical. The idea of someone dancing shirtless to a duet by him and Rosemary Clooney (who appears on his Christmas TV special) is unimaginable.

Comedian Sid Caesar reveals that success on television has its darker side (*following page, left*). Not only does he have his own show, *Caesar's Hour*, but also he has his inner demons, says *Look*, and he's undergoing psychoanalysis and talking about it. But he's always talking about something, which Crosby and Sinatra would never do. And then

OPPOSITE: Comedian Sid Caesar, starring in his second series, *Caesar's Hour*, had a new comic foil in Nanette Fabray. He confided to *Look* in an October profile that his personal life was far from amusing.

FOLLOWING PAGES, LEFT: 1956 was a breakthrough year for actor Yul Brynner. He reprised his stage role in the musical film *The King and I*, starring with Deborah Kerr and Rita Moreno, for which he won an Oscar. And he was in two other hits: *The Ten Commandments* and *Anastasia*. This shot is from a September 4 *Look* article on Moreno.

FOLLOWING PAGES, RIGHT: Judy Garland, like many old-line stars, was trying to make the transition to television. In this news photo, she's prepping with photographer Richard Avedon on a set in Los Angeles for an April episode of *General Electric Theater*, hosted by Ronald Reagan.

there are Jerry Lewis and Dean Martin, who are breaking up their funny act at last for undisclosed reasons. Their "Slapstick with Sex Appeal" shtick hasn't worn thin with fans, but the internal dynamics of a partnership have proven unstable.

Louis Armstrong steps out of a practically antediluvian past in the new movie, *High Society*, and so do Crosby and Sinatra, both in thrall with Grace Kelly, the all-American girl next door. It's a musical remake of *The Philadelphia Story*, with Kelly in the Katharine Hepburn role and Crosby and Sinatra taking the Cary Grant and Jimmy Stewart parts. By the time the movie is released in July, Grace has jumped ship from the S.S. *Hollywood* for a Monaco wedding. That event makes the movie's nuptials look second-rate, at a time when Hollywood seems as far removed from America's problems as Monaco.

Earth vs. the Flying Saucers, released the same month as *High Society*, is really out there; at the same time it is funny and weirdly disturbing. It goes nowhere in telling audiences what those UFOs might actually be, after people have been seeing something up—out?—there for years. If the movie's saucers are real, the aliens' manufacturers have really bad taste in aeronautical design.

The King and I is shaping up as a stronger box-office contender (*following pages, left*). It's about a regent—the bald Yul Brynner—who struts around in what look like pajamas while ruling an Asiatic kingdom, a kind of Siamese *High Society* that older Americans clearly love. Charlton Heston is Moses in *The Ten Commandments*, director Cecil B. DeMille's Biblical spectacle. Heston sports a massive beard and throws stuff—mainly stone tablets—when he gets mad, more irritable husband or boyfriend than prophet. Brynner's here, too, playing Rameses, the pharaoh who takes on Heston over Egypt's enslavement of the Jews. Both these movies are about men with power and not much imagination or human warmth.

Judy Garland, like many old line stars, is trying to make the transition to television. *Look* photographs her, prepping with photographer Richard Avedon for an April episode of *General Electric Theater*, hosted by Ronald Reagan (*following pages, right*). But it is Avedon acting like the star, airily waving a hand as he structures the moment. Though he's only the eye behind the lens, Judy, who ought to be soaring free for posterity, seems unsure, preoccupied with both present and future.

Meanwhile, Hal March is still asking those $64,000 questions on television every Tuesday night (*see page 174*). A lot of people want to hear answers, and all those smart-looking people in their spectacles and bowties know how to answer them. The show has inspired other popular quiz programs: *Twenty-One* pits two contestants against each other, and *To Tell the Truth* has panels of celebrities who never stop entertaining.

RIGHT: Quiz shows were all over the TV schedule, with *The $64,000 Question* ranked fourth of all primetime programs. Here, host Hal March chats with young spelling whiz Gloria Lockerman of Baltimore, who would speak that summer at the Democratic National Convention. *Look* ran a feature on March in its September 18 issue.

PRESIDENT EISENHOWER throws out the first pitch for this year's baseball season, in Washington, D.C., where the downtrodden Senators lose, ten to four, to the dominating Yankees. It looks like this sixty-five-year-old has got a good arm; the ball is high but well thrown, everybody around him seemingly happy with it. During the singing of the national anthem, Eisenhower's hat goes over his heart, and so do the hats of men as varied as our nation—except that there are no black faces in this section of Griffith Stadium.

The president's confident outfit—suit, tie, trench coat and scarf—is reassuring. He has cadres of "Ike girls" working for his reelection, and they look like door-to-door, get-out-the-vote callers who are well dressed, with bright smiles and matching campaign costumes and umbrellas: a formidable tableau of content, well-off, satisfied Americans (*see pages 160–161*).

They're one of the reasons Ike's rival in the presidential campaign, Adlai E. Stevenson again, is having trouble. He's witty enough, but it's hard to compete with an incumbent who's credited with winning World War II more or less singlehandedly, not to mention settling that mess in Korea. Stevenson supporters, in comparison, are working men in T-shirts and caps, the kind of guys who talk politics on the street (*opposite*). Ike's the

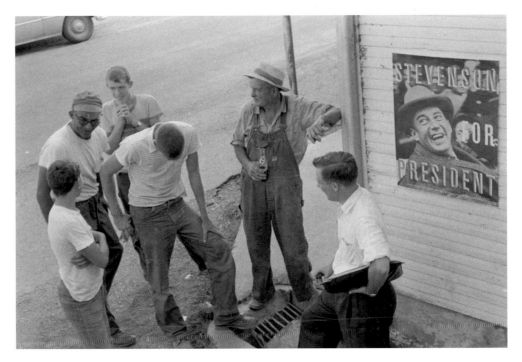

older candidate with the younger face on his campaign. Ike girls, working guys: it's all the same country, but sometimes it doesn't feel that way. Voters are going to have to decide if they want the "in team" to stay in charge.

BOB'S BIG BOY is Los Angeles's number one drive-in restaurant (*see page 12*), but it has competition. Young men and women, sometimes on roller skates, bring hamburgers and fries to the hungry. At the Pantorium Drive-In Cleaners the same model Dodge is getting serviced, the wafer-thin proscenium held up by spindly steel bars like those lofting the sign into the clear blue sky (*following pages, left*).

This is what California's all about, or seems to be about: mobility, convenience, and a sense that everything here is one step ahead of everywhere else. People are eager to go there—or really, anywhere—on Ike's new interstate highway system. Endless good roads and cheap gas mean Californians and all Americans can not only eat but also shop in places like Santa's Village, a fake frosty chalet in the San Bernardino Mountains backed by towering conifers, and attend air shows and barbecues, all in places beyond what were once the limits of cities.

RIGHT: Cover of *Look*, November 27, 1956.

OPPOSITE: On assignment for a September 18 article on Los Angeles, *Look* photographer Maurice Terrell shot the latest California phenomenon: a drive-in dry cleaning establishment with the hip name Pantorium.

Disneyland must represent the best of this open-air, year-round fantasy. It's located south of Los Angeles, in Orange County's Anaheim, whose population during this decade will explode from 14,556 to 104,184. Ride in a spinning teacup, all sun and fun, with a recasting of the past—both Europe's and America's—and a bright, unsullied future full of cartoon characters and those instant castles and marching bands seemingly unaffected by violence or rock and roll.

This idealized vision of America doesn't jibe with the photographs of severe drought in Texas, a continuation of the catastrophe *Look* photographed in 1954, or for that matter with the aging comedians, movie stars, artists, and writers who are supposed to entertain and inform us. Ernest Hemingway, who has chosen to live in Havana, Cuba, instead of here, is a self-imposed exile who largely created the now outmoded notion of the writer as a man of action. Buoyed by his 1954 Nobel Prize but battered from several bad accidents, he's still catching big fish and writing books, checking his weight and blood pressure daily, and looking up at the heads of Cape buffalo he killed in Africa. But his world has been overtaken by atomic war and television, by black athletes such as the seven-foot-tall University of Kansas sophomore Wilt Chamberlain, by advanced medicine—alcohol's not the only easy treatment for depression these days—and by computers that could make the act of writing on a typewriter obsolete.

Also by women writers. Hemingway's writer as a man of action may be replaced by a woman writer interested in another kind of action. Grace Metalious's steamy debut novel, *Peyton Place*, is a big national best seller in the fall of 1956 (*opposite*). In it, people involve themselves in illicit activities—including out-of-wedlock sex, and even adultery. The novel is bought by thousands of Americans eager to read it and be shocked, even after President Eisenhower signed legislation authorizing "In God We Trust" as the national motto.

Another best seller, *The Organization Man*, suggests that an equally good motto might be "In Corporations We Trust." Organized big business now comes as close to civic religion as anybody living in America has known. Corporations, too, set themselves above criticism, says author William H. Whyte, with their own standards of behavior, truths, and aspirations. Believe, big business seems to be saying, because if you don't, you'll never get to Disneyland.

The year's bestselling novelist was an unlikely literary figure: inelegant small-town New England housewife Grace Metalious, whose *Peyton Place* was steamy stuff. The story became an Oscar-nominated film as well as a prime-time TV series. *Look* photographed Metalious in 1957, the year the movie released.

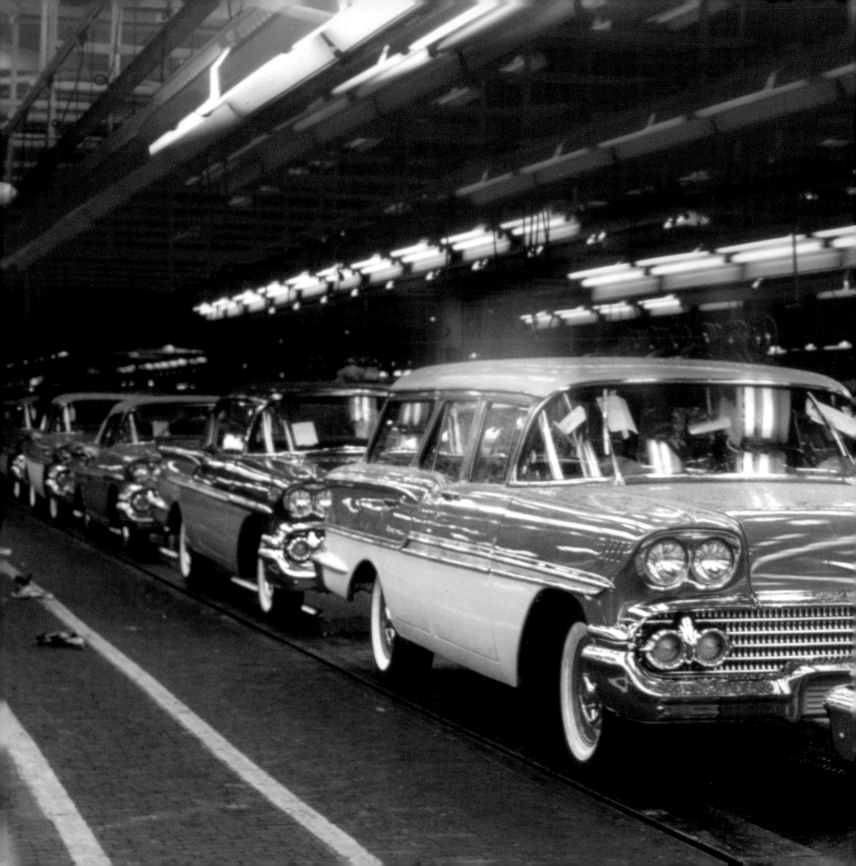

1957

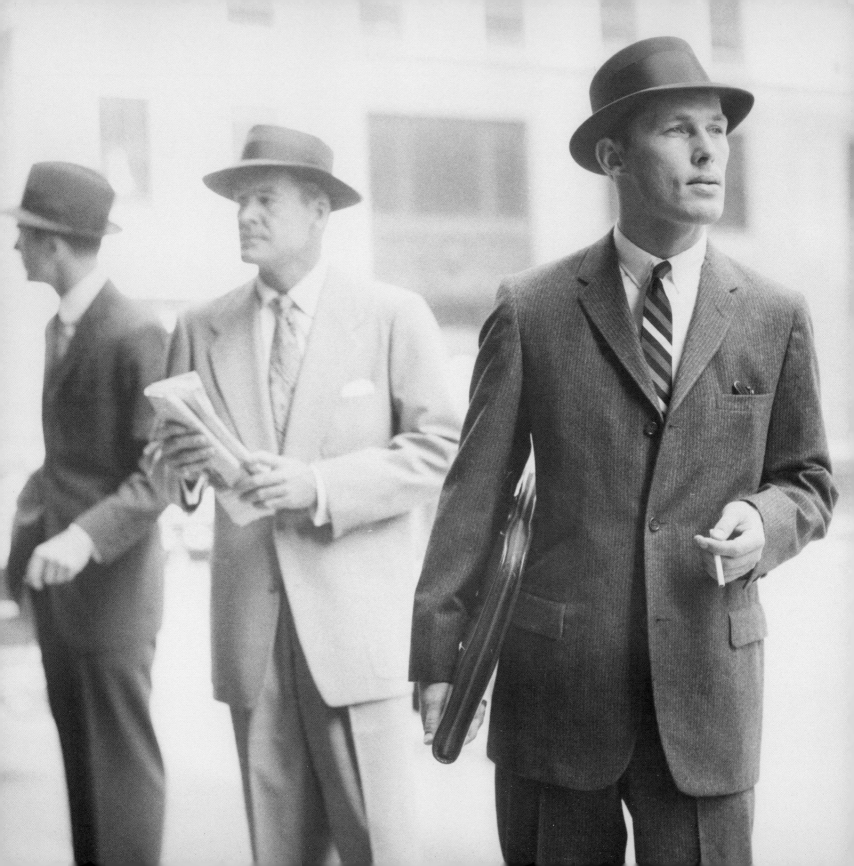

The Things You Used To Do

" . . . And this mess is so big
And so deep and so tall,
We cannot can not pick it up.
There is no way at all! . . ."
—Dr. Seuss, *The Cat in the Hat*

STILL PLENTY OF HATS ON MEN, but there's a change of demeanor from that of 1954 in those wearing them (*see page 23*). Now they're looking up, for one thing, like they just discovered the sky (*opposite*). Not with soaring spirits, though, but with a more sober appraisal of their place in the sun and an awareness that, if trouble comes from any quarter, they're up to it. Cigarettes in hand, more tightly buttoned into dress shirts and three-button jackets than ever, the ideal American male: part intrepid G-man, part hard-headed chief executive.

The uniformed carhop in the Houston drive-in, where air conditioning's pumped into your car while you wait for your food, looks military (*following pages, left*). She's even got epaulets. It seems there are martial styles for girls these days, like the female "middy look," which is modeled on men's naval uniforms (*following pages, right*). In case we miss the point, lots of swabbies are stationed around that pretty brunette in her flared,

PREVIOUS PAGES: *Look* marked General Motors' fiftieth anniversary with a lavish spread, much of it in color. Some of the photography of the assembly line was more impressionistic than representative. Philip Harrington shot this portrait in 1957; the magazine ran the article in January 1958.

OPPOSITE: *Look* did run the occasional feature on men's fashions, though the magazine's eye was nearly on always on women's clothes. "Is Your Wardrobe Up to Date?" asked the magazine of its male readers in October, offering tips on how to make it so.

ABOVE: Air conditioning was becoming more of a necessity than a luxury. A profile of a Houston family for an article in the July 23 issue demonstrated how a drive-in restaurant actually pumped cooled air into their parked car.

OPPOSITE: For a women's fashion shoot titled "Summer Clothes Go Nautical" in the May 28 issue, *Look* boarded the destroyer USS *Maddox* with a model and posed her with a complement of real-life sailors.

pale-blue skirt with a sailor's collar and scarf, posing for a promotional photo that also stars a real naval destroyer. The overall impression—model, sailors, ship—is of a world scrubbed clean and bright in the sun, like our republic sailing confidently on the shared strengths of convention and technology, its destination as yet unannounced.

EYES TURN AGAIN to younger Americans who can decide to grow up and act like executives and housewives, or like Elvis or one of those beatniks described in that new novel *On the Road*. Can adults make a difference? The question includes the role of schools, and what it should be. Answering is harder than it should be. Parental involvement can make a difference; so can adult example, although that's not what is getting talked about these days.

A teacher succeeds admirably in getting kindergartners interested in brushing their teeth, but all those proud, eager, open mouths have to be filled for a lifetime, which means working and having families of their own. Nothing gets to us like the idea of a kid

ABOVE: Disruptive childhood behavior was no longer chalked up to "boys will be boys," as scientific tests measured brain waves to locate organic reasons for tantrums and aggression. "Children in Search of Sanity" ran in the May 28 issue.

with "problems," like the boy getting his brain waves checked (*left*). He's cute, well fed, unruffled, but he does look a little apprehensive about the procedure. He attacked a classmate after some disagreement and nowadays, what was once considered normal, is deemed "disturbed."

Is it his fault, or his parents'? Nobody seems to want to talk about that. They're looking for some third source of problem behavior. And if we are to believe that kids want to do what's right, why do so many end up doing what isn't? *Look*'s "How Teenagers Live" should offer some insight, but the photos just show a lot of kids walking around in school yards and leaning on each other, and guys whispering over gals' shoulders in class and putting things into their hair. However, when they get into cars, there's a change. They "make out," perhaps innocently, but there are deeper urges there and nobody's talking much about those, either.

ONE URGE, AMERICANS ARE REMINDED, IS HATRED. The Supreme Court has ruled that black kids may go to school with white kids, period. In the South, the custom "separate but equal" has been paid lip service with a culture of distinct schools, though with vastly different resources. But when authorities try integrating only nine students into the all-white Central High in Little Rock, Arkansas, all hell breaks loose.

A mob of more than 1,000 people surround the school, screaming insults at the black girls and boys, who have to be ushered inside by soldiers. Among the hecklers, belligerent and defiant, are teenagers, nothing new there. But the faces of the white adults shock, especially those of the women.

A young housewife in a nice dress and a military cap holds a limp Confederate flag (*opposite*). Both she and the white-haired matron next to her oppose integration, whether or not it's the law of the land; and the photographs of the Lemon family as part of what they themselves casually call "the mob" reveal little more, only that they distrust outsiders and have an implacable resistance to change.

The photo of the imperial wizard of the Ku Klux Klan in Atlanta, Georgia, is more laughable (*opposite*). How can a grown man standing in his own living room in what looks like an elaborate satin bathrobe—complete with mystical medallions and sleeve stripes—wearing a peaked cap with tassels on it, think that he looks anything but ridiculous? Why isn't some expert asking if he's "disturbed" and trying to measure his brain waves?

RIGHT: The Lemon family of Little Rock, Arkansas, met attempts this fall to desegregate Central High School with taunting and threats. They proudly called themselves "the mob," letting their names be used and their photos taken by *Look*'s John Vachon for the November 12 issue.

BELOW: Resisters to court-ordered integration included the Ku Klux Klan, and *Look* profiled the Klan's Imperial Wizard Eldon Edwards in his Atlanta home for the April 30 issue. This photograph was never published.

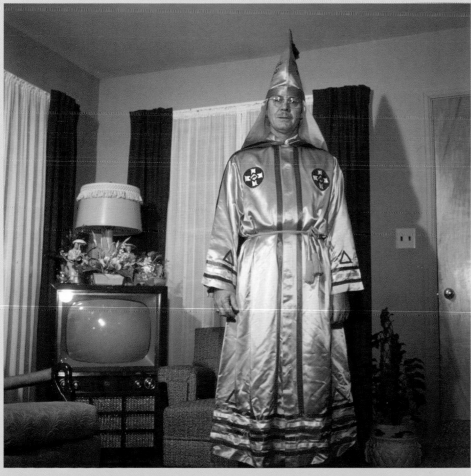

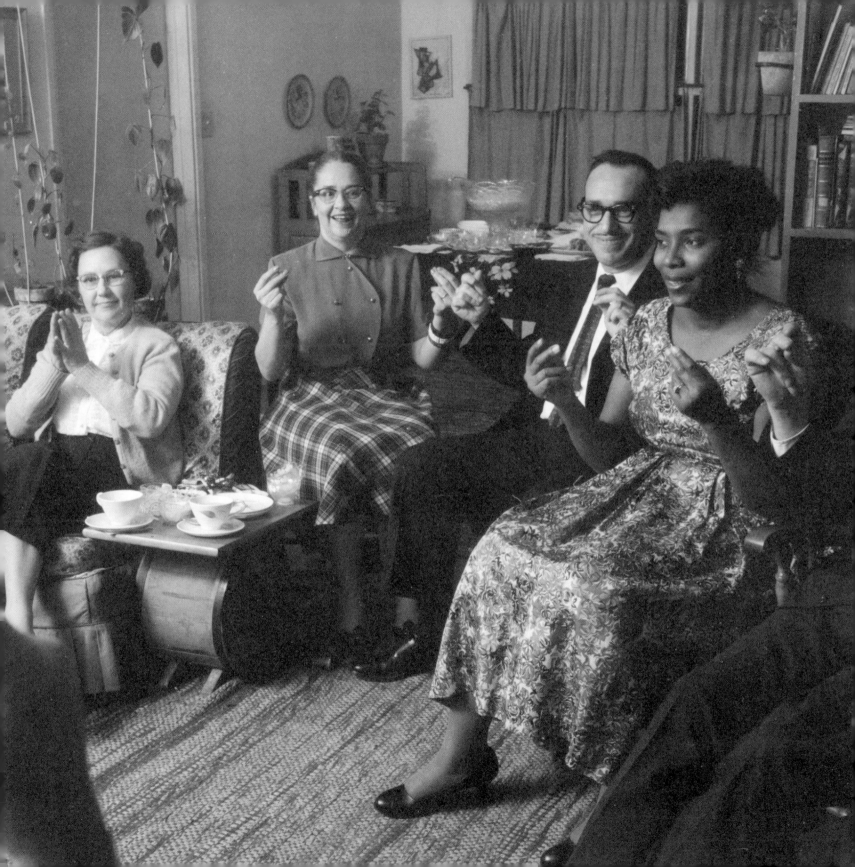

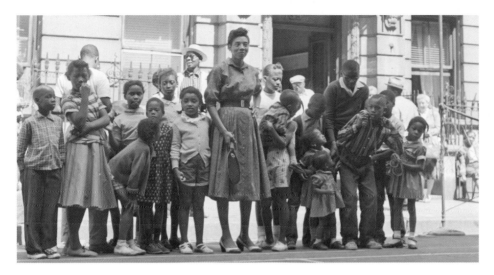

ABOVE: Black tennis star Althea Gibson made history by winning both Wimbledon and the U.S. Open, and she was just as graceful on the streets of Harlem with a group of young fans. *Look* ran a feature on her in the November 12 issue.

OPPOSITE: The planned suburb of Levittown, Pennsylvania, was a scene of tension when William and Daisy Myers became the first African American couple to buy a house there. *Look* recorded this nevertheless congenial-seeming occasion in 1957 with some of the Myers' new neighbors. The article did not run until the following August.

Could the imperial wizard, like those Little Rock housewives, be affecting unruly teenagers in the South, and elsewhere?

IN MAY, THERE IS A PRAYER PILGRIMAGE FOR FREEDOM at the Lincoln Memorial in Washington, D.C., featuring the black singer with the big voice, Mahalia Jackson, and the Reverend Martin Luther King Jr., who makes his "Give Us the Ballot" speech. Two weeks before Little Rock explodes, the first civil rights legislation since Reconstruction passes in Congress, despite a thirty-hour filibuster conducted by Strom Thurmond, a South Carolina senator and a 1948 Presidential candidate for the short-lived Dixiecrat party. In the aftermath of Little Rock, segregationists are picketing the White House, but it's clear a page has turned. *Look* features no fewer than ten stories this year on race relations, and a staff photographer drops in on the first black family to move into the famous housing development, Levittown, in Bucks County, Pennsylvania (*opposite*). They have been invited to a tea party in a neighbor's living room, which looks friendly enough. But what's that game they're playing?

A page has turned, but there are many chapters yet to go. African Americans still encounter racism in northern cities. If it wasn't for the example of success in sports and other professions, they would be having a tougher time. It's hard even for racists to bet against a graceful tennis player like Althea Gibson, the first African American to win championships at Wimbledon and at the U.S. Open (*above*).

Harry Belafonte is talented, popular, and good-looking. He poses for *Look* with his white wife; in his new film, *Island in the Sun*, he's romancing white actress Joan Fontaine. And the chief counsel for the National Association for the Advancement of Colored People, whose offices are being attacked around the South, is tough and effective. Thurgood Marshall, who successfully argued before the Supreme Court in Brown v. Board of Education, looks like an adult, which is more than you can say for the guy in the Klan bathrobe.

PLEASE REPLACE DIVOTS		1	2	3	4	5	6	7	8	9	TOTAL		10	11	12	13	14	15	16	17	18	TOTAL	GRAND TOTAL	SECOND NINE	NET
FRONT TEE		399	450	136	419	360	390	395	177	441	3167	FIRST NINE	446	161	273	335	148	375	417	395	412	2962	6129		
BACK TEE		427	496	167	439	400	428	419	202	471	3449		496	190	306	378	164	409	460	424	428	3255	6704		
PAR		4	5	3	4	4	4	4	3	5	36	±	5	3	4	4	3	5	5	4	4	36	72		
STROKES	+−	3	7	17	1	13	5	11	15	9	OUT		8	16	14	12	18	2	6	10	4	IN			
D.W.E	✓	4	7	4	5	5	5	6	3	5	44		5	4	4	3	5	5	5	5					84
Sen Bush		5	5	3	4	5	4	5	4	5	40		5	4	5	4	3	5	5	5	6				82
Kishi		6	5	4	6	6	6	5	6	50			7	5	5	6	4	4	7	5	6				99
Matsumoto		6	6	4	7	4	5	5	4	6	47		6	4	5	7	5	6	5	5	5				95
TOTAL													−1	0	−1	0	+1	+3	+2	+2	0				
LOW BALL						+4	+2	+2	+2	−	−														

THE PRESIDENT TRIES TRAVELING IN A HELICOPTER for the first time. It lands on the south lawn of the White House, and may eventually deliver him to the Burning Tree Country Club, in suburban Maryland, for a round of golf. Completing his June 19 foursome is Senator Prescott Bush of Connecticut—politics is part of every game in Washington—and Nobusuke Kishi, the prime minister of Japan, and his interpreter. The scorecard shows that Ike's no embarrassment on the links (*above*). Back in Washington, Mamie's wearing a beaver coat given to her by the Maine Trappers Association; the Eisenhowers are, by their very natures, immune to favoritism and political graft, or so it seems.

"The Big Change in Richard Nixon," says *Look*, is his increased confidence, despite the fact that Ike doesn't seem to like his vice president much. Nixon's smiling, though, and relaxed with his family at the outset of his and Ike's second term (*opposite*). He's taken an interest in foreign policy, which is good training for a president in case Nixon decides to run in 1960 as the Republican nominee, which seems likely.

The Democrats are looking over Ike's shoulder, too, particularly the Kennedy brothers: Jack, Bobby, and Teddy (*following pages, left*). Theirs is a big, rich, ambitious family and few can compete with their blessed aura of good fun and happiness. Senator Jack's career is enhanced by his wife Jacqueline's assertive good looks and sense of humor to match. But Jack can handle her, and a football, and his role in Congress. His daddy's wealthy, a former ambassador to Britain whose sons seem to know more about most things than they let on.

One of those things might be who's going to be the next president of the United States and what that might require of the handsome, tanned, enigmatic Jack. But Bobby seems the tougher, more daring one, a lawyer advising the Senate select committee

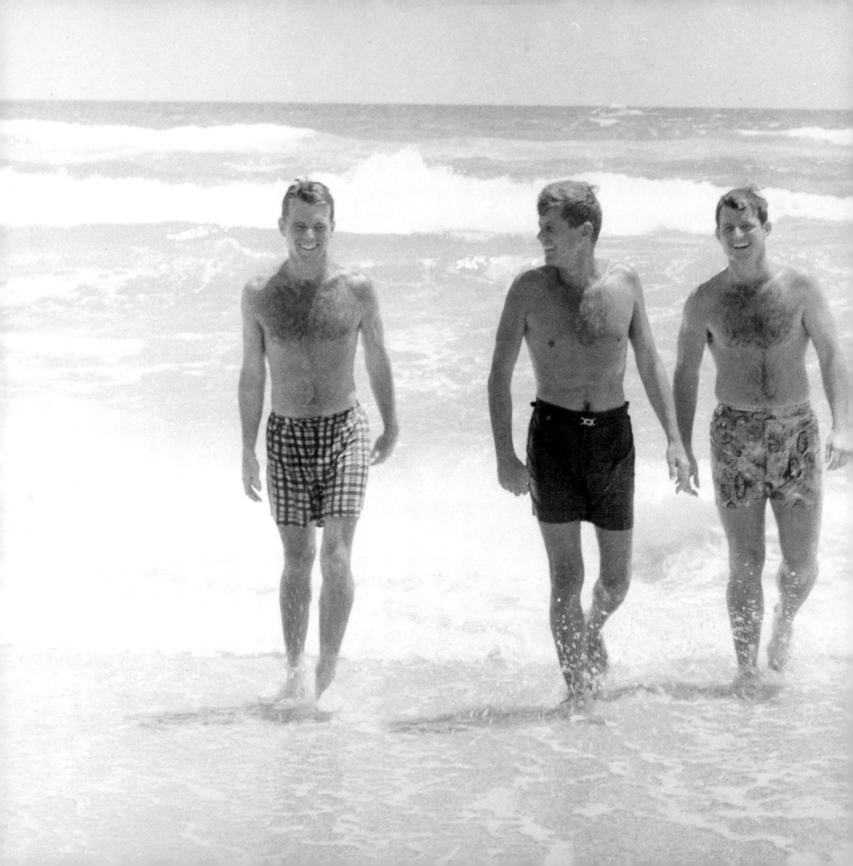

investigating organized crime in labor unions. The head of the American Federation of Labor-Congress of Industrial Organizations, George Meany, is not happy to be testifying, but Jimmy Hoffa, the newly elected head of the Teamsters, is even less pleased. The connection between his scowl and all those haulers on America's highways is hard to make.

BRITAIN'S RULING COUPLE, the Windsors—Queen Elizabeth and her husband, the Duke of Edinburgh, tough customers if *Look*'s cover photo's any indication—is touring the former colonies (*below*). She has her work cut out for her, being nice all the time, which is apparently what queens do all day. Still, we're partial to royals, even descendants of the ones we kicked out.

The idea of Grace Kelly, married last year to the prince of Monaco and now a princess, or a family like the Kennedys, who approximate royalty, excites. Shots of the queen smiling, like the one of her at a University of Maryland–North Carolina football game, is more reassuring—she's not exactly one of us but she's close enough.

Sophia Loren graces the cover of *Look* (*following pages, left*), as Hollywood stars do, but she looks different. Maybe because she's Italian and new to the practice of making films in America. Is she sad, or bemused? Most actresses would be ecstatic to pair in a single year with a craggy John Wayne (*Legend of the Lost*), panting Cary Grant and Frank Sinatra (*The Pride and the Passion*), and pretty Alan Ladd (*Boy on a Dolphin*), but her slight, gorgeous smile's noncommittal.

INSIDE THE N.A.A.C.P. NEW HOPE FOR ACNE VICTIMS

LOOK

20¢ AUGUST 6, 1957

THE AMERICANIZATION OF SOPHIA LOREN

ABOVE: Sophia Loren on the cover of *Look*, August 6, 1957.

OPPOSITE: Only nineteen years old but already a veteran of more than two dozen films, Natalie Wood returned, for a photo shoot, to Los Angeles's Griffith Observatory, an iconic location in her 1955 breakthrough, *Rebel Without a Cause*. Maurice Terrell photographed her for the June 25 issue.

Is she laughing at American men? Or is she just bored in some incomprehensible European way that we find a bit annoying —even while we're falling in love with her?

Compared to Sophia Loren, Natalie Wood looks underage (*opposite*). (She's only four years younger, nineteen to Loren's twenty-three.) But then her pose for *Look* in front of the planetarium in Los Angeles, where two years ago, the knife-fight scene was filmed for *Rebel Without A Cause*, reminds us that most popular American actresses look—and often act—like teenagers.

A television show wraps up two American male icons—the cowboy and the stern but fair father, or in this case, father figure— into one character: Marshal Matt Dillon, played by the very tall James Arness. It's called *Gunsmoke* (*following pages, left*). Now in its third season, it's number one in the ratings, almost a Wild West show, with a hotel bar as its gathering place, presided over by a "hostess" named Kitty, a woman of ill repute, although that's never spelled out.

You can watch everything now on pay TV, just by dropping a coin in the box on top of the set. But doing that suggests you can't afford a set of your own, or you are in a motel somewhere and don't want to miss anything. Because it's all on television now.

To be without a television is to be outside the culture, whether it's smart aleck Jack Paar hosting *The Jack Paar Tonight Show* with strange, fascinating characters including Jonathan Winters of the rubber face (*see page 198*); or Danny Thomas beating that dying horse in *Make Room for Daddy*; or Lawrence Welk and his bubbly music from some mythical place halfway between America and the Alps (*following pages, right*).

You can bet the kids aren't watching Lawrence Welk, not if they have a chance instead to catch Chuck Berry singing "School Day (Ring Ring Goes the Bell)" or "Rock and Roll Music" on that teen dance show out of Philadelphia, *Bandstand* (*see page 199*). He's real in a way much of America doesn't often see, whether we're decrying the Soviet launch of their space satellite, *Sputnik*, or worrying about Red China.

Ayn Rand, in her fattest novel yet, *Atlas Shrugged*, speculates about a future American dystopia, in which the makers go on strike because they're tired of paying taxes and supporting the takers. And Vance Packard says in *The Hidden Persuaders* that advertisers warp our minds, conning us into buying products we don't need or even want.

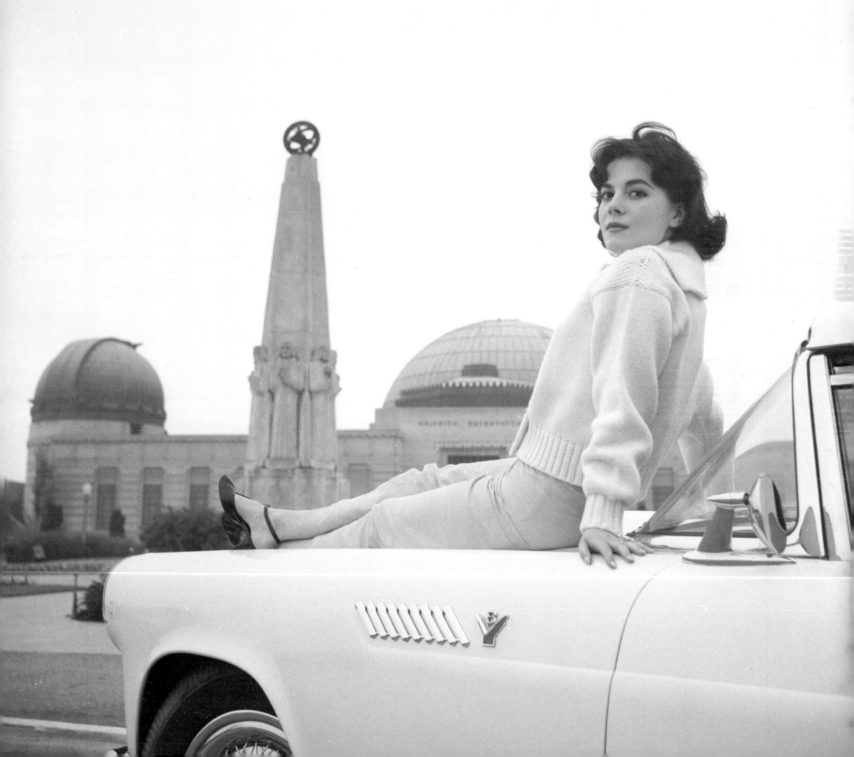

PREVIOUS PAGES, LEFT: James Arness played Marshal Matt Dillon in *Gunsmoke*, the top-rated TV show from 1957 to 1961. The program went on to become the longest-running primetime drama, far outlasting its numerous Western competitors from the decade. *Look* took notice early on, running a feature in the October 29 issue.

PREVIOUS PAGES, RIGHT: "Nobody likes him except the public," *Look* declared in its June 25 issue on Lawrence Welk, shown here with the Lennon Sisters. Beginning in 1955, Welk's TV show would be, for the next twenty-seven years, a haven from the cacophony of rock and roll, soul, disco, and punk.

RIGHT: On July 29, Jack Paar took over as host of *The Tonight Show*. Over his five-year run, Paar made the late-night talk show an important feature of the TV landscape with a mix of guests: entertainment regulars like comedian Jonathan Winters (seen here) and more "serious" figures including William F. Buckley and John F. Kennedy. *Look* photographed Paar in 1957 for a feature that ran in January 1958.

OPPOSITE: If Elvis was the visual embodiment of early rock, Chuck Berry, seen in this 1957 news photo, was its first true poet, seemingly effortlessly spinning out songs of thwarted love, teenage angst, and hot cars.

But those books can't compete with "Maybellene," Chuck's first hit, with its powerful narrative and underlying hint of betrayal, loss, and pursuit—the classic elements of literature and drama. And of *Gunsmoke*, too, come to think of it.

GENERAL MOTORS' AUTO-ASSEMBLY PLANT is a dream factory: onto a dreary industrial assembly line slip beautiful, sleek metallic shells with bright engines with unlimited power hidden inside, along with comforts for drivers and passengers imagined by engineers with nothing else to do (*see pages 180–181*). But the real attraction is the freedom the new cars represent, both to roam at will, in style, and to drive up the highway ramps and forever up the scales of success and gratification.

The lines of those Chevys are so clean and forward thrusting. How could anybody, wherever he or she happens to be, own and drive one and not feel bound for something better? Little changes in the latest models are noticed and discussed, the yearly unveiling of new cars still the closest thing we have to a national, shared aesthetic. Even the taillights, driving away, offer promise, their precise, colorful contours winking on in a happy farewell.

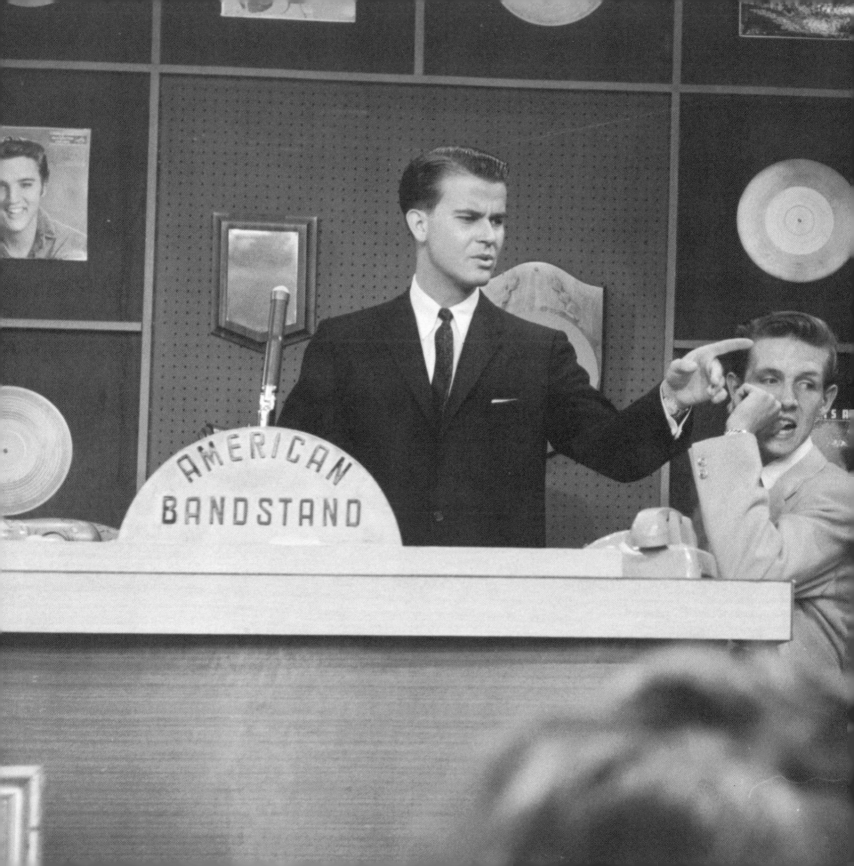

1958

Light, Cheap, Everlasting

"And this is the only immortality you and I may share . . . "
—Vladimir Nabokov, *Lolita*

PREVIOUS PAGES: *American Bandstand*, with host Dick Clark, quickly became teenagers' favorite after-school entertainment, airing at 3:30 p.m. They could watch their peers in Philadelphia dance to the latest hits and their favorite artists lip-synch those songs. *Look* got to the party a little late, not running an article on him until November 1959.

OPPOSITE: Jerry Lee Lewis (on the right in this news photo) was one of early rock's true originals, a dynamic performer and songwriter. But 1958 proved a watershed year for him when it was revealed that he had married his thirteen-year-old cousin. Bookings, including on *American Bandstand*, quickly dried up.

AMERICAN YOUTH IS NOW SPLIT into two distinct groups. One represents its parents' generation: the boys wearing suits, ties, trousers with little buckles in the back that are useless but all the rage; and the girls, full skirts, high heels, and perms. Their televised avatar is twenty-eight-year-old Dick Clark, so clean-cut he looks processed (*previous pages*). His show, *American Bandstand*, is a throwback to the big band era. The kids dress up, they dance politely, they are respectful of their genial host. He seems more comfortable playing songs like the Everly Brothers' "Bye Bye Love," a song with a strong beat but lacking the dark, soulful anarchy of a song by Elvis or the mayhem gleefully perpetrated by Jerry Lee Lewis (*opposite*).

Now, Lewis is another bizarre white phenomenon out of the South. Jerry Lee, squatting on his piano and assaulting the keyboard backwards, howling, driving kids wild, is like someone out of a parent's nightmare titled "Bad Influence." When it comes out in the fall that Jerry Lee has married his thirteen-year-old cousin, it doesn't sit well with the public, or with the authorities, either. Maybe there's an object lesson in all this, but what is it exactly? That statutory rape's a new kind of nose-thumbing at tradition?

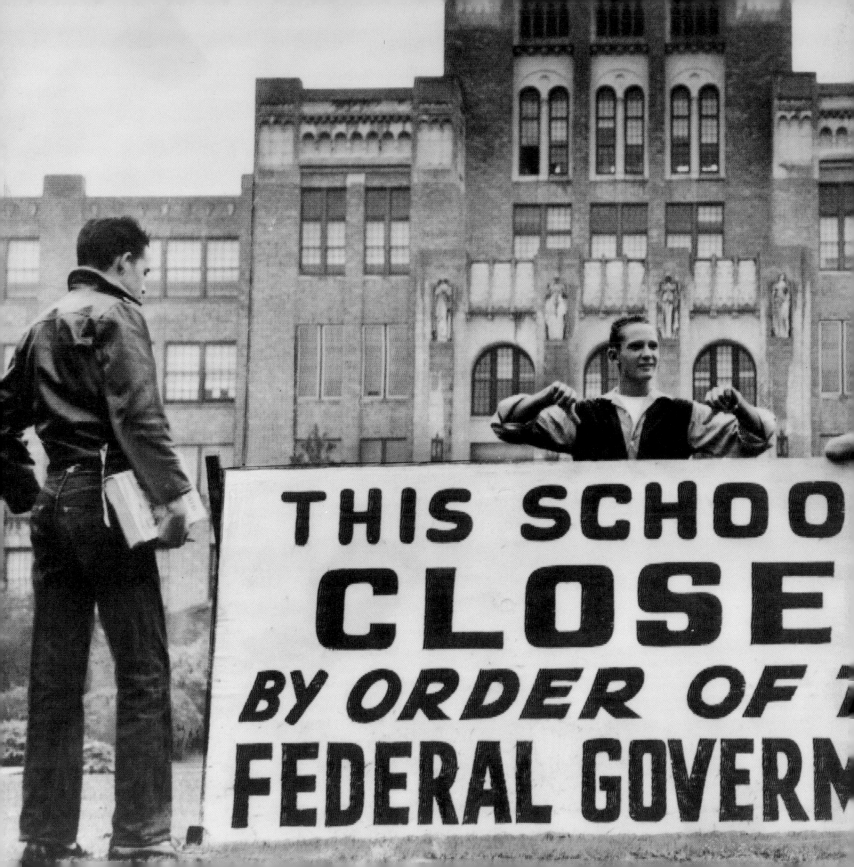

LITTLE ROCK CENTRAL HIGH SCHOOL has been closed, after all the trouble with integration last fall, by order of Governor Orval Faubus (*opposite*). The future of its black students in America's own new revolution isn't clear, or much else about it for that matter. Who set up that sign on the wet pavement outside Central? Was it the federal government, the school board, or pro-segregation protesters? That huge facade in the background looks forbidding, a citadel housing the past. And Governor Faubus is holding up his own sign, a blowup of a ballot opposing integration. His dead eyes and peculiar expression suggest that he hasn't figured all of this out yet, including how to escape from his predicament.

The first African American to graduate from Central High School (in May, before the shutdown), Ernest Green, wears a skinny tie with a very white shirt and holds his shingle gingerly (*below*). It's proof that he made it through, but does he think it was worth all the trouble? He looks exhausted and so does his mother, but she's proud, too, something that can't be said for the squinty-eyed policeman in the background. The most revealing thing in the photograph is the left eye of the black student directly behind Green, which is wide and fearfully focused on the cop.

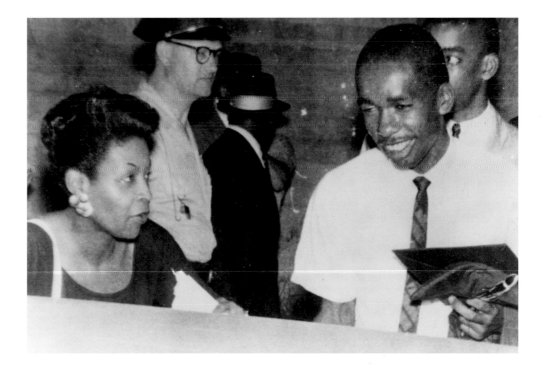

PREVIOUS PAGES, LEFT: Little Rock Central High School, after a tumultuous year of integration, was closed by Governor Orval Faubus just before the 1958 school year began, sparking a protest captured in this news photo. In the summer of 1959, a federal court ordered it reopened.

PREVIOUS PAGES, RIGHT: In June, Ernest Green (on right in this news photo) became the first black graduate of Central High, before the Faubus shutdown that began the so-called "Lost Year," as all four of the city's high school were closed to students.

In Atlanta, blacks are signing up to vote, getting instruction in what looks like a classroom. Mississippi's requiring new voters to take a test to qualify, an earnest, orderly process. But why aren't there any white people sweating over those questions, and how would they do on that test if they were forced to take it to cast a ballot?

Americans elsewhere get the feeling that something's not being revealed about segregation down South, that there's something more. And the South's not the only part of the country where blacks are having trouble being accepted.

Up in Harlem, people cling to a high meshed-wire fence as if arrayed in flight from the stark realities on the ground (*following pages, left*). Those hopeless streets are difficult to pinpoint in time—except for a photo with a late-model Buick—as if they had been captured during a revolution in a different country, in a different century. It's cold; that much is clear, the kids peering into a car window the only warmth, human or otherwise. Those hopeful grins make optimism at least possible against a backdrop of the dreary, black-and-white landscapes also found in Chicago and even in Washington, D.C.

THEY'RE CALLING IT A REVOLUTION but against what, exactly? Cuba's practically a part of the Florida Keys, or at least that's the way most Americans think of it, liberated from Spain by Teddy Roosevelt and his Rough Riders in 1898 and mostly forgotten after that, except as a place to party and buy cigars.

This current struggle alarms, because the rebels look like they mean business, with their shaggy beards and mustaches and long hair, standing around under thatched roofs in old military jackets and suspicious-looking berets (*following pages, left*). A *Look* reporter, Andrew St. George, tells of the rebels who are executing locals accused of crimes by their fellow villagers.

The surrounding jungle can't camouflage their accomplishments. What look like hunting rifles were used to bring down troops loyal to longtime dictator Fulgencio Batista. There's something disturbing about their certitude, as if they're beyond argument. They want land for the people, they say, but would they pass up all that money and glitter down in Havana, too? Would they take over American investments on their big, green island?

The rebels' leader, Fidel Castro—tall, borderline arrogant—isn't in the mood for compromise and looks like he might never be. (And on the last day of this year, Batista does flee the island, leaving a void for Castro and his followers to fill.)

One thing is sure to endure: the Mafia. Despite all the hearings in Congress over the years, organized crime still seems to have a hold on labor unions. Jimmy Hoffa, the new president of the Teamsters, is said to be connected to gangsters (*left*). Although nobody's ever proved it, Hoffa has the stereotypical slicked-back hair and—what else? Thick wrists and lots of confidence. The rumors persist, and the AFL-CIO threatens to expel the Teamsters unless Hoffa resigns. To no one's surprise, he refuses.

Labor problems persist in the Midwest, too, where an unemployed steelworker lives his own private recession. The mood in the photos featured in Look's article "One Man's Recession," is one of resignation, not defiance. In one photo, the guys in line waiting for work (or claiming unemployment insurance) look decent and concerned about their place in the economy and the country (*below*).

In Detroit, the heart of the car industry, some factories are shutting down. Talk nowadays is about reducing the size of American cars, probably influenced by the growing popularity of small European makes such as the Volkswagen Beetle. But foreign cars of any size are bound to take away jobs from Americans here at home.

RIGHT: Cuban rebels, led by Fidel Castro, appeared in the February 4 issue, thanks to intrepid journalist Andrew St. George, who was imbedded within their mountain camp. By year's end, they would be marching in triumph into Havana.

OPPOSITE: In February, *Look* ran "This Is New York: Behind New York's Facade," offering a less glamorous view of the Big Apple. Included were photos by Paul Fusco of street scenes in Harlem.

FOLLOWING PAGES: James Garner played a new breed of TV cowboy, Brett Maverick, a gambler who would rather draw cards than his gun. In its second season, *Maverick* overtook both Ed Sullivan's and Steve Allen's variety shows in the Sunday primetime ratings. *Look* sent photographer Maurice Terrell to the set for a September 16 article; this picture was never published.

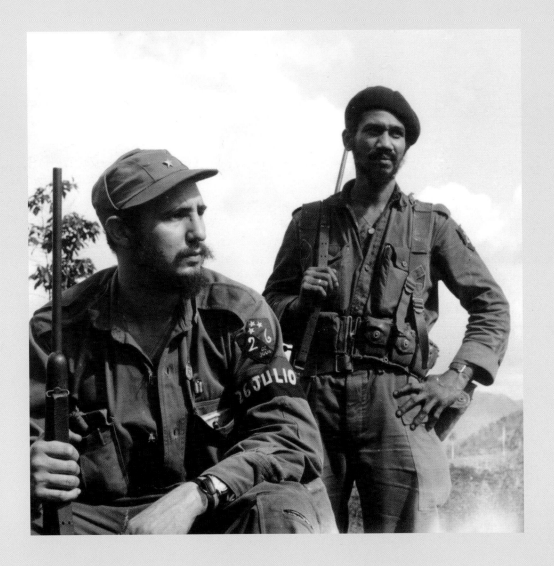

Texans are souping up engines and going to football games en masse and marching in the University of Texas Longhorn Band with a drum so big it requires six men just to move it: Texas on wheels. Everything about the place—cheerleaders, oil depots, kids fishing in a swamp, horses, saddles, oil derricks, even a guy in a hard hat—suggest a civilization unto itself and proud of it (*following pages, left*). A lot of talk about Texan culture and independence, but shouldn't somebody be talking about all the federal dollars being pumped into the state?

Cowboys are as popular on television as they are in Texas. James Garner, from Norman, Oklahoma, plays the lead in *Maverick* on Sunday nights on ABC, which is shouldering aside CBS's *The Ed Sullivan Show* and NBC's *The Steve Allen Show* in the ratings (*opposite*). The Wild West seems to extend even to quiz shows. It turns out that some contestants, on programs from the low-rent *Dotto* to the high-end *The $64,000 Question*, know the answers to the questions before they are asked, which is the equivalent of outlaws holding up the bank of believability.

This scandal could knock that whole idea of quiz shows off its horse.

MORE PEOPLE, BLACK AND WHITE, are moving north from Dixie, where the quality of life's deteriorating. Many farms are drought stricken, and industrial jobs, when you can get them, don't pay a decent wage. The whole region appears to be devastated in *Look*'s photographs for its article on "The Shrinking South." In one photo featured, a guy in a cowboy hat seems to be hiding behind a post, probably out of work and ashamed of his surroundings (*following pages, right*). The long shadow of the walker on the deserted road seems to point to more of the same.

There are pockets of prosperity, though, such as Cocoa Beach. Once a sleepy town on the Florida coast, it has been transformed by the budding space program, its growth (a 1000-percent population increase between 1950 and 1960) stimulated by the Soviets' launch last year of Sputnik. There's nothing like government money, and lots of it, to perk things up. A rocket-supporting platform looks pretty rickety, and like the model on the table, the whole operation has a kind of seat-of-the pants feel, with guys standing around waiting for somebody to make a decision (*see page 214*).

Elsewhere in Cocoa Beach, people are going to the beach and partying, touched by an enthusiasm that, once you consider the real possibility of space exploration, is catching. A few years ago that notion would have seemed preposterous, but now the idea of

ABOVE: One exception to *Look*'s view of the contracting South was Cocoa Beach, Florida, home to the nascent space program. Propelled by the January launch of America's first successful Earth satellite, planning was underway for future ventures, as with the satellite model on this makeshift table. *Look* reported on the town's boom times in its June 24 issue.

touching the heavens, encouraged by the January launch of Explorer I, the first American earth satellite, is at least imaginable.

Many of the workers at the Cape Canaveral space facility are living in trailers and motels, temporary quarters before a housing boom gets underway. A sign on a motel—Starlite—promises something just beyond our reach.

THE UNITED STATES MAY BE LAUNCHING SATELLITES, but down on the ground, designers are working at the edge of something hard to define. In "the Age of Plastic," they're building entire houses out of the stuff, assuming pliability and modernity will somehow divert us from the question of its durability. Bank of America has introduced a plastic credit card, which allows you to eat out and pay for it later. It's a new iteration of the Diner's Club card that debuted in 1950, but this one charges no annual fee. If

Americans are ready for that, too, maybe they're ready for fluoridated water. A dentist has gone public with his endorsement, and a community in Connecticut has voted in favor of putting the stuff in the drinking water to cut down on cavities. Better that than taking sugar out of the national diet.

THE AFRICAN AMERICAN WRITER Ralph Ellison has returned to the United States after living in Rome for three years. The winner of a National Book Award for his 1952 novel, *Invisible Man*, he flirted with the Communist Party before rejecting it and is now teaching literature at Bard College. He looks pretty dour, but the fact that he's here now has to be some kind of affirmation of America. The book he's working on, *Juneteeth: A Novel*, might even be fun to read.

Hard to say that about the work of the late James Agee, a Southerner who just won the Pulitzer Prize for fiction for his posthumous novel, *A Death in the Family*. It's based on the death of his own father when he was six years old. Some people had a problem reading Agee's unflinching 1941 book of reportage, *Let Us Now Praise Famous Men*, about white poverty in Depression-era Alabama, a literary match for a photograph in which he looks like he's been beaten up.

But the book everyone seems to be talking about is *Lolita*, by Vladimir Nabokov, a Russian who moved to America in 1940 at the age of forty-one. He wrote this novel in English but had to get it published first in France in 1955, because it's about a man who has a sexual relationship with an underage girl. It's flying out of the book stores in America now, hitting Number One on the *New York Times* bestseller list in September. The subject matter seems to be acceptable in literary circles, but those same people aren't so understanding about Jerry Lee Lewis marrying his thirteen-year-old cousin.

But *Lolita*'s a work of the imagination. It's art, not life, and art's letting a lot of new stuff into the culture, some of it good. Like a plastic house.

1959

And Then It Was Over

"I started to have bad dreams. Nightmares, and cold sweats at night . . .
I got drunk and woke up in strange places with faces on the next pillow
I'd never seen before. My eyes had a wild look in them . . . "

—Tennessee Williams, *Sweet Bird of Youth*

FIDEL CASTRO ROLLS TRIUMPHANTLY INTO HAVANA in January, after the army serving dictator Fulgencio Batista puts up a pathetic resistance (*following pages, left*). Now the rebels control the place, and they look even tougher and more self-assured than when they operated up in the mountains.

Castro's visibly aged since his last appearance in *Look* a year ago and annoyed by the presence of a photographer, but it's the men around him that we notice: the bearded soldier on the left with a star on his cap radiates toughness and ability; and so do the others, some of whom are little more than kids—like the one with the submachine gun, who is shouting down anybody who might bother the supreme leader.

The soldier in the foreground—with the goatee and a beret—is as good-looking as a movie star and could pass for one of Herb Caen's beatniks out in San Francisco, except that he has clearly been through a transformative experience and isn't inclined to give up

PREVIOUS PAGES: *West Side Story*, a musical about gang strife in a heavily Puerto Rican section of New York, was Broadway's big draw in 1959, and so *Look* decided to take its readers on a tour down the story's real mean streets, focusing on fourteen-year-old José Rivera. The article would eventually run in the February 16, 1960, issue.

OPPOSITE: On the TV quiz show *Twenty-One*, Charles Van Doren, professor and unlikely TV star, (shown on the right, with show host Jack Barry, in this news photo) won big money in 1957. Two years later, he testified before Congress that he was supplied in advance with the questions.

anything to anybody. That could be a problem for America, which supported Batista for many years and ignored the lot of ordinary Cubans.

WHAT NEEDS A REVOLUTION in America is television. Is that Red Skelton still up there, his face and act as old and worn as your grandfather's smoking jacket? And why do we need so many Western shows—more than twenty-five of them on the fall prime-time schedule. At least *77 Sunset Strip* is more promising, a "private eye in L.A." kind of show-case for new faces. Edd "Kookie" Byrnes, who plays the hip young parking lot attendant, has lots of hair Brylcreemed into submission, singing songs that sure aren't rock and roll (*opposite, top*). Others on the show—Roger Smith, Efrem Zimbalist Jr.—are at ease with the medium, as if the camera isn't even there.

When you consider how far-reaching television has become since the beginning of the decade, you also realize how the energy of those early years has dissipated. The anthology drama series including *Playhouse 90* and *Kraft Television Theatre*, doing

RIGHT: *77 Sunset Strip* was TV's hottest detective show, with scene stealer Edd Byrnes, as parking attendant Gerald Lloyd "Kookie" Kookson III, a character who spoke like a beatnik and looked like a pop star. *Look* featured the "Kookie Kraze" in its July 7 issue.

BELOW: Lawyering up was easy when your counselor was Perry Mason, played on TV by Raymond Burr. Burr, often a heavy in movies, was an odd but effective choice to play Erle Stanley Gardner's implacable creation who never lost a case.

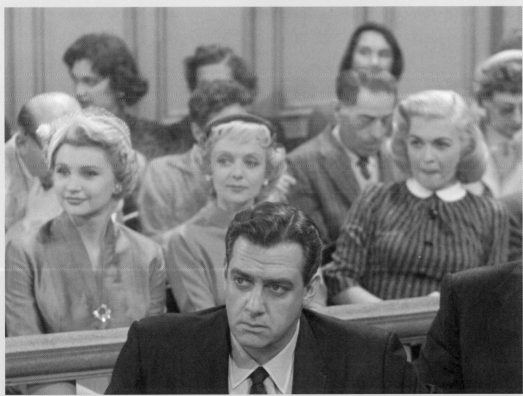

live plays out of New York with fresh talent culled from the theater, have given way to scripted series with familiar faces filmed in and around Los Angeles. The novelty for the viewer has worn off, too. Now we take it for granted: switching channels no longer seems like a betrayal of whatever desperate face clings to the flickering light.

In spite of the dominance of Westerns on the prime-time schedule, the real gripper this year is *Perry Mason*, which is unexpected, since the dark, brooding Raymond Burr looks disturbed and not like someone you'd want to defend your life (*previous page, bottom*). He spends all his time onscreen cogitating on ways to free his clients, and in court his rumbling voice is oddly soothing, even as it reveals the real perpetrators.

ROCK AND ROLL has supposedly come of age, but those teenagers standing admiringly behind Dick Clark look younger than ever, as if the sound's reaching down demographically, instead of keeping up with those who first embraced it (*opposite*). Elvis is serving a two-year hitch in the Army, Buddy Holly's dead in a plane crash (and so are Ritchie Valens and the Big Bopper), Jerry Lee Lewis is still blackballed for marrying his teenage cousin, Chuck Berry is in trouble with the law over a fourteen-year-old girl, Little Richard has quit music for the ministry—the whole scene is looking tired and shopworn.

Even Clark's stagy pose in that *Look* photo lacks the spontaneity of the early *Bandstand* days, his eyes tired and the smile vacant. Popular music needs someone—or something—fresh enough to keep younger kids interested, and there's nothing promising on America's broad horizon.

The same can be said for WABC Radio's former star disc jockey, Alan Freed (*following pages, right*). He's squeezing a cigarette confidently, posed at the mic, and then suddenly, he's a payola bum who accepts money to play songs and manipulate the charts and so has to resign. Now all the photos of Freed look like mug shots.

There's corruption in the quiz show world, too. Now it has surfaced in Congress, which had to get into the act. Clean-cut contestant Charles Van Doren, everybody's idea of a smart, respectable guy in a suit, turns out to be a liar, admitting in Congressional testimony that he was supplied with answers during his appearances two years ago on *Twenty-One* (*see page 218*). By appearing as guests on a show spun off from *The $64,000 Question*, bandleader Xavier Cugat and child star Patty Duke get dragged into the mess, she wearing white knee socks to the hearing, reminding us how fine the line is between innocence and scarring notoriety.

MR. FERRER

What's My Line? still manages to keep clean, since its debut in 1950 as a simple question-and-answer show, and a goofy one at that, despite the fact that its panelists dress up in gowns and tuxedos and have to wear masks when the celebrity guest trots out (*opposite*). There's no prize involved here, but the highbrow, edge-of-your-seat anticipation of a big-money quiz-game payoff is now history.

THE MOVIE EVERYONE'S TALKING ABOUT is *North by Northwest*, by director Alfred Hitchcock (*following pages*). In it, Cary Grant plays the standard Hitchcock innocent man, a New York advertising executive being pursued all over the country, at one point strafed in a Midwestern corn field by a homicidal pilot flying a crop duster. Nobody in the audience knows why, or what's going on, or anything for that matter, except that the chase somehow involves a beautiful, enigmatic Eva Marie Saint.

The suspense is real, and unusually disturbing. Something beyond Grant's—or our—control bears down on a respectable American and is unstoppable by the ordinary

forces of law and order. Are the Reds behind this, you may well ask, or the Mob? Or some other amoral, uncontrollable force at large in a world that we no longer control and that doesn't share our values?

Grant's still good-looking at fifty-five (and he's only eight years younger than the actress who plays his mother in the film), well dressed, a standout on the crowded streets of New York, which could be any city these days. But his character is really alone in his fear and his flight, Hollywood merging *The Man in the Gray Flannel Suit* and *The Lonely Crowd*. Except, this time, someone really is trying to kill him.

Sidney Poitier's starring in a Broadway production of *A Raisin in the Sun*, a powerful story about a black family trying to move into a white suburb of Chicago. It's by Lorraine Hansberry, the first black playwright to have her work staged on Broadway. *West Side Story*, a Broadway musical about life in a Manhattan neighborhood torn by the ethnic strife between white and Puerto Rican gangs, inspired photography by *Look* about the real thing (*see pages 216–217*). Hard to imagine Carol Lawrence on these tough, scrappy streets, where the kids are wary and set for trouble.

Groups of young men gather and disperse like mercury; they're American but they speak Spanish and they're poor, in T-shirts with rolled sleeves, and there's something about their daring that seems not just foreign, but also unreachable.

Poverty and hardship are just as much in evidence in Harlan County, down in Kentucky, where coal underlies the economy and the place itself. There's a forlorn quality about the miners, stuck in history and in a ravaged landscape, head lamps extinguished, the next descent uncertain.

For hope, there's a revival meeting, but all those exuberant arm wavers, mostly women, look as preoccupied as the miners. That faith's freighted with challenges we can only guess at, the ceremony probably good for the community even if a little bizarre.

The houses some of those families return to look as decrepit as anything in sharecropper Mississippi or the mean streets of Harlem and Detroit. For once, it isn't race that's the issue, but instead poverty and the difficulty that many Americans face to keep their heads up. They hope for deliverance, and maybe some happiness along the line, too.

DR. SPOCK'S NOW A GRANDFATHER, but then he never looked like anything but. He holds a baby like he made it, and in many ways he did (*opposite*). For many years he was the unofficial advisor to America's prospective mothers, and he's still interested.

Other signs of the times: a drive-up pay phone north of Baltimore—how convenient can things get?—and this question asked by *Look*: "Can a Girl Be an Astronaut?" She fits well into that gleaming white flight suit with the biggest circle collar ever (*following pages, left*). Though, the device behind her looks more like a giant pressure cooker for pot roast than a space capsule.

WE JUST CAN'T SEEM TO GET OVER FLORIDA. In the fifties, its population nearly doubles, and here it is again in *Look*, this time around presented a bit less ideally, despite all the sunshine. The old ways persisting in America, including segregation, persist in Florida, too. Even a fortune-teller has a separate door for black patrons (*see page 232*). So is the palm reading you get on the black side as good as the palm reading you get on the white?

It's the Florida light that holds us, whatever the subject matter, reflected from the glazed surface of a jukebox or a card table or the bald heads of middle-age men having a drink outdoors. Even the trailer homes look inviting, with their little idealized white picket fences and plantings—anything will grow in Florida—and couples walking confidently from the past into a sun-burnished future (*see pages 28–29*).

Warmth, that's the main point; everybody is suspended like that girl jumping off the high board between an ever-bright blue sky and a plunge into cool oblivion (*see page 233*).

ABOVE: Dr. Benjamin Spock's best-selling book on baby care was published at just the right moment, when an explosion of births coincided with an appetite for advice and self-help solutions. The July 21 issue featured the famous pediatrician on a visit to Cleveland's Babies and Children's Hospital, where he was checking on patient William Craig Wilson.

VICE PRESIDENT NIXON goes toe-to-toe with that fireplug, Nikita Khrushchev, the Soviet premier who is invited to an early viewing of the American pavilion set up in Moscow as part of a cultural exchange (*following pages, right*). Five million Russians are expected to see our $5 million showcase, which includes Disney's "Circarama" (a 360-degree film presentation) and a $250,000 "miracle kitchen" with an "electronic brain" built by RCA-Whirlpool.

ABOVE: On July 24, at the American National Exhibition in Moscow, visiting Vice President Richard Nixon and Soviet Premier Nikita Khrushchev exchanged something sharper than pleasantries at a kitchen exhibit. The so-called Kitchen Debate immediately became a part of Cold War lore. *Look* photographer Paul Fusco captured the discussion.

OPPOSITE: America was still several years away from its first manned space flight, but NASA was already considering putting a woman into orbit. Betty Skelton, training like the Mercury astronauts of *The Right Stuff* fame, didn't make it to the launching pad (and twenty-four years would pass before Sally Ride did). *Look* photographed Skelton in 1959 and featured her on the cover of its February 2, 1960, issue, with the headline, "Should a Girl Be First in Space?"

But after we go all out to show the Russians what we can do, Khrushchev takes the opportunity to reprimand Nixon for a resolution passed in the U.S. Congress condemning Russia's dominance of Eastern Europe. He's just jealous of the American color television set that Nixon shows him, sneering at it and the other innovations, claiming Russia will have them, too, in a few years.

Nixon gives as good as he gets, chiding the premier for threatening war all the time, and for being "afraid of ideas." The photograph looks more like a confrontation between two irate drivers at a traffic barrier than between an idealized capitalist and a member of the proletariat. Nixon wears his standard dark jacket and tie, Khrushchev looks more casual, one arm draped over the metal railing, close to taking a swing at the vice president's famous ski-jump nose.

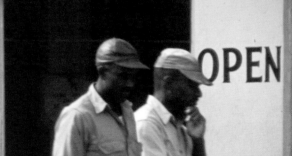

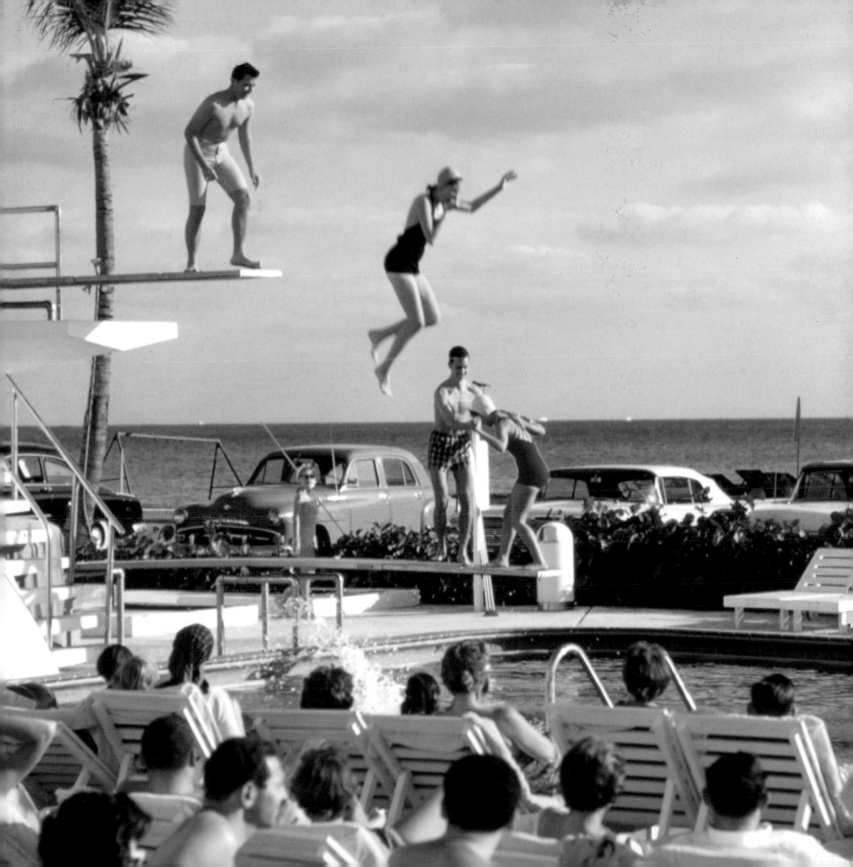

They're calling it the "kitchen debate," although the kitchen's a stage set and the debate more a demonstration of each politician's guile and feigned courage. Did it make the chances of an atomic exchange more, or less, likely?

Well, Nelson Rockefeller's taking no chances (*left*). He's down there in a bomb shelter—could it be his own basement?—where two kids are in double-decker bed and supplies have been arranged on the shelves. Is that a new garbage can Rockefeller's holding?

PREVIOUS PAGES, LEFT: In April, *Look* examined "Expanding Florida," which was becoming America's new frontier for retirees, college students on spring break, and job seekers. Photographer Frank Bauman found that the old ways of segregation still lingered in Miami.

PREVIOUS PAGES, RIGHT: On his swing through the Sunshine State, Bauman also recorded a spring tradition: the migration of college students to Florida to engage in elaborate mating rituals, here one involving diving boards. This photo was not published.

ABOVE: Nelson Rockefeller, Republican governor of New York and would-be candidate for the 1960 presidential race, takes stock of a bomb shelter, a discreet feature of the Cold War landscape. Shot in 1959, this photo was not used when *Look* published a feature on Rockefeller in its April 12, 1960, issue.

IF ANYONE'S IN CONTROL at the end of the decade, it should be the president. But, nearing the end of his second term, Eisenhower's withdrawing, and his party seems adrift. Senator Margaret Chase Smith loudly opposes Ike's nominee for Secretary of Commerce, not as dramatic as her denunciation of McCarthyism back in 1950 but an indication that Republicans have serious doubters within their ranks.

The president won't even say whether or not he'll endorse his own vice president in next year's election. If Nixon decides to run for the ultimate office—and everyone knows he will—he'll need Ike's nod, and their relationship's anything but warm. But Nixon keeps smiling anyway.

Another possibility for president is that influential senator from Texas, Lyndon Johnson (*opposite*), a big, profane Democrat who has a ready answer for *Look*'s question, "Can a Southerner Be Elected President?" (Their answer is "yes.") But Southern politicians have been tainted by the furor over continuing segregation and their reluctance to speak clearly about race. Then, as *Look* has shown us, Texas isn't really Southern, but rather a world unto itself. Could that be just what it takes?

A stronger candidate might be found up north, in the higher reaches of wealth and privilege. The young senator from Massachusetts, John Kennedy, seems more mainstream than Johnson, and he's getting more publicity of late. Kennedy's good looks and easy, outdoor manner remind you, for some reason, of one of those new mentholated cigarettes.

His wife's in a class by herself, a cross between debutante and matron. She's clearly at ease in that chair, wearing virginal white but also a suggestive half smile, watching something off-camera (*following pages*). It's probably a child but is he or she coming or going? Jackie's poised there between beauty and enduring motherhood, the road before her longer than we can imagine at what will soon be the outset of a brand new decade.

ABOVE: The Senate majority leader, garrulous and persuasive Lyndon B. Johnson, was spoken of as a challenger for the Democratic presidential nomination. *Look* ran two articles on LBJ in August, citing his "tremendous masculine appeal to the female voter." In this unpublished photo by Bob Sandberg, the future president is holding forth for a group of visitors to the Capitol.

FOLLOWING PAGES: One of Senator John F. Kennedy's greatest assets in the run-up to the 1960 presidential race was his glamorous wife, Jacqueline. No first lady in living memory could match her youth and sophistication. *Look*'s Philip Harrington shot this portrait in 1959, which was never published in the magazine.

CODA

The decade about to pass seems as if it went by not in years, but in minutes. Faces flashed across the screen as they did in television's beginnings, on them the essential American smile, but now everybody looks older and not necessarily wiser. What happened to all those things we were supposed to buy and couldn't—hats, new cars, freezers, houses—and all the personal things we worried about and still do? They haunt the decade as much as anti-Communism, Korea, women and work, men and sports, racial violence, quiz shows, irrepressible music, and juvenile delinquency.

Where's it all going, we ask, even with the answer right there in front of us, in grainy black-and-white photographs and in bright, garish hues. In those 1959 pictures, the country's still recognizable from those shot in 1950 but it's changing fast—again—right there under the surface of the paper, the idea of us as alluring as ever, even beautiful, but untouchable.

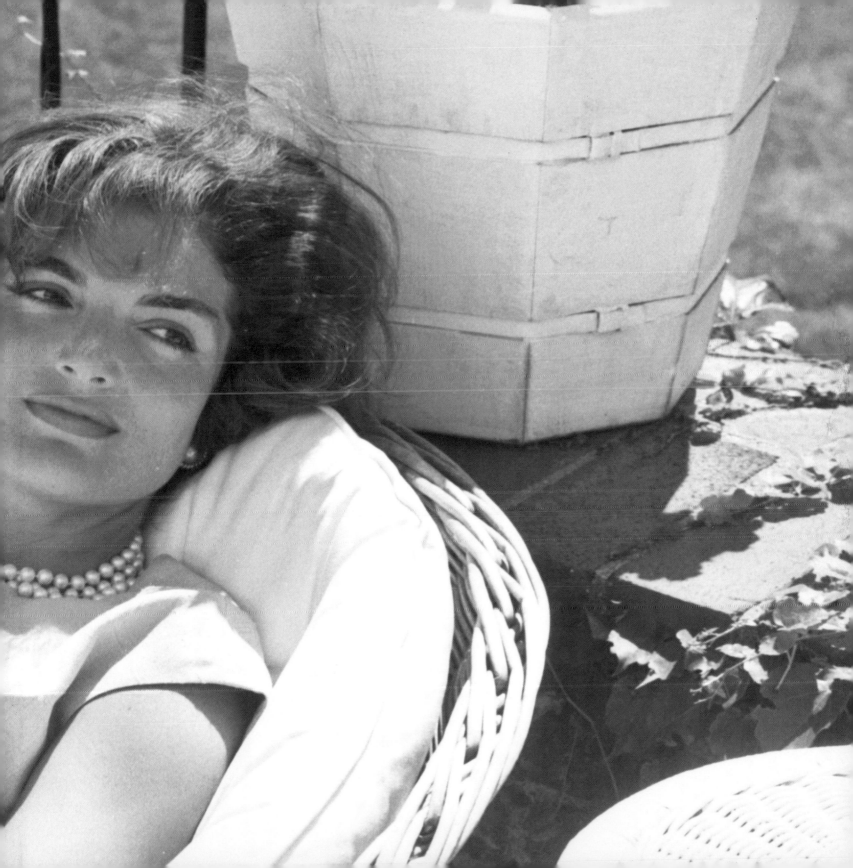

NOTE ON IMAGES

Unless otherwise noted, all photographs are from the Library of Congress's Look Magazine Collection. For the Look Collection, we have provided the photographer (if identified) and LC reproduction number. In some instances, two photographers were credited for the same story, and we have included both names. For Look covers, we have included photographer credits where available. For other photographs from the Library, see key below. Photographs from outside the Library are credited according to the key.

To obtain reproductions of Library of Congress images in this book, note the negative or digital ID numbers that follow page numbers in the chapter lists below. Many images in this book from the Library's Prints & Photographs Division can be viewed by searching the online catalog (http://www.loc.gov/pictures/). Contact Duplication Services of the Library of Congress, http://www.loc.gov/duplicationservices/, (202) 707-5640 to purchase reproductions. Rights information for the LOOK Magazine Photograph Collection and other Prints & Photographs Division collections can be found at: http://www.loc.gov/rr/print/res/rights.html.

KEY

LC P&P	Library of Congress Prints & Photographs general collections
LC Gen Coll	Library of Congress General Collections
Corbis	Corbis Images
Photofest	Photofest

Page 2: Bob Sandberg, LC-L9-54-3299, no. 106. Page 4: Charlotte Brooks, LOOK - Job 52-1740.

Introduction. Page 6: Maurice Terrell, L901A-56-4175, #1. Page 8: Look Cover, February 26, 1952; John Vachon (Exercise girl), Harris & Ewing (Ike) Bob Sandberg (Betty Hutton). Page 9: Look cover, December 25, 1956, Bob Vose (Lucille Ball and Desi Arnaz), LC-USZC4-4889. Look cover, April 5, 1955, Charlotte Brooks (Ed Sullivan). Page 10: LC P&P, Eide, LC-L9-54-3252-A #12. Page 12: John Vachon, LC-L9-57-7770-GG #29. Page 15: Dierks & Arthur Rothstein, LC-L905A-55-3950, #5. Page 17: Douglas Jones & Arthur Rothstein, LC-L904A-55-3864, #6. Page 20: John Vachon, LC-L9-51-54 Vachon South frame 346. Page 23: Paul Himmel, LC-L9-57-7394, #183. Page 24: Cal Bernstein, LC-L9-58-7842. Page 26: Robert Lerner, LC-L9-56-6540-P #2. Page 27: Stanley Kubrick, LC-L92-50-Y1, #2. Page 28: Frank Bauman, LC-L905A-59-8151, #7.

Chapter One. Page 30: Corbis/LC P&P, LC-USZ62-136142. Page 32: Jim Hansen, L-92-50 W47_1u. Page 35: Corbis, U1142921INP. Page 36: LC P&P, 3c14730. Page 37: LC P&P, 3c15591v. Page 38: Stanley Kubrick, LC-L9-49. Page 39: Stanley Kubrick, LC-L92-49-U34-#2. Page 41: Frank Bauman, 01232u. Page 42: LC Gen Coll. Page 43: Stanley Kubrick, 01132u. Page 44: Stanley Kubrick, 01133u. Page 46: Frank Bauman, L-92-49-085-5. Page 47: Philip Harrington & John Vachon, LC-L92-50-X66#1. Page 49: Stanley Kubrick, L92-50-Y1_3u.

Chapter Two. Page 50: Earl Theisen, LC-L9-52-1331, #79. Page 52: Maurice Terrell, LC-L9-52-1135-D, no. 3. Page 54: LC P&P, LC-USZC4-1451. Page 55: Maurice Terrell, LC-L904A-51-59, #2. Page 56: Maurice Terrell, LC-L92-51-AF72, #1. Page 57: Earl Theisen, LC-L92-51-AL99, #8. Page 59: Earl Theisen, LC-L905A-51-74, #3. Page 60: Douglas Jones, LC-L904A-51-AD54, #7. Page 61: Robert Lerner, LC-L904A-51-172, #2. Page 62: Frank Bauman & Philip Harrington, LC-L922-51-AF77, #1. Page 63: Frank Bauman & Philip Harrington, LC-L9-51-AF77-P. Pages 64-65: Frank Bauman & Philip Harrington, LC-L9-51-AF77-II. Page 66: Frank Bauman & Philip Harrington, LC-L9-AF77-NNN, #16. Page 67: Frank Bauman & Philip Harrington, LC-L9-51-AF77-J20. Page 68: Frank Bauman & Philip Harrington, LC-L9-51-AF77-A, #22. Pages 70-71: Frank Bauman & Philip Harrington, LC-L9-51-AF77-E4, #30.

Chapter Three. Page 72: Philip Harrington, LC-L9-52-1016, I #29. Page 74: Frank Bauman, LOOK-L914-52-1745. Page 76: John Vachon, LOOK - Job 51-54. Page 77: Jim Hansen, LC-L9-52-87, #1. Page 78: John Vachon, LOOK - Job 51-54. Page 79: Earl Theisen, LC-L92-52-6, no. 19. Page 80: Look cover, June 26, 1952, Robert Lerner (Hornsby), Michael Vaccaro (Greer), MGM (Gabor). Page 81: Louis Faurer, LC-L904A-52-1278 #9. Page 82: Charlotte Brooks & Arthur Rothstein, LC-L904A-52-1907, #1. Page 84: Earl Theisen, LC-L9-52-72, E #19. Page

85: Charlotte Brooks, LC-L9-52-1667, #97. Page 86: LC P&P, Gordon Parks, PR 13 CN 1998:061. Page 87: Bob Sandberg, LC-L9-1220 #19. Pages 88-89, Charlotte Brooks, LC-L905A-52-1304, no. 24. Page 90: Bob Lerner, LOOK-L905A-52-1712, no. 43. Page 91: Charlotte Brooks, LC-L905A-52-1740, no. 39. Page 92: Charlotte Brooks, LC-L917-52-1607. Pages 94-95: Michael Vaccaro, LC-L917-52-1780, #3. Page 96: LC P&P, Shel R. Alpert, LC-USZ62-44252.

Chapter Four. Page 100: Philip Harrington, LC-L9-L917-53-2606, #3. Page 102: Douglas Jones, LC-L9-53-2462, no. 16. Page 104: (Top) Douglas Jones, LC-L9-53-2462-D; (Bottom) Charlotte Brooks, LC-L9-2439-A. Page 105: Earl Theisen, LC-L92-53-1395, #95. Page 106: Robert Lerner, LC-L9-53-2258, #17. Page 107: (McCarthy) Frank Bauman, LC-L904A-53-2220, #2; Look cover, November 3, 1953, Catherine Stover. Page 108: LC P&P, LC-USZ62-127228. Page 109: LC P&P, Toni Frissell, LC-USZC4-4349. Page 110: Robert Vose, LC-L9-53-1438, #9. Page 111: Earl Theisen, L905A-53-1342, no. 2. Page 112, John Vachon, LC-L9-53-1424, H-#39. Page 113: Robert Vose, LC-L9-53-2266, #202. Page 114: Strock, LC-L901A-53-2741, #2. Page 115: Maurice Terrell, LC-L901A-53-1375, #2. Page 116: Philip Harrington, LC-L901A-53-2268, #5. Page 117: Maurice Terrell, LC-L905A-53-1414 #3. Pages 118-119: Milton Greene, LC-L914-53-2602, #3.

Chapter Five. Page 120: Bob Sandberg & Jack Star, LOOK-L905A-54-3299, no. B20. Page 122: Bob Sandberg, LC-L9-54-3299, no. 106. Page 124: Bob Sandberg & Jack Star, LC-L9-54-3299, no. B20. Page 126: Charlotte Brooks, LC-L905A-54-3136, #14. Page 127: Maurice Terrell, LC-L9-54-1530. Pages 128-129: Robert Vose, LC-L9-54-2888-M, #11. Page 130: Robert Lerner, LC-L9-54-3544-D. Page 131: Frank Bauman, LC-L9-54-3304-K. Page 132: Milton Greene, LC-L905A-54-3632, #2. Page 133: Robert Vose, LC-L904A-54-1573, #1. Page 134: Maurice Terrell, LC-L9-54-3579 #45. Page 135: Arthur Rothstein, LC-L9-54-3180-E, #35-35A. Page 137: Robert Vose, L904A-54-1578, #1. Page 138: Jim Hansen, LC-L9-55-6215-G #19. Page 139: John Vachon, LC-L9-54-3007-E #45. Page 141: Earl Theisen, LC-L904A-54-1567 #1. Page 142: Eide, LC-L9-54-3252-A #12. Page 143: Jim Hansen, LC-L904A-54-2024 #2.

Chapter Six. Page 144: Charlotte Brooks, LC-L9-55-3868-B, #34. Page 146: Douglas Jones & Arthur Rothstein, LC-L901A-55-3864, #4. Page 148: Arthur Rothstein, LC-L9-55-6280-C, #2. Page 150: Jim Hansen & Philip Harrington, LOOK - Job 55-3883. Page 151: Milton Greene, LC-L905A-55-3858, #1. Page 152: Jim Hansen & Robert Lerner, LC-L9-55-3719-GG, #10. Pages 154-155, Philip Harrington, LC- L901A-55-6422, #11. Page 156: LCP&P, LC-USZ62 110733. Page 157: Earl Theisen, LC-L9-55-6001-J, #15. Page 159: Maurice Terrell, LC-L9-55-4052. Page 160: Arthur Rothstein, LC-L9-55-6373, #88. Page 161: LC P&P, Thomas O'Halloran, LC-U9- 165B-G10. Pages 162-163: Philip Harrington, LC-L901A-55-6422, #19.

Chapter Seven. Page 164: John Vachon, LC-L9-56-6792-E #8. Page 166: Philip Harrington, LC-L9-56-6706-H, no. 3. Page 168: Ed Fingersh, LOOK - Job 56-6625. Page 169: James Abbe, LC-L9-56-6818, #175. Page 170: Bern Keating, LC-L9-55-6492, #221. Page 171: John Malone, LC-L9-56-7004, #4. Page 172: Douglas Jones, LC-L9-56-6595, folder 2, T2, #21. Page 173: Philip Harrington& Arthur Rothstein, LC-L901A-56-7013, #1. Page 175: Leo Friedman, LC-L9-56-6446-X. Page 177: Maurice Terrell, LC-L905A-56-4103, #8. Page 179: LC P&P, LC-USZ62-137211. Page 180: John Vachon, LC-L9-56-6711, E-#18. Page 181: John Vachon, LC-L9-56-6792-F. Page 182: Maurice Terrell, LC-L901A-56-4175, #4. Page 183: Look cover, November 27, 1956, n/a. Page 184: Bob Sandberg, LC-L9-57-7610-C #18.

Chapter Eight. Page 186: Philip Harrington, LC-L901A-53-2268, #3. Page 188: Paul Himmel, LC-L9-57-7394, #183. Page 190: Jim Hansen, LC-L9-57-7201, E, #21. Page 191: Christa, LC-L905A-57-7156, #4. Page 192: Robert Lerner, LC-L9-57-7144, S #30. Page 193: John Vachon, LC-L9-57-7488-F, #21. Page 193: Jay Leviton, LC-L905A-57-7118, #1. Page 194: Charlotte Brooks, LC-L9-57-7621-I, no. 28. Page 196: LC P&P, U9-972-1. Page 197: Bob Sandberg, LC-L9-57-7283-B #10. Page 198: Douglas Jones, LC-L9-57-7228, #7. Page 199: Robert Lerner, LC-L901-57-7509, #1. Page 200: Look cover, August 4, 1957. Page 201: Maurice Terrell, LC-L9-57-4231 #43. Page 202: Maurice Terrell, LC-L9-57-4256. Page 203: Earl Theisen, LC-L905A-57-4250, #4. Page 204, Bob Sandberg, LC-L9-57-7507-F, #18. Page 205: LC P&P, LC-USZ62-123597. Pages 206-207, Philip Harrington, LC-L901A-57-7502, #6.

Chapter Nine. Page 208: LC P&P, LC-USZ62-125086. Page 210: John Vachon, LC-L9-59-8361- E #25. Page 212: LC P&P, LC-USZ62-126828. Page 213: LC P&P, LC-USZ62-126830. Page 215 (Hoffa): Philip Harrington, LC-L9-58-7706, L #224. Page 215 (Unemployment): Charlotte Brooks, LC-L9-58-7822, J 2. Page 216: Paul Fusco, LC-L9-58-7636 E #11. Page 217: Andrew St. George, LC-L9-57-7568, #136. Page 218: Maurice Terrell, LC-L9-58-4329-N #4. Page 220: LC-L9-58-7952-Y4-#2. Page 221: Bern Keating, LC-L9-58-7585-E 2. Page 222: John Vachon, LC-L9-58-7770-B #17. Page 224: John Vachon, LC-L9-58-7770-D #22.

Chapter Ten. Page 226: Paul Fusco, LC-L9-59-8462-G. Page 228: LC P&P, Orlando Fernandez, LC-USZ62-126813. Page 230: LC P&P, LC-DIG-ds-00926. Page 231 (Byrnes): Maurice Terrell, LOOK - Job 59-4393. Page 231 (Burr): Maurice Terrell, LOOK - Job 58-7793. Page 233: Howell Conant, LC-L904A-59-8466, #1. Page 234: Robert Lerner, LC-L9-59-8242-H #8. Page 235 (Freed at mike): LC P&P. Page 235 (Freed 40-shot): LC P&P. Pages 236-237: Photofest. Page 239: Jim Hansen, LC-L9-59-8270-DD, #13. Page 240: Bob Sandberg, LC-L901A-59-8504, #3. Page 241: Paul Fusco, LC-L901A-59-8410, #3. Page 242: Frank Bauman, LC-L905A-59-8151, #3. Page 243: Frank Bauman, LC-L901A-59-8151, #7. Page 244: Douglas Jones, LC-L9-59-8579-14. Page 245: Bob Sandberg, LC-L9-59-8351-H, #33. Pages 246-247: Philip Harrington, LC-L9-59-8435-E #13.

DEDICATION

To Ralph Eubanks
whose idea it was

ACKNOWLEDGEMENTS

From Jim Conaway: This book couldn't have come to be without the talent and perserverance of Tom Wiener and Amy Pastan. Tom brought a love and knowledge of the decade to the multiple tasks of research and editing, and Amy a trained eye and intimate knowledge of the wonderful photographic trove from which these images are taken. I also want to thank everyone in the Publishing Office of Library of Congress, and in particular these interns who helped: Sydney Sznajder, Courtney Hall, Caroline Bowman, and Jaci Moseley. Also, thanks to Allison Power of Rizzoli for her editorial support, and to Phil Kovacevich for his outstanding design.

From Amy Pastan: In the Library of Congress Prints & Photographs Division, I had help from many staff members, most of all Jan Grenci, Helena Zinkham, and Barbara Natanson; also, Jonathan Eaker, Kristen Sosinski, Kit Arrington, and Georgia Zola.

First published in the United States of America in 2014 by
Skira Rizzoli Publications, Inc.
300 Park Avenue South
New York, NY 10010
www.rizzoliusa.com

2014 2015 2016 2017 / 10 9 8 7 6 5 4 3 2 1

Printed in China

ISBN: 978-0-8478-4373-2

Library of Congress Catalog Control Number: 2014936549

For Skira Rizzoli Publications, Inc.:
Editor: Allison Power
Design: Phil Kovacevich
Design Coordinator: Kayleigh Jankowski

For Library of Congress:
Editor: Tom Wiener
Photo Editor: Amy Pastan

Cover photo: Frank Bauman, Look Magazine Collection, Prints and Photographs Division, Library of Congress, LC-L901A-59-8151, #7.